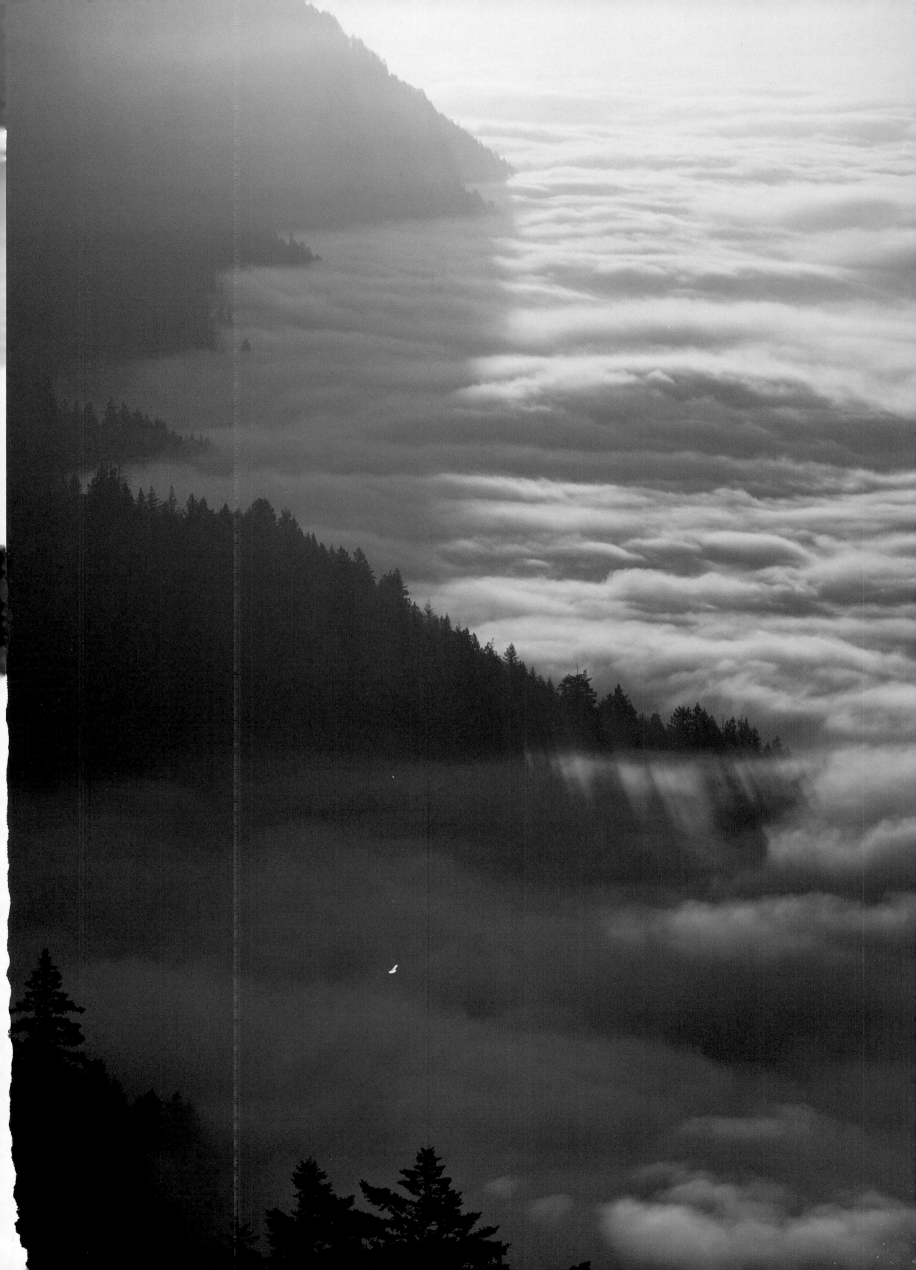

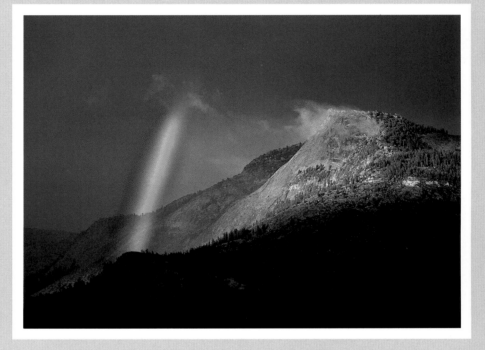

MARC MUENCH

CALIFORNIA

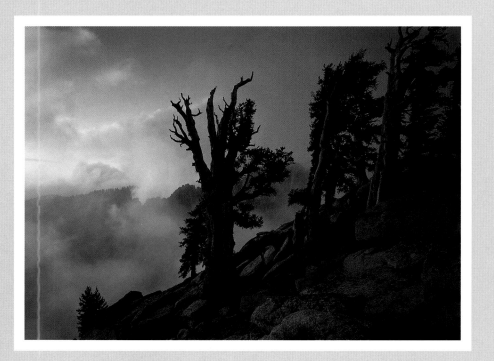

DAVID MUENCH

ESSAY BY JAMES LAWRENCE

GRAPHIC ARTS CENTER PUBLISHING®

All photos are by David Muench,
Marc Muench, or Zandria Muench Beraldo.
For information regarding copyright of individual
images and for sources of quotes used in text,
please see page 144.
Text © MCMXCIX by James Lawrence
Book compilation © MCMXCIX
by Graphic Arts Center Publishing®
An imprint of Graphic Arts Center Publishing Company
P.O. Box 10306, Portland, Oregon 97296-0306
503/226-2402 www.gacpc.com

Library of Congress Cataloging-in-Publication Data

Muench, David.
 California / photography by David Muench
and Marc Muench ; essay by James Lawrence
 p. cm.
 ISBN 1-55868-469-7 (hc : alk. paper)
 1. California Pictorial works. 2. Landscapes—
California Pictorial works. I. Muench, Marc.
II. Lawrence, James, 1945– . III. Title.
F862.M92 1999
917.94—dc21 99-21542
 CIP

President: Charles M. Hopkins
Editorial Staff: Douglas A. Pfeiffer, Ellen Harkins Wheat,
Timothy W. Frew, Diana S. Eilers, Jean Andrews,
Alicia I. Paulson, Deborah J. Loop, Joanna M. Goebel
Production Staff: Richard L. Owsiany,
Lauren Taylor, Heather Hopkins
Designer: Bonnie Muench
Digital Pre-Press: Tom Dietrich of DMPI
Freelance Editor: Linda Gunnarson
Cartographer: Ortelius Design, Inc.
Book Manufacturing: Lincoln & Allen Company
Printed and bound in the United States of America

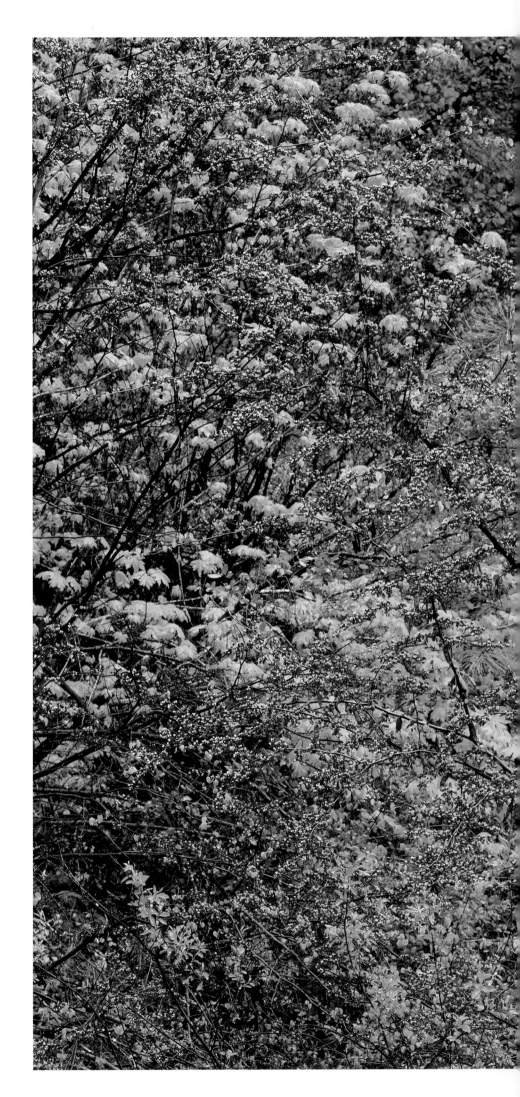

◄ ◄ ◄ Lost Coast, King Range Nat'l Conservation Area.
 ◄ ◄ Olmstead Point, Yosemite National Park.
 ◄ Foxtail pines, Alta Peak, Sequoia National Park.
 ► California redbud against bigleaf maple in the
 McCloud River Canyon Preserve.

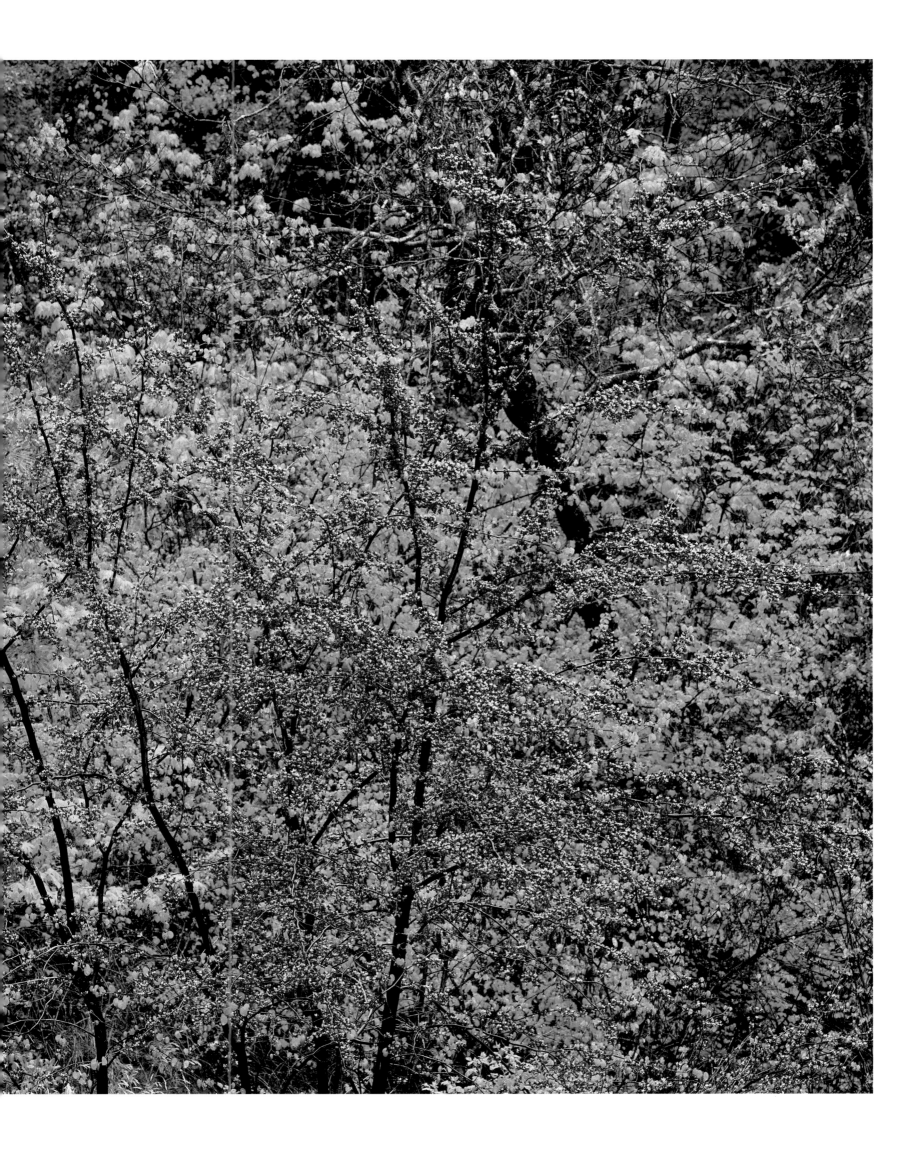

CONTENTS

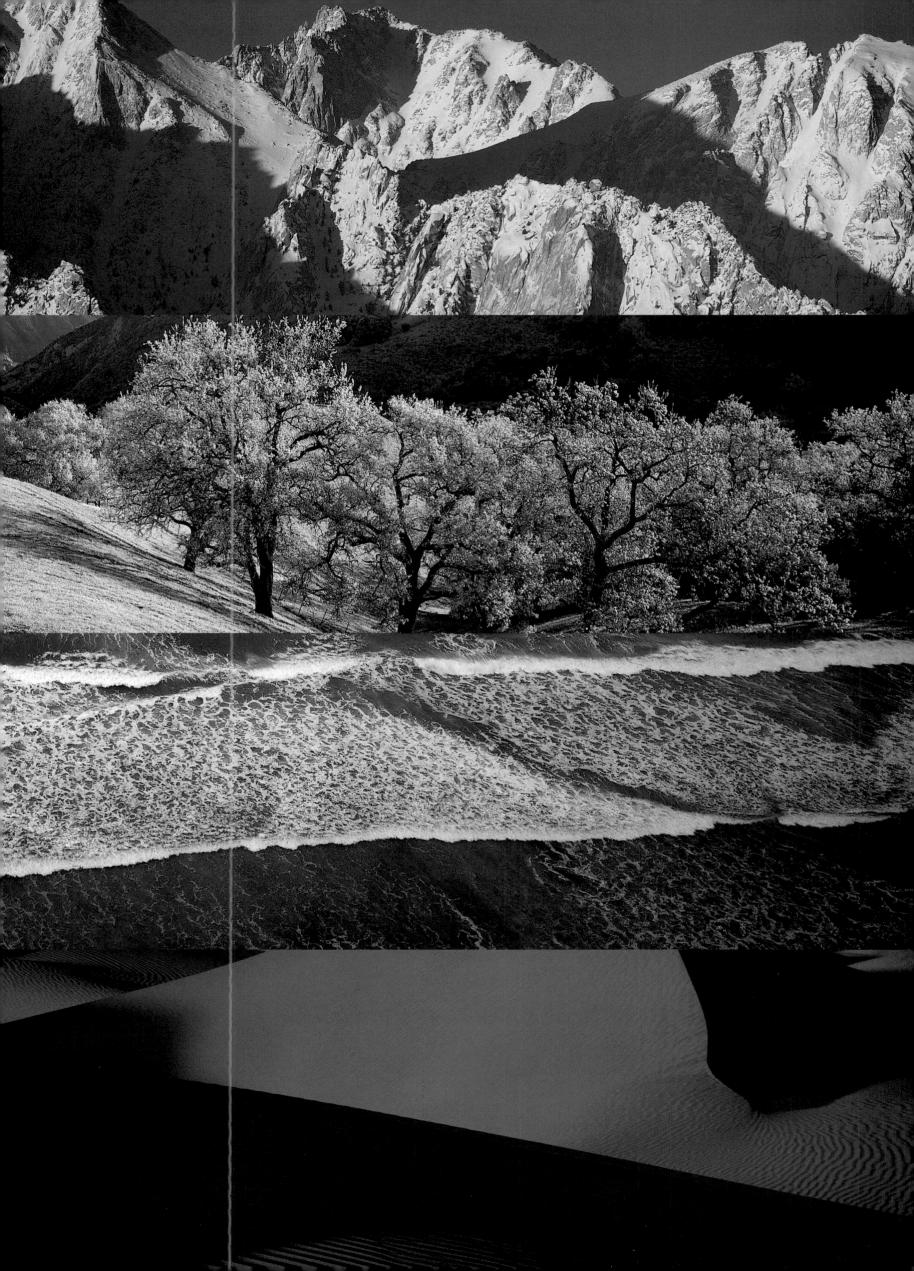

PROMISE AND FRUITION

"And what is your religion?" I asked him.
"I think it is California," he replied.
— California landscape painter Gottardo Piazzoni (1993)

The only real voyage of discovery consists not in seeking
new landscapes but in having new eyes.
— Marcel Proust, *Remembrance of Things Past* (1934)

There are the dreamers of gold, and the dreamers of a golden life. To this day, California croons a siren song to both. Even as it rolls mightily into the new millennium, the state and its state of mind continue to entice with visions of wealth and opportunity, framed in a natural geographic paradise unrivaled anywhere in the world in diversity and sheer magnificence. California is the place where everything seems possible (and often is), as any multi-millionaire software magnate or movie star, rocket engineer or backpacking photographer, migrant farm worker or fifty-year-old surfer will tell you. California is the place where lives can change in big ways—over decades or overnight.

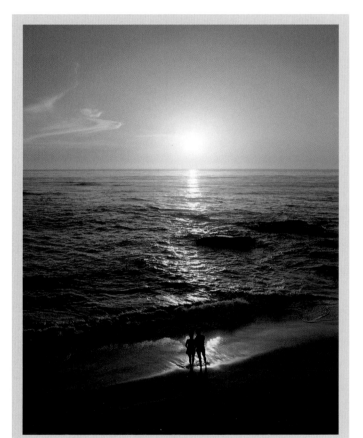

Yet there is another California that awaits us, a place where we may go to reconnect with the bedrock of our humanity. It is that California we discover in the pages that follow.

But first, a brief look at the modern state, which begins and turns on a malleable, beautiful yellow metal called gold. Riding the tidal wave of Gold Rush hysteria that washed bright-eyed fortune hunters onto its still-unspoiled shores, California the independent republic became California the state on September 9, 1850. The beached dreamers, mostly male, mostly young, flowed out from the endless stream of sailing ships anchored in the great harbor of San Francisco. Armed with pans and sluice boxes, then mountain-leveling hydraulic hoses and lake-scouring gold dredges, surviving on hard tack, beans, and six-guns, they flushed their destinies from the soils of the great valleys, hills, and the Sierra Nevada—and forever changed the future of the state and the nation.

Gold has been an integral part of the California mystique from the beginning, even as the word itself remains an indelible adjective for the area and its features: the Golden State, the Golden Gate, the Golden City. Long before the Gold Rush, obsession with the metal drove Spanish and English explorers half a globe from home in search of golden plunder, the fuel of empire. Often their boxy galleons labored for weeks on end against prevailing northwesterlies to travel mere scores of miles up the wild coast. So primitive was navigation and mapping, so effective a cloak was the Pacific Coast fog, that every Drake and Cabrillo and Vasquez in search of a world-class harbor outpost flat-out failed to discover, beneath their very noses, one of the largest, most magnificent potential seaports in all the world—San Francisco Bay—for two hundred years!

For thousands of years before the Europeans arrived, California's natural paradise sheltered and sustained myriad tribes of aboriginal hunter-gatherers, basket weavers, and fishers. They lived contentedly within the harmonic cycle of give-and-take with the land, flourishing on its abundant resources: fresh water, quail, trout, deer and elk, fruits, seaweed, and acorns.

As many as 500,000 Indians thrived in pre-European California, protected from invasion by tribes from the north, east, and south by impenetrable mountain and desert barriers. Twenty distinct family lines of more than 60 tribes spoke 5 main language stocks and 135 dialects, all mostly unintelligible to one another. They called themselves Yurok, Chemehuevi, Karok, and Wintun; Hupa, Yowlumnni, Mohave, and Esselen (from which the famous Esalen Institute, a spiritual retreat along the Big Sur Coast, takes its name); Chumash, Patwin, and Nomlak; and many more.

Today, California has metamorphosed from a sparsely populated land of wild resources to the immigrant's dream of a "civilized" life. With the coming of the railroads to link the new, wealthy state with the rest of the nation, land, agriculture, mining, fishing, and real estate created a fully realized geopolitical colossus of 163,707 square miles. California is so rich in natural and human resources that it boasts the seventh-largest economy among all nations of the world—not states, *nations.* Civilization-shifting industries such as aerospace and personal computers pop up like spring shoots with mind-boggling regularity.

California dangles the dream and the realizable promise that anyone from any walk of life can throw down kindling here and blow the spark of ambition into a firestorm of success. Maybe that's why you find such a rich cultural mélange among its thirty-three million people, such as the 140 distinct nationalities that live in Los Angeles County alone. Dealing with the immigration of peoples from around the world continues to be one of California's major challenges: 25 percent of all Californians are foreign-born, and an estimated two million undocumented aliens live here.

California endures as both symbol and reality: the easy-life land of the sundown sea, the cutting edge of enterprise and global vision, yet also a place where new frontiers are sought and found within ourselves. Technology, New Age spirituality, alternative medicine, genetic engineering, and the formula for the perfect blockbuster movie or frozen margarita all get equal billing here.

Nothing comes more naturally to Californians than a shot at fame—or infamy. Ask the ghosts of Howard Hughes and William Randolph Hearst, Duke Snider and Marilyn Monroe, John Steinbeck and Robinson Jeffers; or the monarchs of the new empire of Entertainia, such as Aaron Spelling, Steven Spielberg, and Michael Eisner. And then there's the purest embodiment of go-for-it Californiana ever: "Governor Moonbeam," the ever-reemergent Jerry Brown, presidential candidate, author, radio talk show host, Oakland mayor, and, for all we know, future emperor of the League of Galactic Brotherhood. Simply stated, California is that Oz-like place where anyone's name might be up in lights tomorrow.

People who live elsewhere sometimes poke fun at the Golden State's endless stream of fads, celebrity hijinks, environmental activism, and run-amok urban sprawl—until they move here, in pursuit of their own slice of the fuller life. They're drawn, above all, to the mild-climate coasts, to the environs radiating out from the golden cities of San Francisco—the Paris of America, the City by the Bay—and Los Angeles, the everywhere that feels like nowhere else you've ever been, with its teeming millions, empire-building industries, star-maker machinery, and king's-ransom real estate, still beckoning with the promise of a life of plenty, balmy skies, and endless Pacific zephyrs.

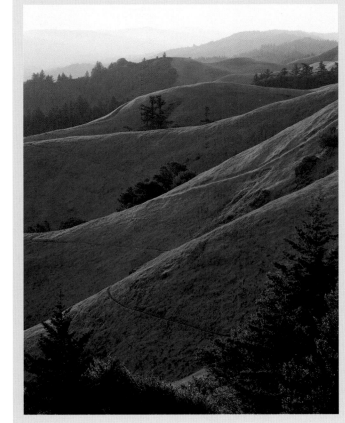

California weather, famous for its mostly benign winters and hot, dry summers, adds to the myth as the seasons blend one into another and the years flow by like a Mercedes on cruise control.

And where else but in California can you go back to nature, back to work, back to the past at thousands of historical sites, back to the future in Silicon Valley, back to Mars at Pasadena's Jet Propulsion Laboratory, back to your childhood at Disneyland—all within a day's drive along the state's vast freeway and highway system?

California is not as big as Texas or Alaska in about the only way that doesn't matter much any more—sheer size. Not nearly as old or steeped in tradition as New England's original colonies, it engenders a more freewheeling approach to the environmental, societal, and economic challenges of the day. Appropriately, it could be rechristened the Moniker State, for certainly no one nickname can capture its exuberant variability. California is the fertile loam from which pilgrims harvest not only enough food to feed the world, but the better mousetrap, computer mouse, cartoon mouse, genetically engineered Supermouse, and chocolate mousse with equal facility. If ever a place signified having "arrived," it's California.

Yet for all its giddy rush and bustle, there is a quieter, more ethereal side to California that abides in full view of the endless tract homes, shimmering skyscrapers, and farmer's fields. Move beyond the eight-lane freeways and wispy contrails of California's wild ride into the next millennium and you find an enduring spiritual presence, an immense and endlessly pleasing natural world ready to welcome its prodigal children home.

California's truest gold is its incomparable landscape. Since most of the state's people live along the coasts near San Francisco and in Southern California, the vast majority of its land is sparsely populated and has increasingly fallen under federal and state protection, bestowing a legacy of rich, diversified natural areas upon the future.

In the eastern United States, less than 10 percent of the land is publicly owned. In California, 50 percent is set aside in some form of protected holdings. Most of these preserved areas encompass the mountain and desert regions of the state, although much of the thirteen-hundred-mile seacoast is also publicly held.

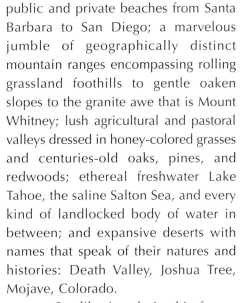

You find a surfeit of magnificent vistas here: rugged, bracing rock-cliff coasts from Big Sur to the Oregon border; long, sublime public and private beaches from Santa Barbara to San Diego; a marvelous jumble of geographically distinct mountain ranges encompassing rolling grassland foothills to gentle oaken slopes to the granite awe that is Mount Whitney; lush agricultural and pastoral valleys dressed in honey-colored grasses and centuries-old oaks, pines, and redwoods; ethereal freshwater Lake Tahoe, the saline Salton Sea, and every kind of landlocked body of water in between; and expansive deserts with names that speak of their natures and histories: Death Valley, Joshua Tree, Mojave, Colorado.

Set like jewels in this frenzy of geography are the special places that continue to defy description: the colossal natural cathedral that is Yosemite Valley, the brooding Redwood National Park in the primordial North Coast wilds, the spectacular panoramas of Point Reyes National Seashore.

And so we propose, with this gathering of evocative imagery and a pilgrimage of words, to redirect your soul's compass in the direction of California's mountains and deserts, coasts and grasslands. We invite you to open your spirit to its potential for offering respite from our busy lives and high-rise cities. It might seem ironic at the end of this technologically explosive century to suggest that California's vast natural lands—lands that we so vigorously sought to subdue just one hundred years ago—may again help us sense the beating pulse of Earth, and so beguile us into intimate communion with life's joys and mysteries.

Yet this is our conviction and invitation: to let yourself slip, with the faith of a child, into this natural California and so invite wonder, worship, and gratitude for the simple joys of being alive. Along the way, may you hear the whisper of the sacred, which is everything.

◄ A COUPLE ENJOYS THE SUNSET ALONG SHELL BEACH AT LA JOLLA POINT.

▲ OAK, GRASS, AND PINE COVER BOLINAS RIDGE IN MAY, MOUNT TAMALPAIS STATE PARK.

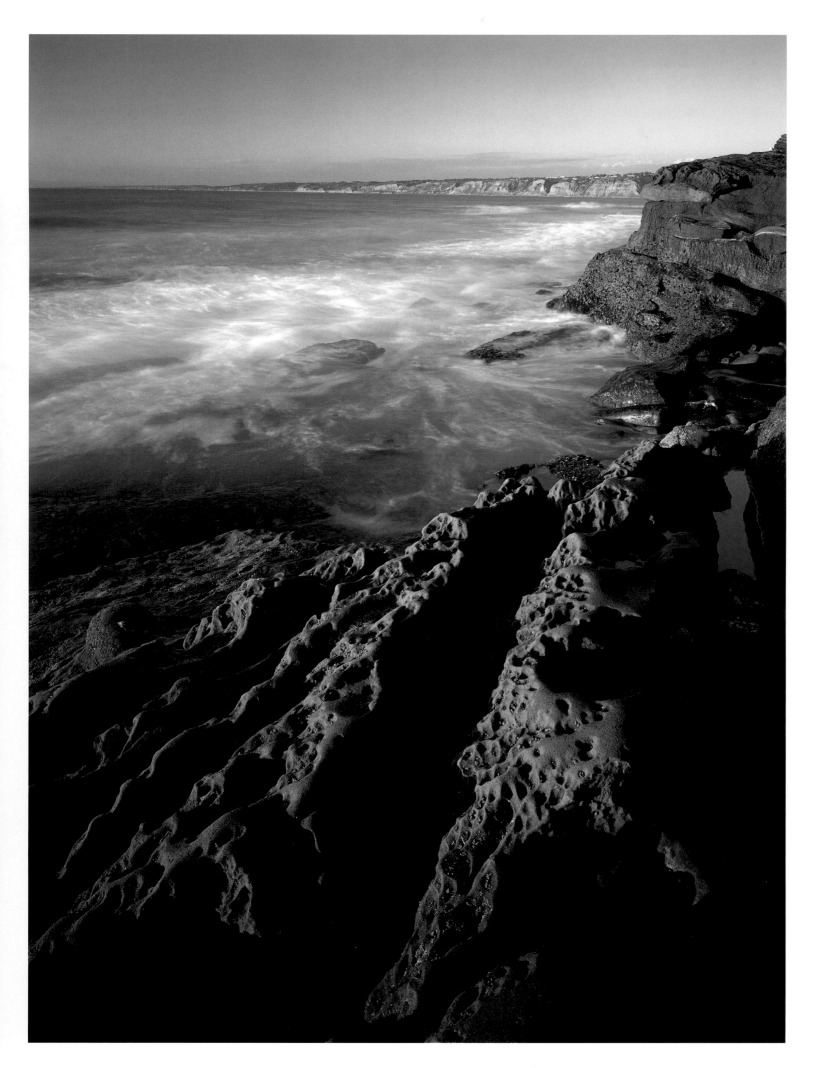

▲ Waves break along the rocky shores of the La Jolla coast.
► Cascading plumes seem to explode from the granite shelf to become Nevada Falls
along the Merced River in Yosemite National Park.

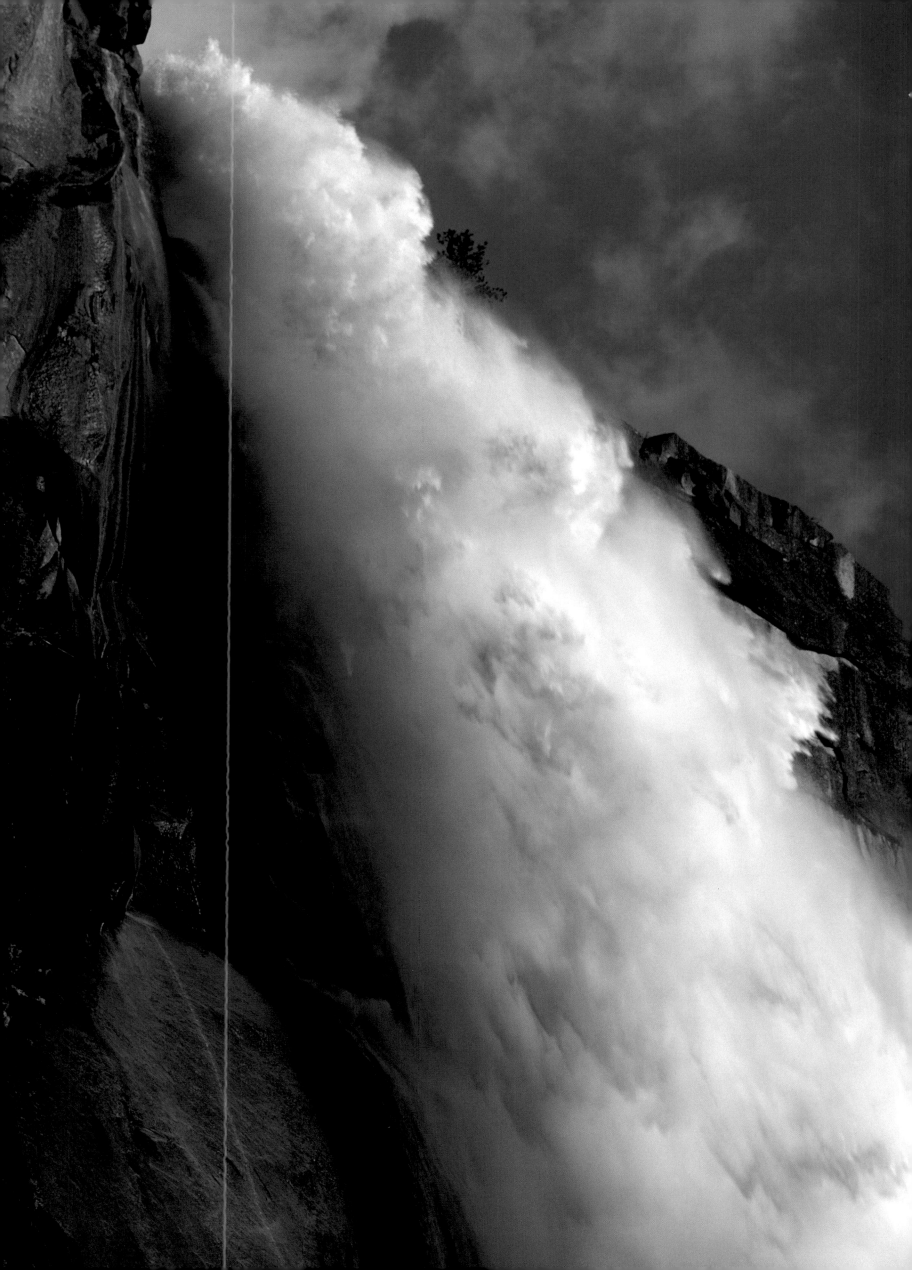

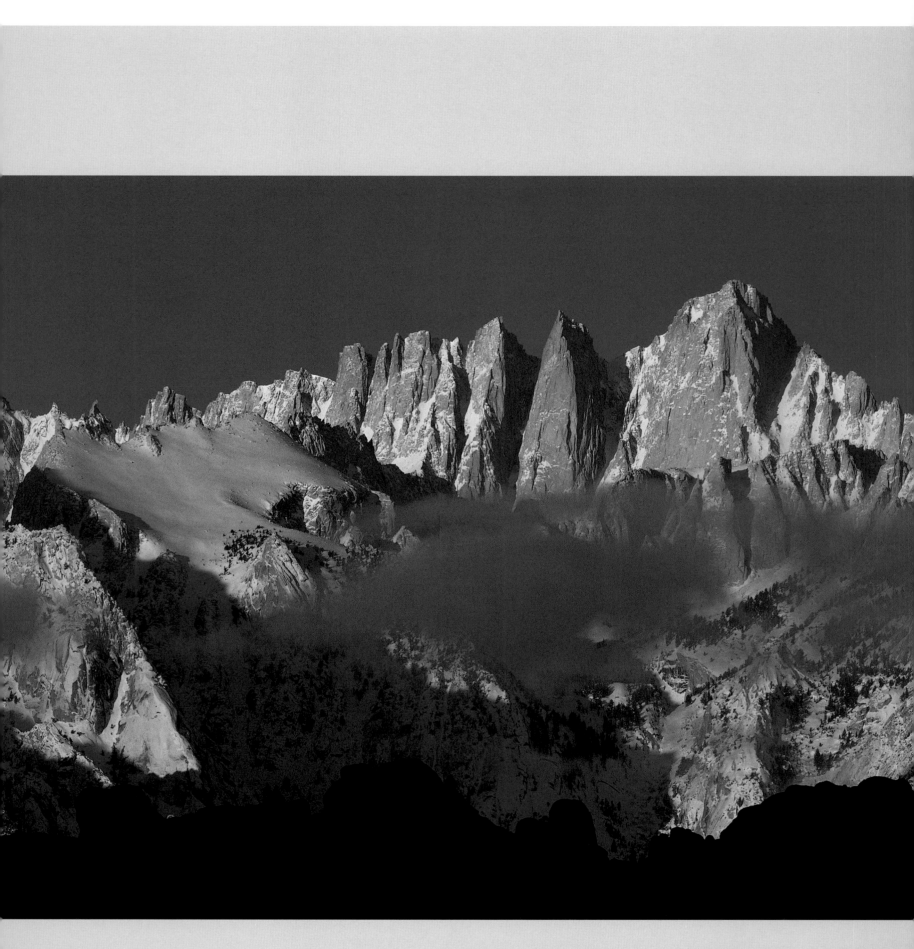

MOUNTAINS

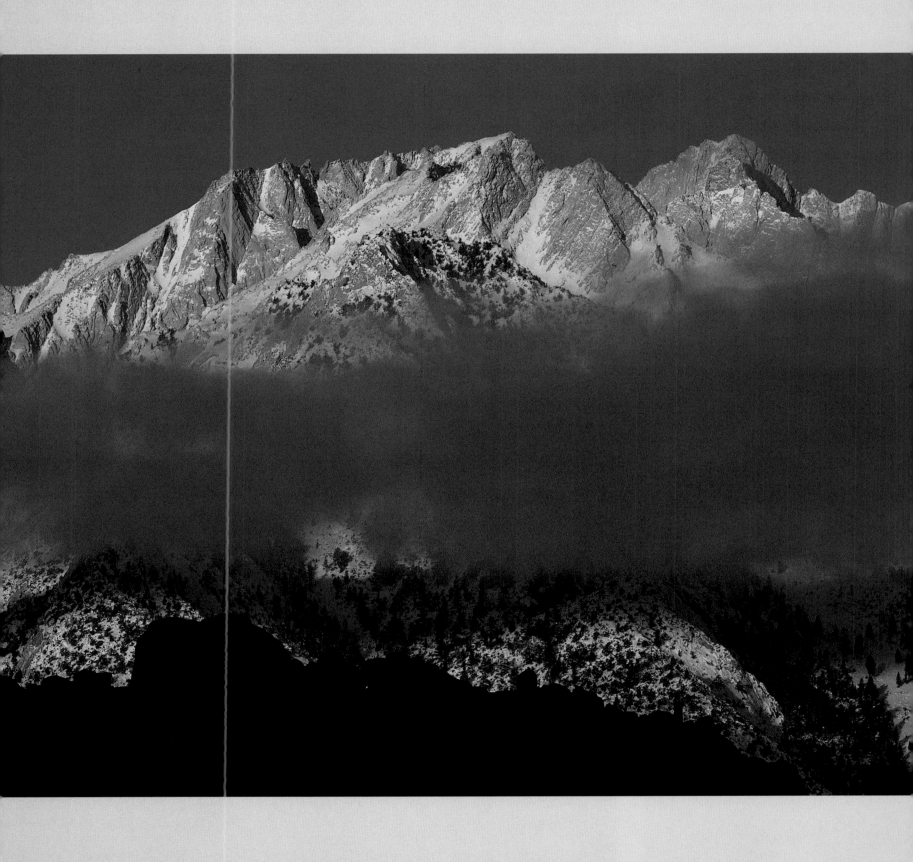

Mount Whitney, at 14,496 feet, cuts a serrated granite skyline along the eastside Sierra
Nevada between Sequoia National Park and the John Muir Wilderness.

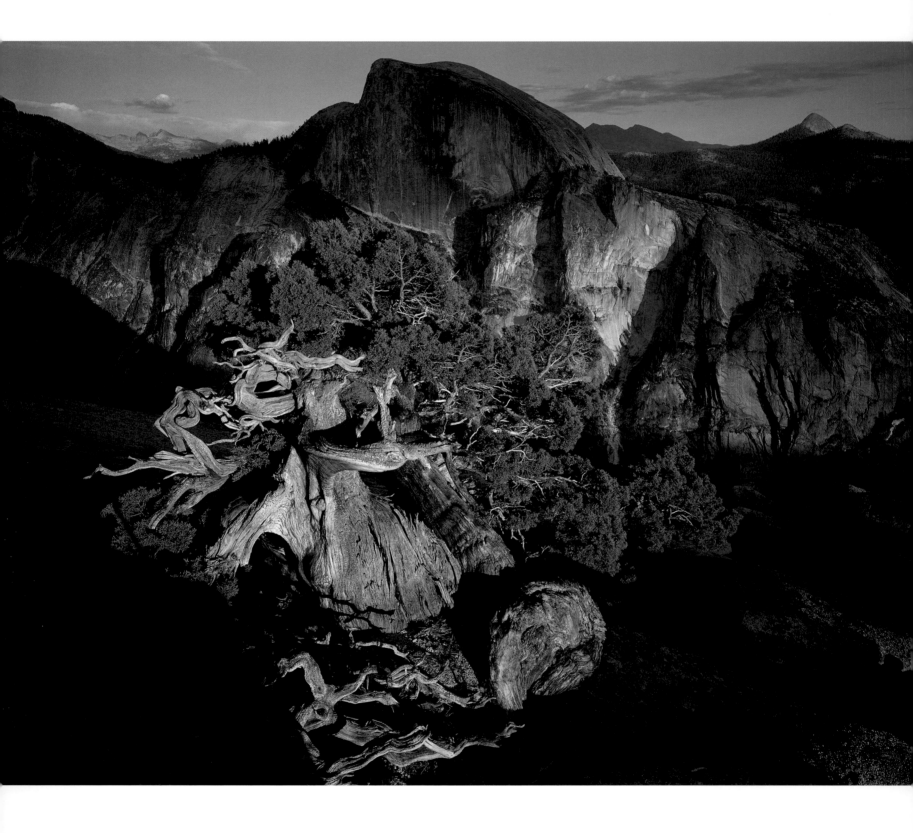

CRAGGY AND WEATHER-BEATEN WESTERN JUNIPER (*JUNIPERUS OCCIDENTALIS*) BRAVES THE ELEMENTS
AMONG THE GLACIALLY CARVED GRANITIC DOMES AND CLIFFS OF THE SIERRA NEVADA.
HALF DOME, IN YOSEMITE NATIONAL PARK, BROODS IN THE CENTER BACKGROUND.

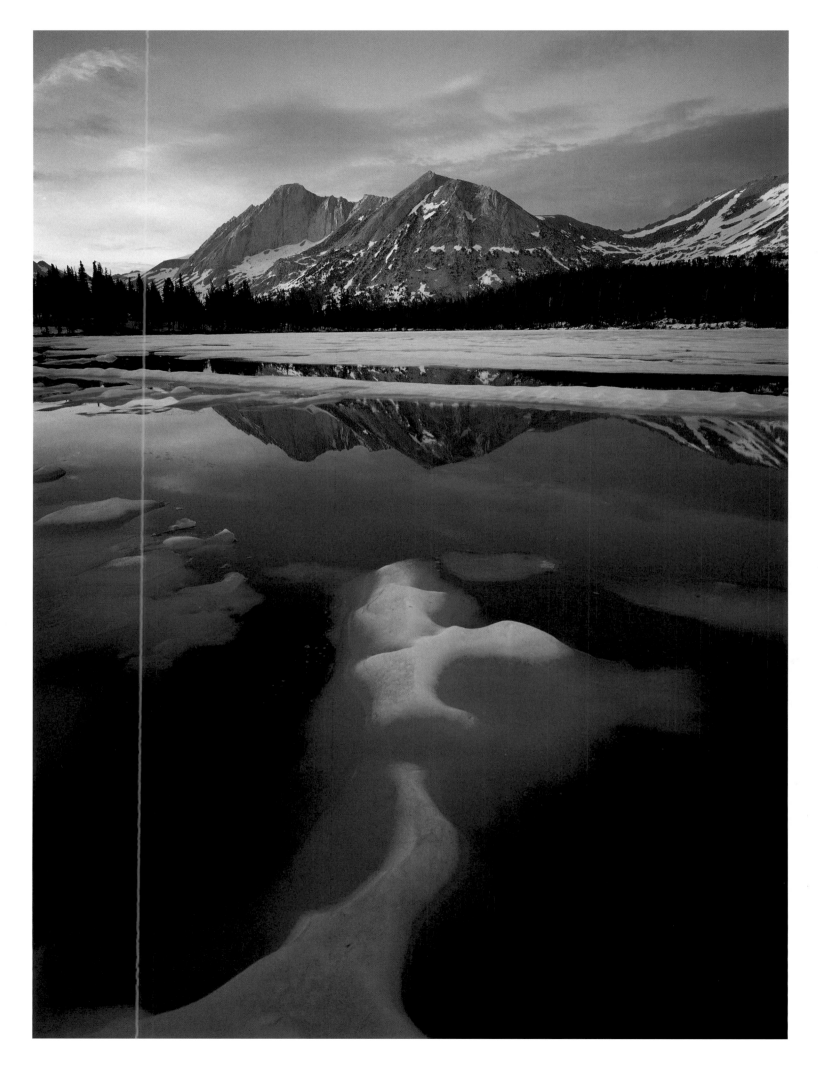

As winter gives way to summer, ice floes break up in Young Lakes, casting a double image of Mount Conness (12,590 feet), part of the magical Yosemite high country.

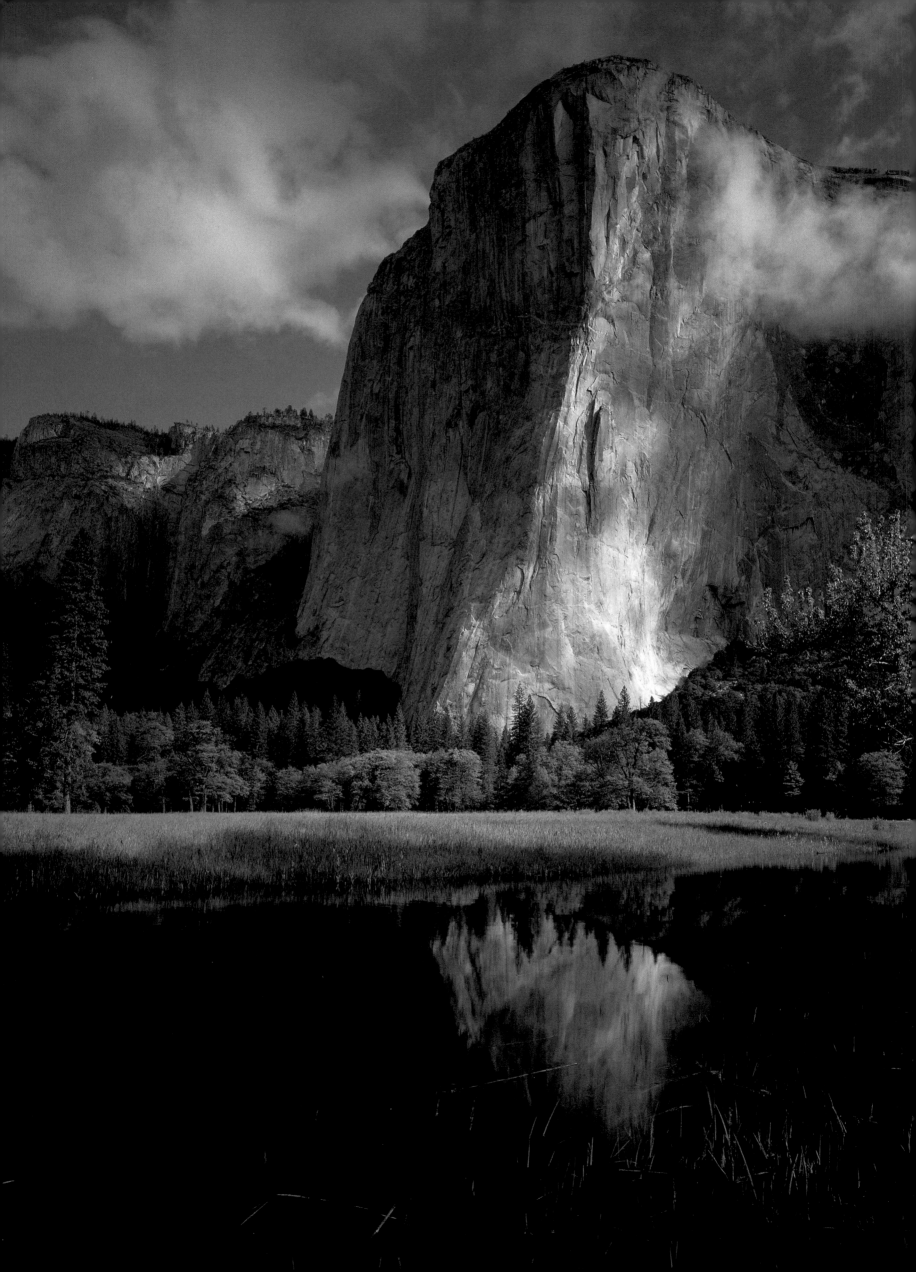

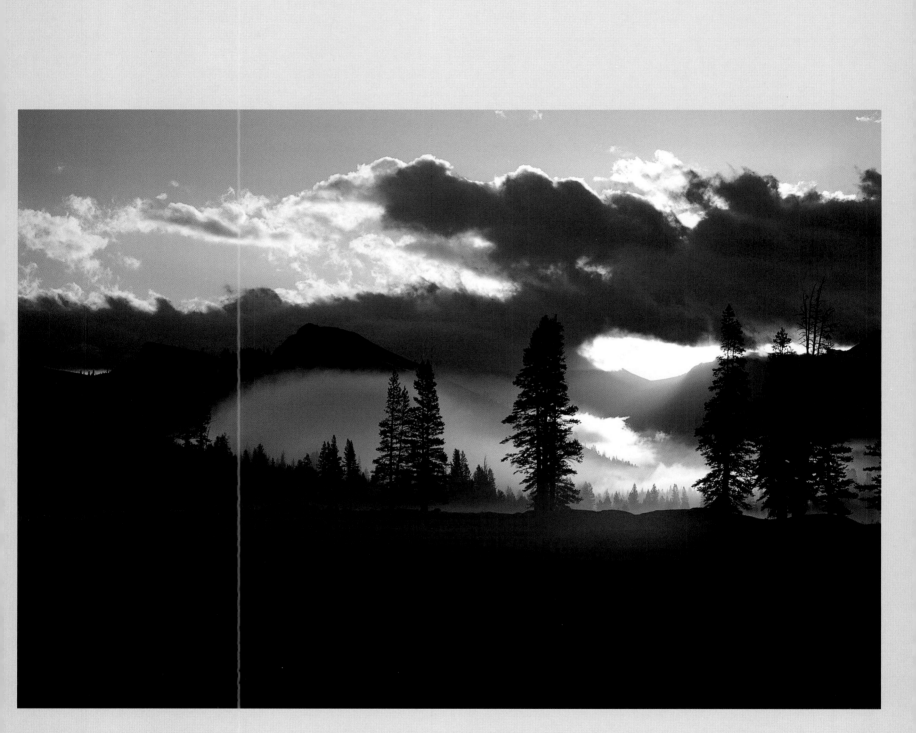

◄ THE FOUR-THOUSAND-FOOT FACE OF YOSEMITE'S COMMANDING EL CAPITAN DRAWS ROCK CLIMBERS
FROM ALL OVER THE WORLD. THIS MASSIVE MONOLITH IS THE LARGEST SINGLE GRANITE ROCK ON EARTH.
▲ YOSEMITE'S TUOLUMNE MEADOWS, THE LARGEST SUBALPINE MEADOW IN THE SIERRA, CATCHES GOLDEN
BACKLIGHT IN ITS MOUNTAIN MISTS. CALIFORNIA BIGHORN SHEEP ARE SOMETIMES SEEN GRAZING HERE.

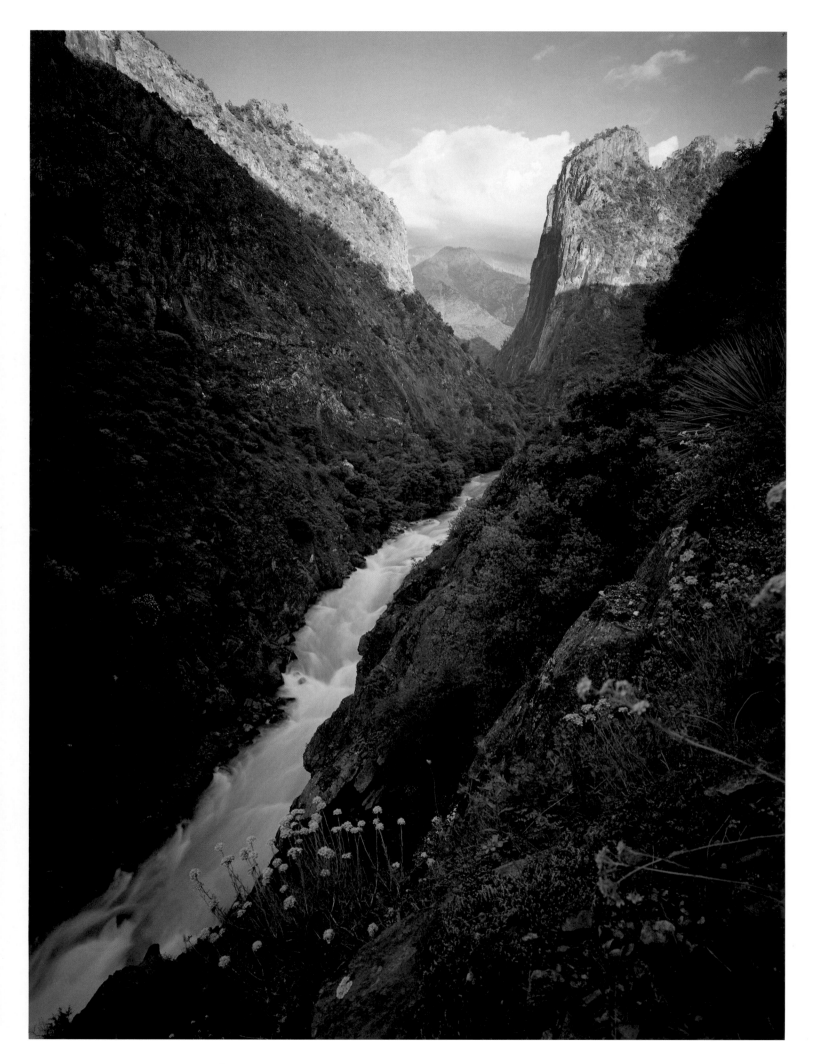

SWOLLEN WITH SPRING SNOWMELT RUNOFF, THE SOUTH FORK OF THE RIO DE LOS SANTOS REYES
(RIVER OF THE HOLY KINGS) AS NAMED BY SPANISH EXPLORERS IN 1805, PASSES THROUGH
A GLACIALLY SCULPTED GATEWAY TO KINGS CANYON NATIONAL PARK.

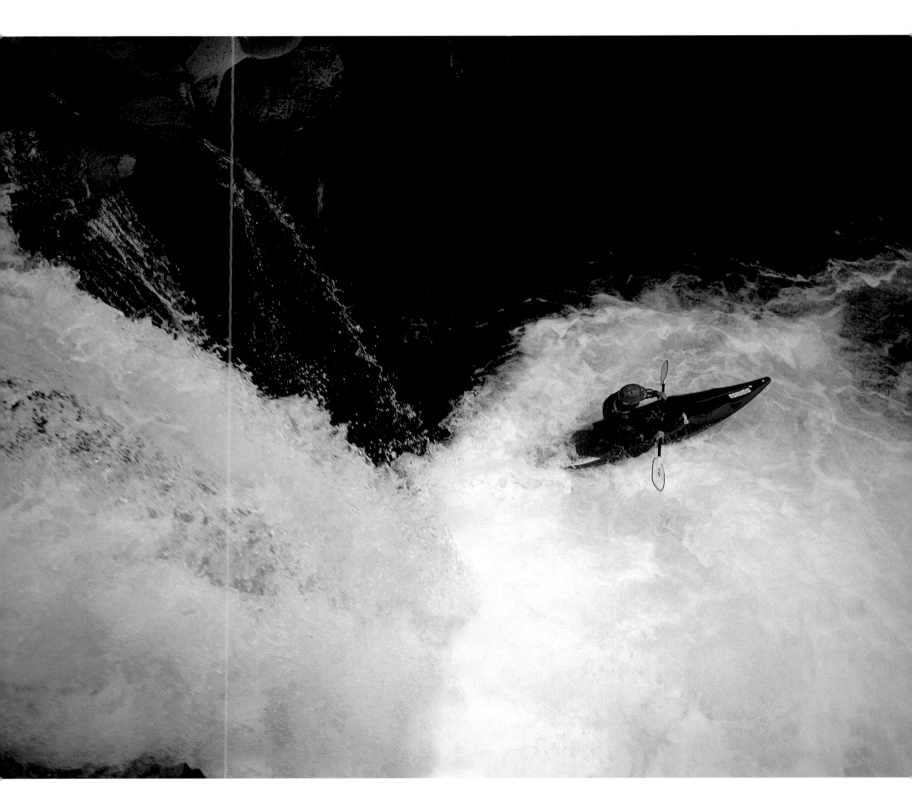

AFTER SUCCESSFULLY NAVIGATING THE WATERFALL TO THE LEFT, A LONE KAYAKER HEADS

DOWN THE MCCLOUD RIVER, ONE OF MANY OUTDOOR SPORTS AREAS ACCESSIBLE FROM THE NEARBY

TOWN OF MOUNT SHASTA IN THE CASCADE RANGE OF NORTHERN CALIFORNIA.

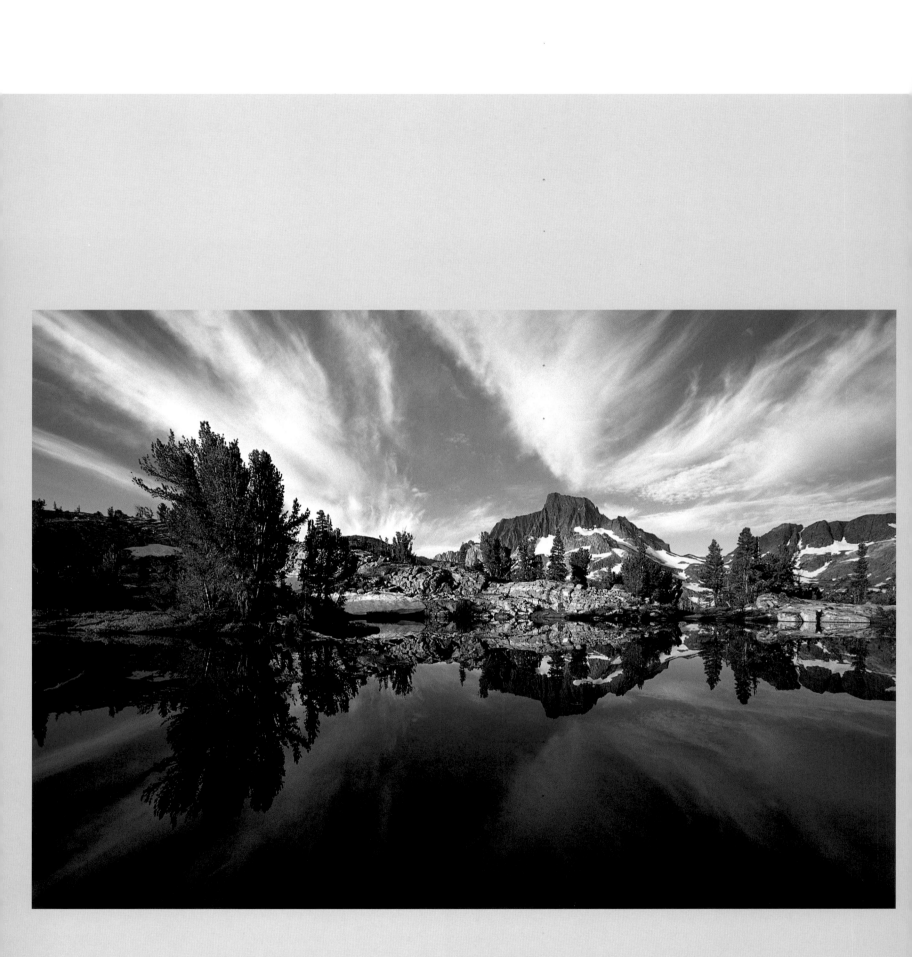

MOUNT RITTER (13,157 FEET) AND BANNER PEAK (12,945 FEET) HOLD THE HIGH GROUND IN THE
HORIZONTAL SYMMETRY OF AN ALPINE POND REFLECTION AT THOUSAND ISLAND LAKE,
PART OF THE RITTER RANGE, ANSEL ADAMS WILDERNESS, JUST BELOW YOSEMITE.

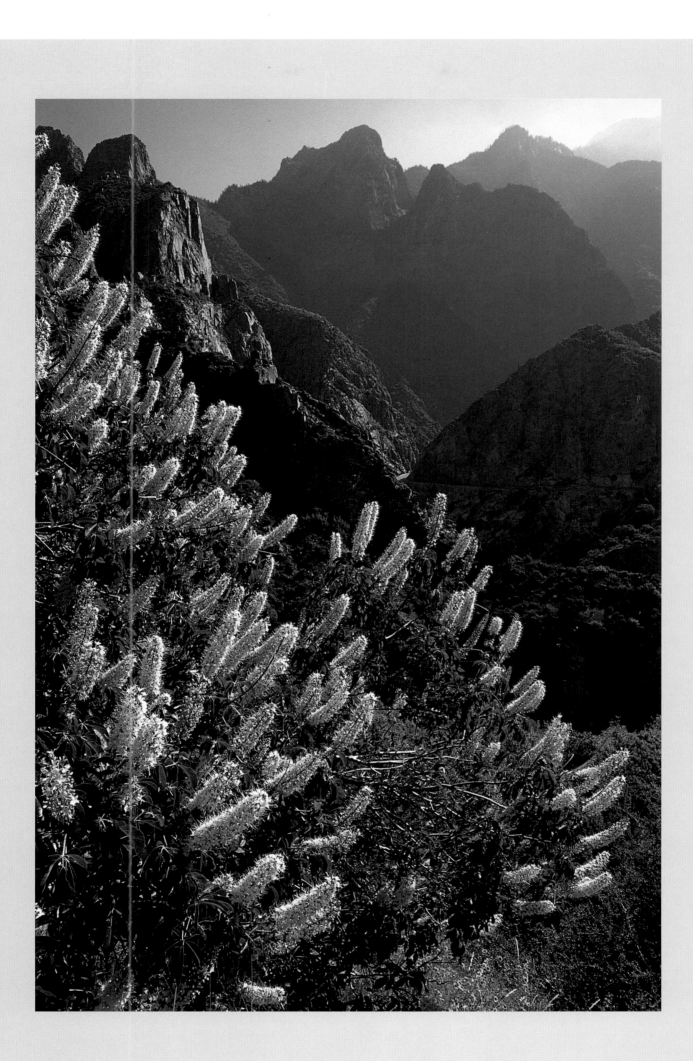

THE PEAKS OF THE MONARCH DIVIDE TOWER ABOVE THE SOUTH AND MIDDLE FORKS OF
KINGS RIVER CANYON. BUCKEYE *(AESCULUS CALIFORNICA)* ADDS JUNE COLOR
TO THE SHEER ROCK WALLS OF THIS SEQUOIA NATIONAL FOREST LOCALE.

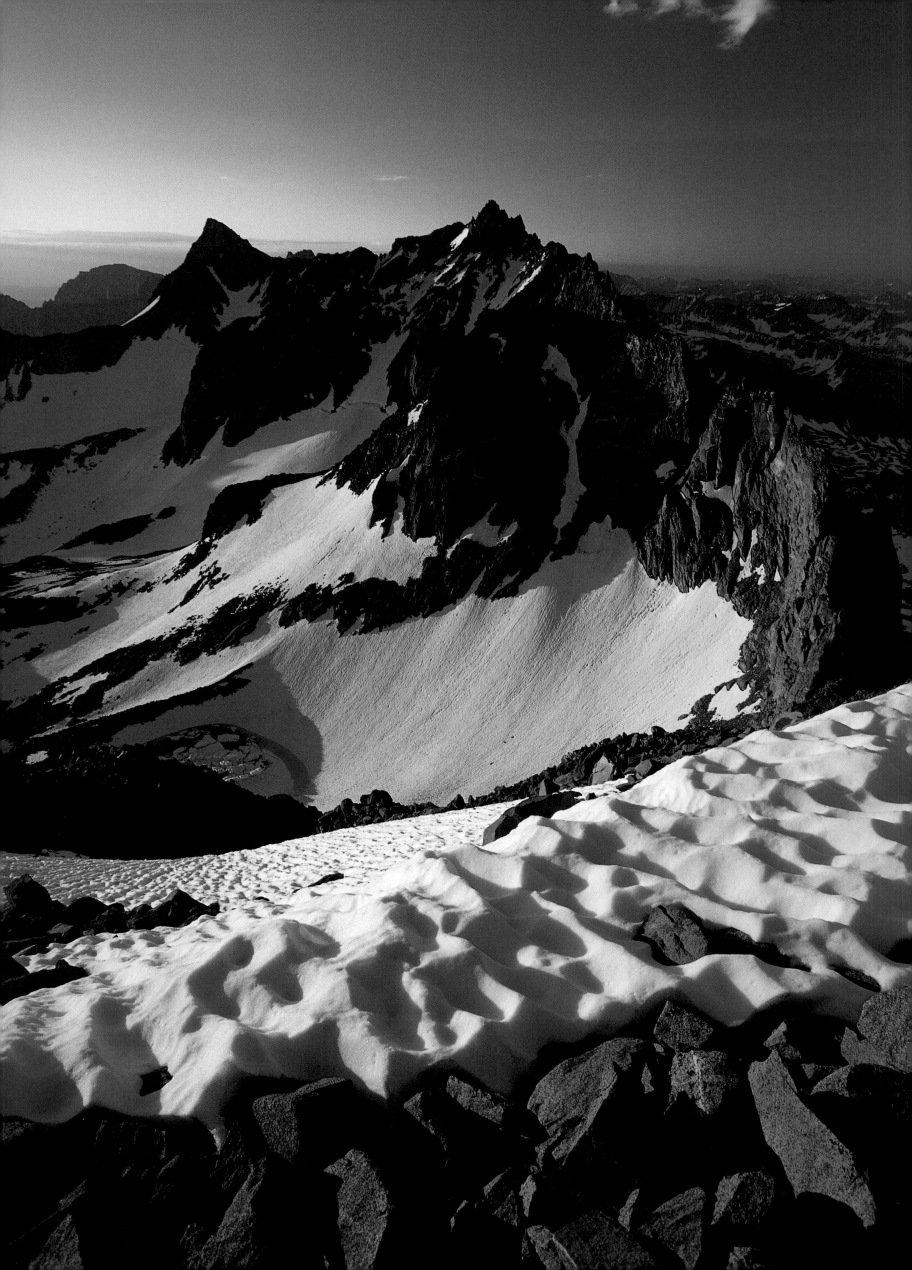

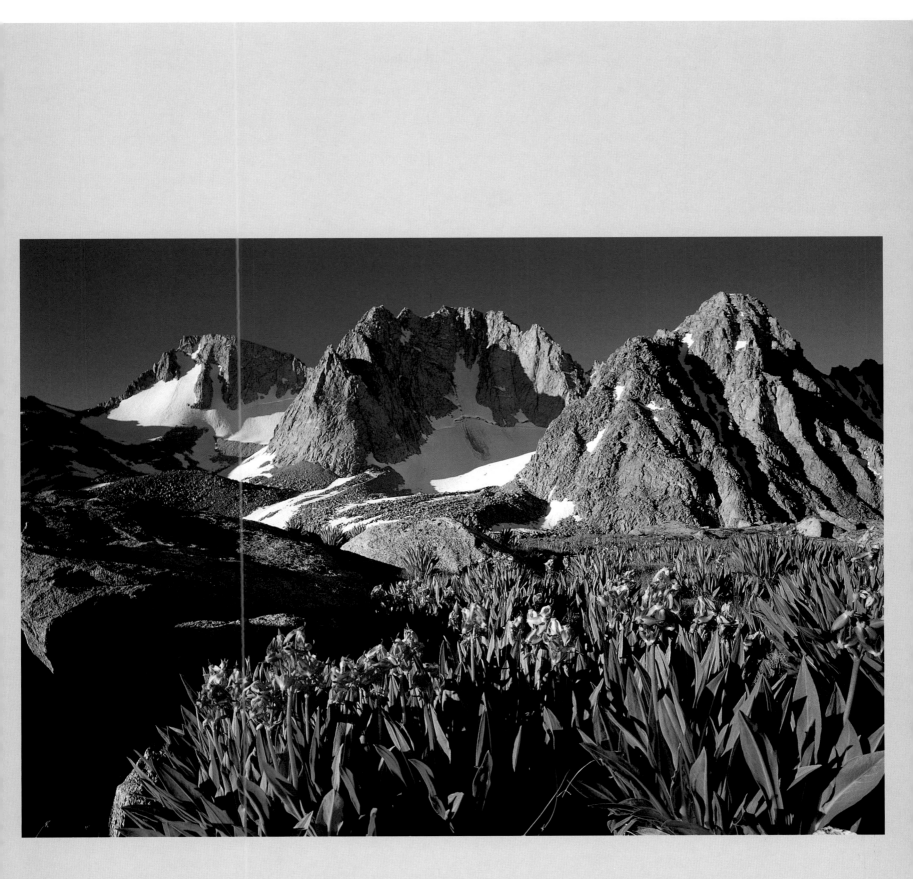

◄ MOUNT SILL (14,153 FEET) AND NORTH PALISADE (14,242 FEET) DOMINATE THIS AUGUST
MORNING VISTA OF THE PALISADE GLACIER, AS SEEN FROM THE TOP OF MOUNT AGGASIZ (13,883 FEET).
▲ ALPINE SHOOTING STARS (DODECATHEON ALPINUM) ADD GRACE TO THE IMPOSING MIGHT OF
MOUNTS DARWIN (13,381 FEET) AND MENDEL (13,170 FEET), IN KINGS CANYON NATIONAL PARK.

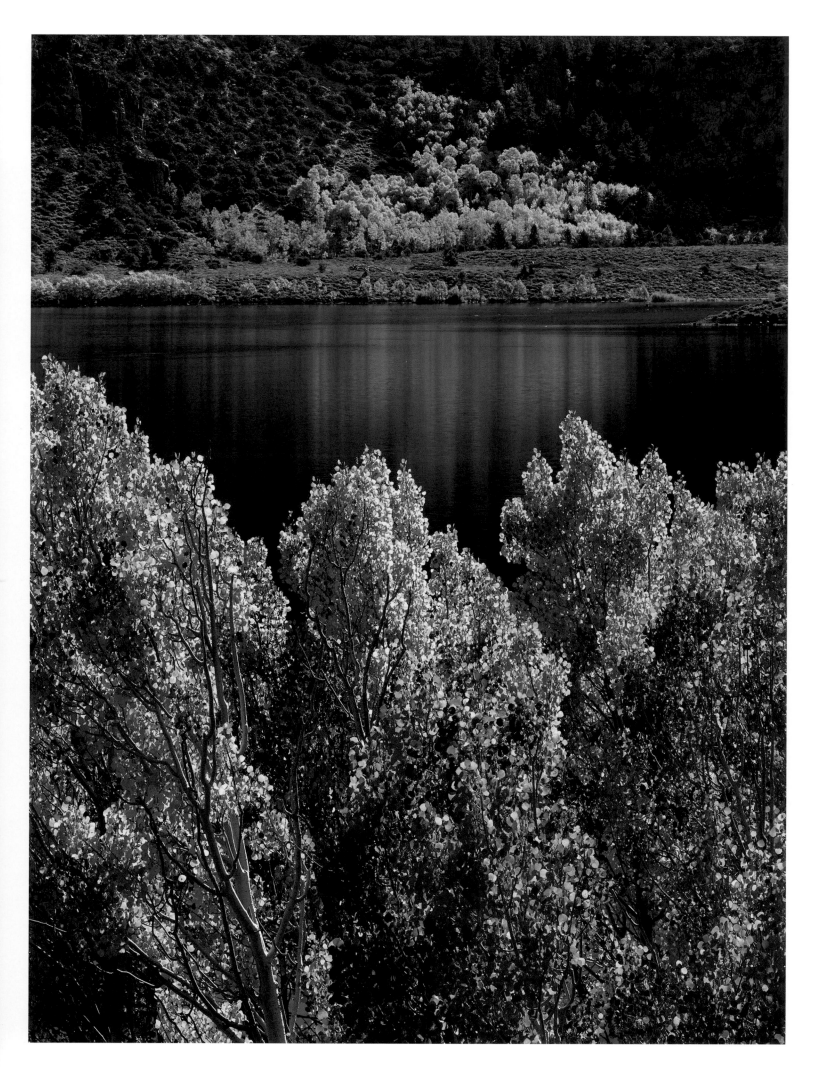

Pastoral autumn colors glow against the cool palette of Grant Lake along the
June Lake Scenic Loop, south of Tioga Pass in the Eastern Sierra.

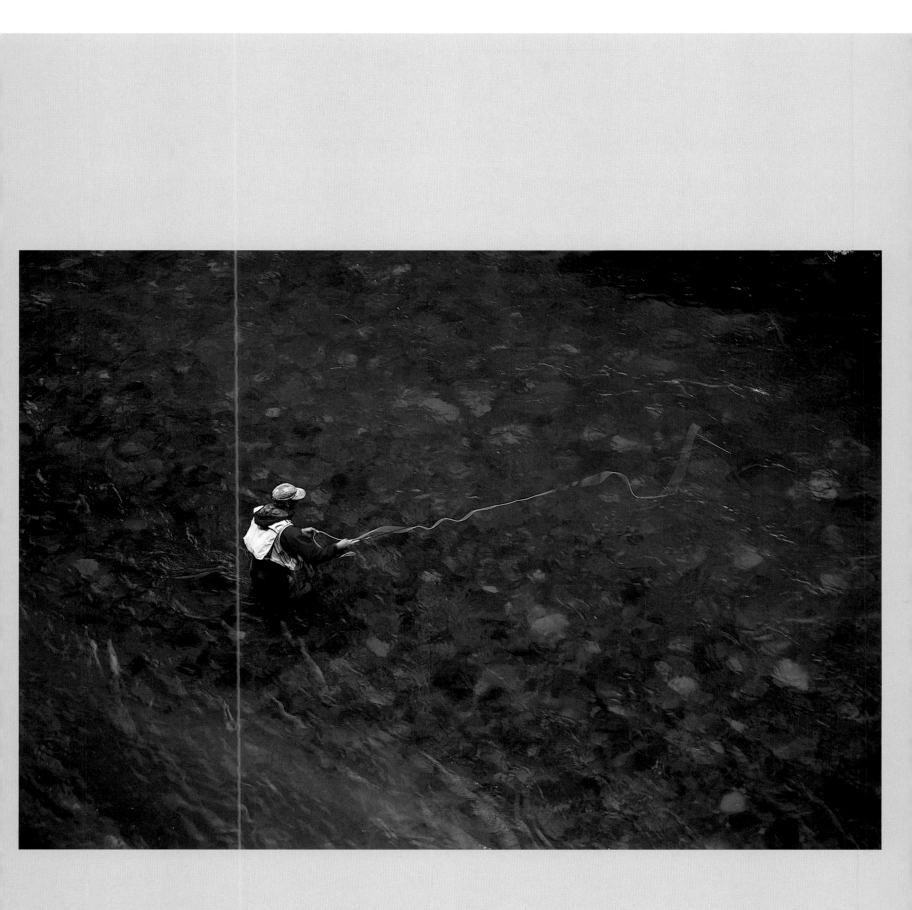

THE LIFE-GIVING WATERS OF THE UPPER SACRAMENTO RIVER PROVIDE AMPLE

OPPORTUNITIES FOR BROWN TROUT FLY FISHING.

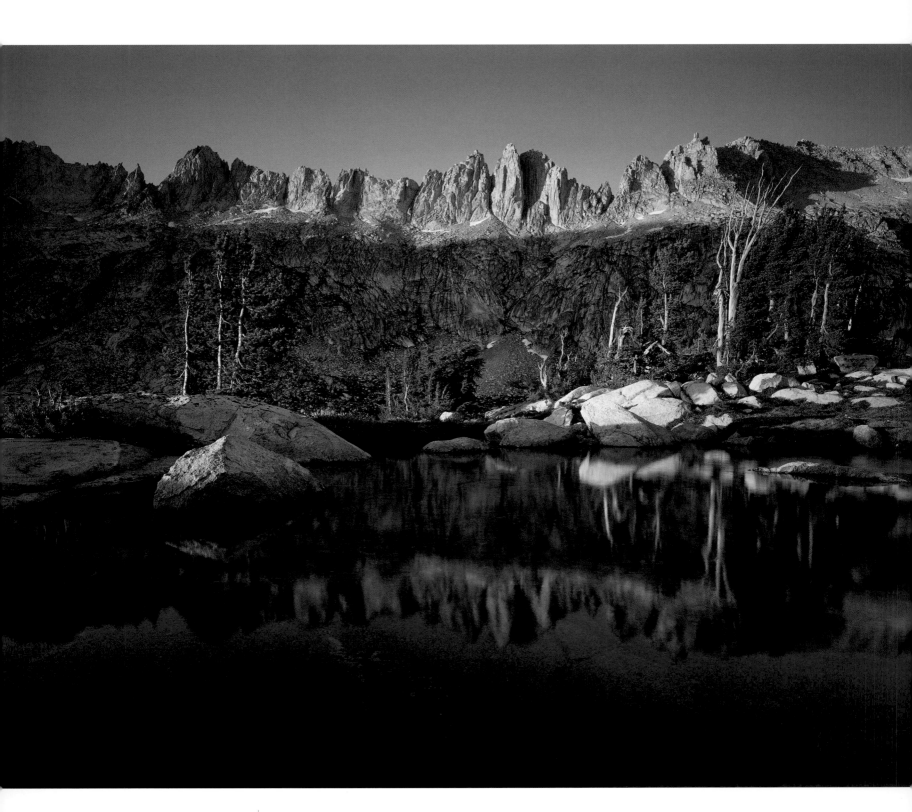

The aptly named Sawtooth Ridge echoes a stand of whitebark pine *(Pinus albicaulis)* at timberline along the head of Piute Creek, Yosemite National Park.

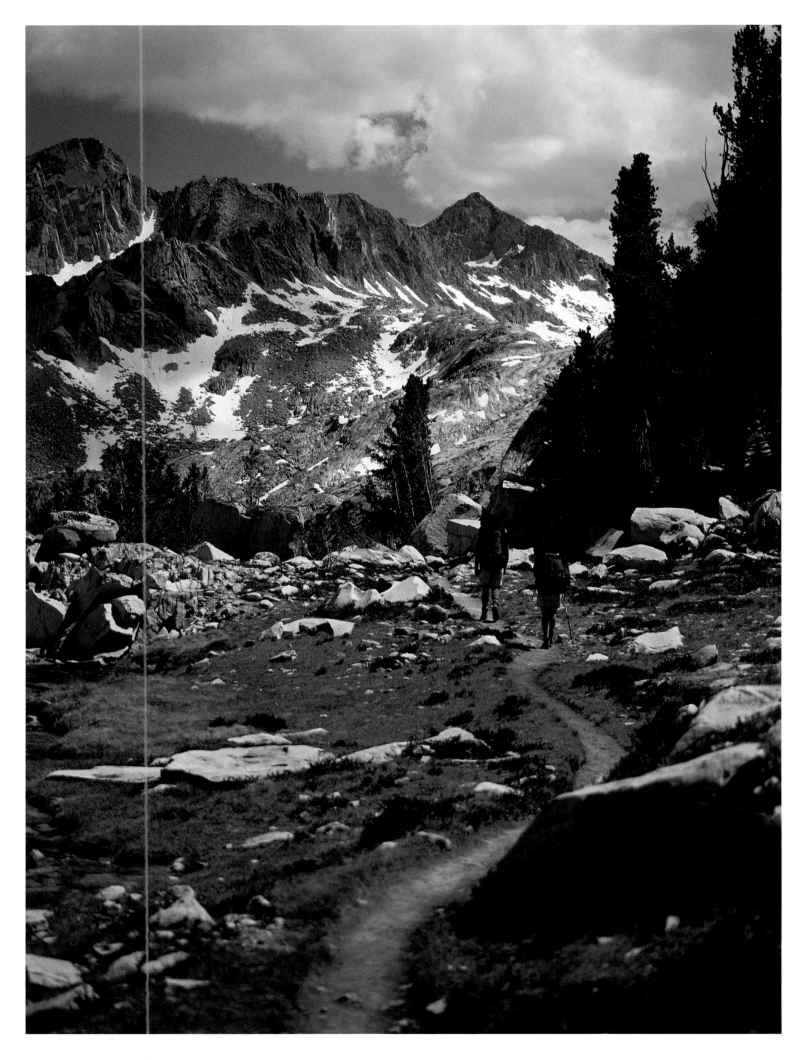

THE CONSERVATIONIST LEGACY OF JOHN MUIR LIVES ON ALONG THE TRAIL NAMED AFTER HIM.
HIKERS WEND THEIR WAY ABOVE LE CONTE CANYON EN ROUTE TO MUIR PASS,
HALFWAY BETWEEN MOUNT WHITNEY AND YOSEMITE VALLEY.

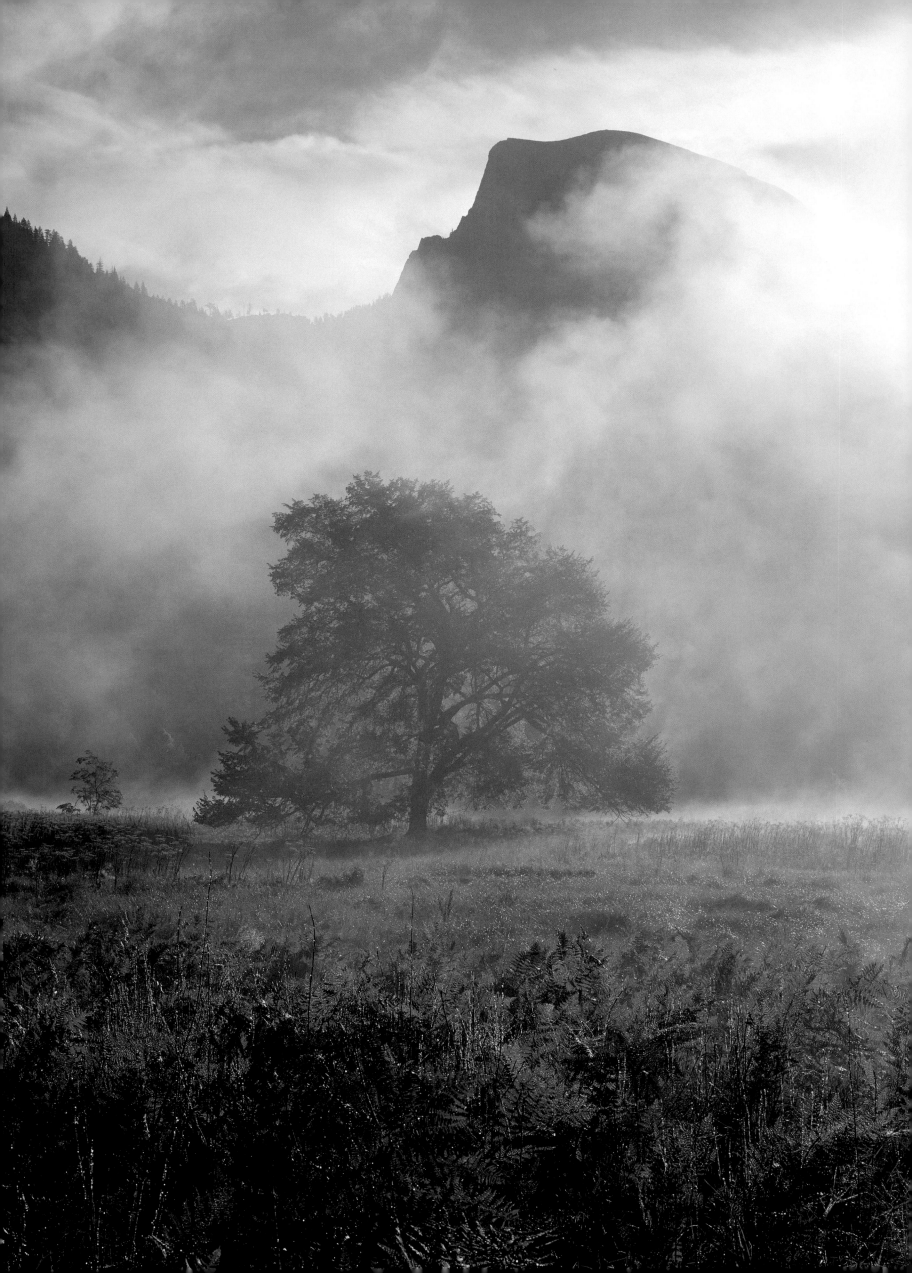

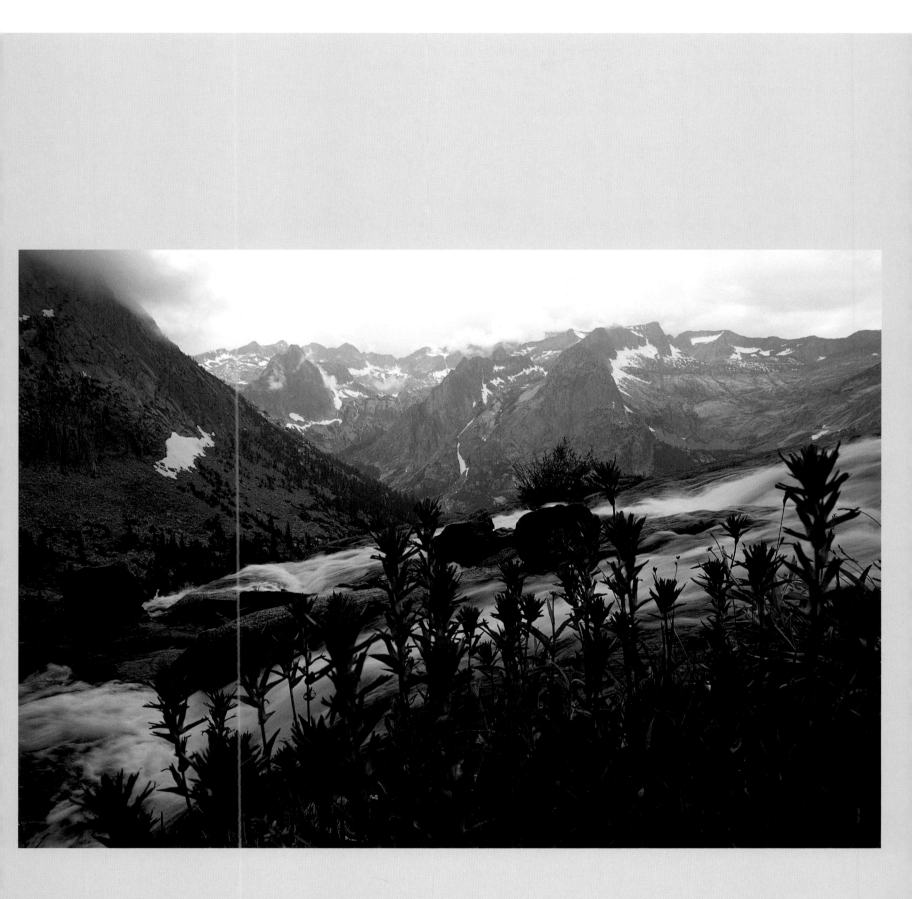

◄ A SLEEPY BLACK COTTONWOOD *(POPULUS BALSAMIFERA)* PULLS ASIDE THE MORNING VEIL
FROM HALF DOME'S MONOLITHIC NORTH GRANITE WALL IN YOSEMITE VALLEY.
▲ AS SIERRA STORMS QUICKLY COME AND GO, BLOOMS OF PAINTBRUSH *(CASTILLEJA INDIVISA)*
STAND ALONG THE DUSY BASIN, MIDDLE FORK OF THE KINGS RIVER.

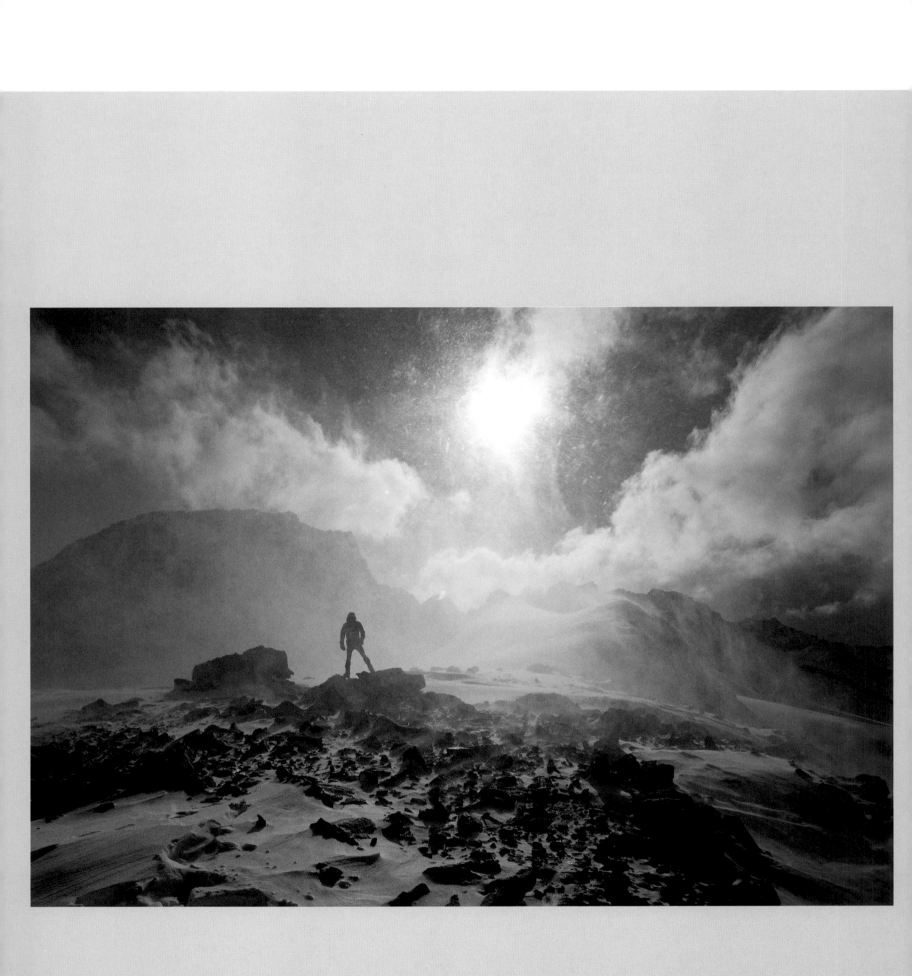

▲ A backcountry skier rests at Junction Pass (13,000 feet) in the
High Sierra of Kings Canyon National Park.

► Fiery sunset colors silhouette hardy, ancient foxtail pines clinging to life on
Alta Peak's windy granite slopes in Sequoia National Park.

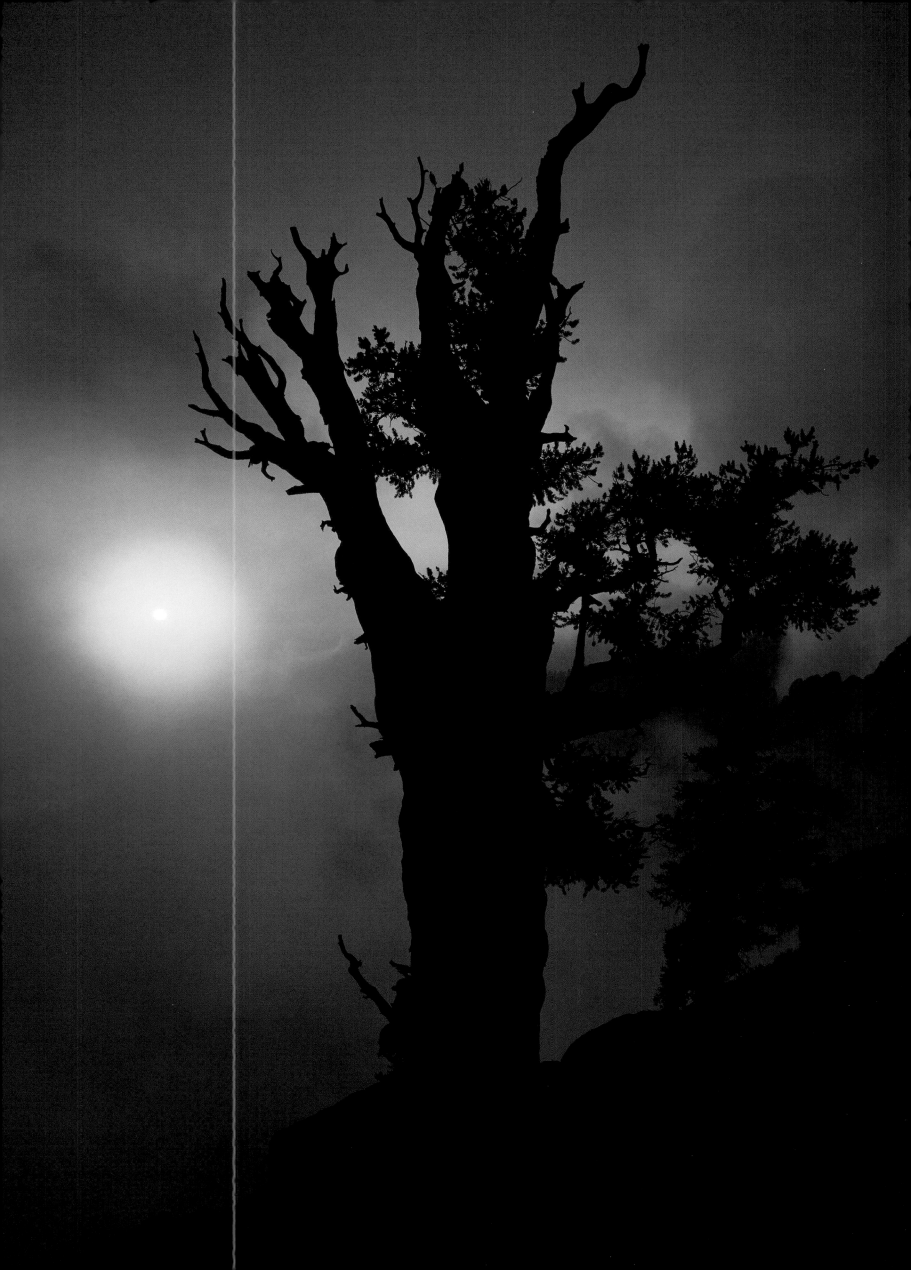

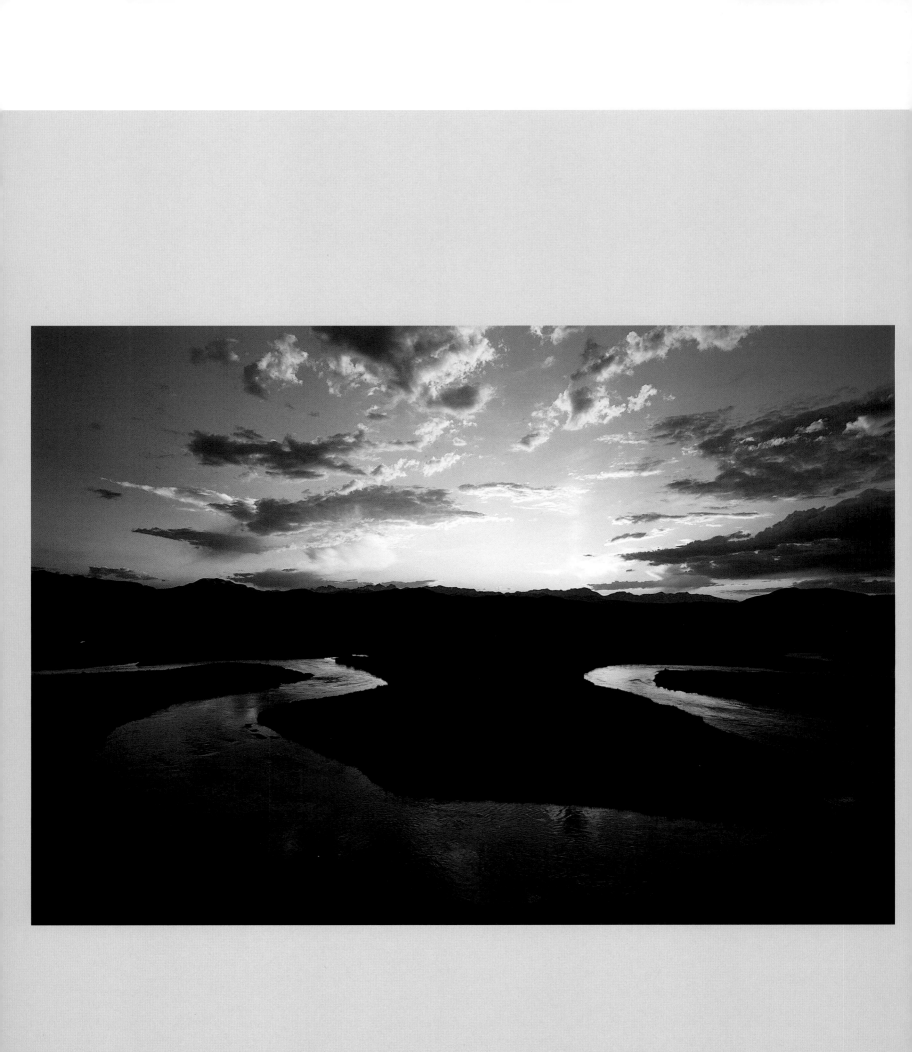

Evening splendor lights up the meandering Owens River to reveal a boy fishing for trout.
Mammoth Mountain, the Minarets, and Mounts Ritter and Banner line the horizon.

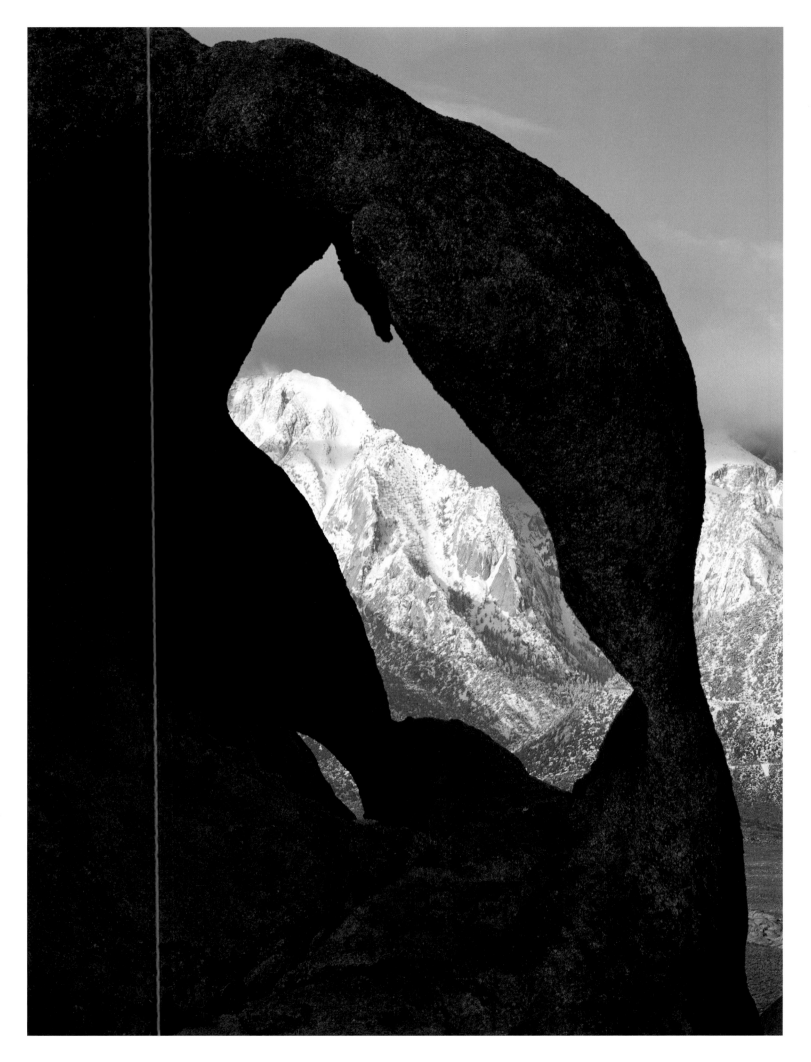

DOUBLE OPENINGS MADE BY GRANITE ARCHES IN THE ALABAMA HILLS FRAME PEAKS
ALONG THE EASTERN SLOPE OF THE SIERRA NEVADA IN WINTER.

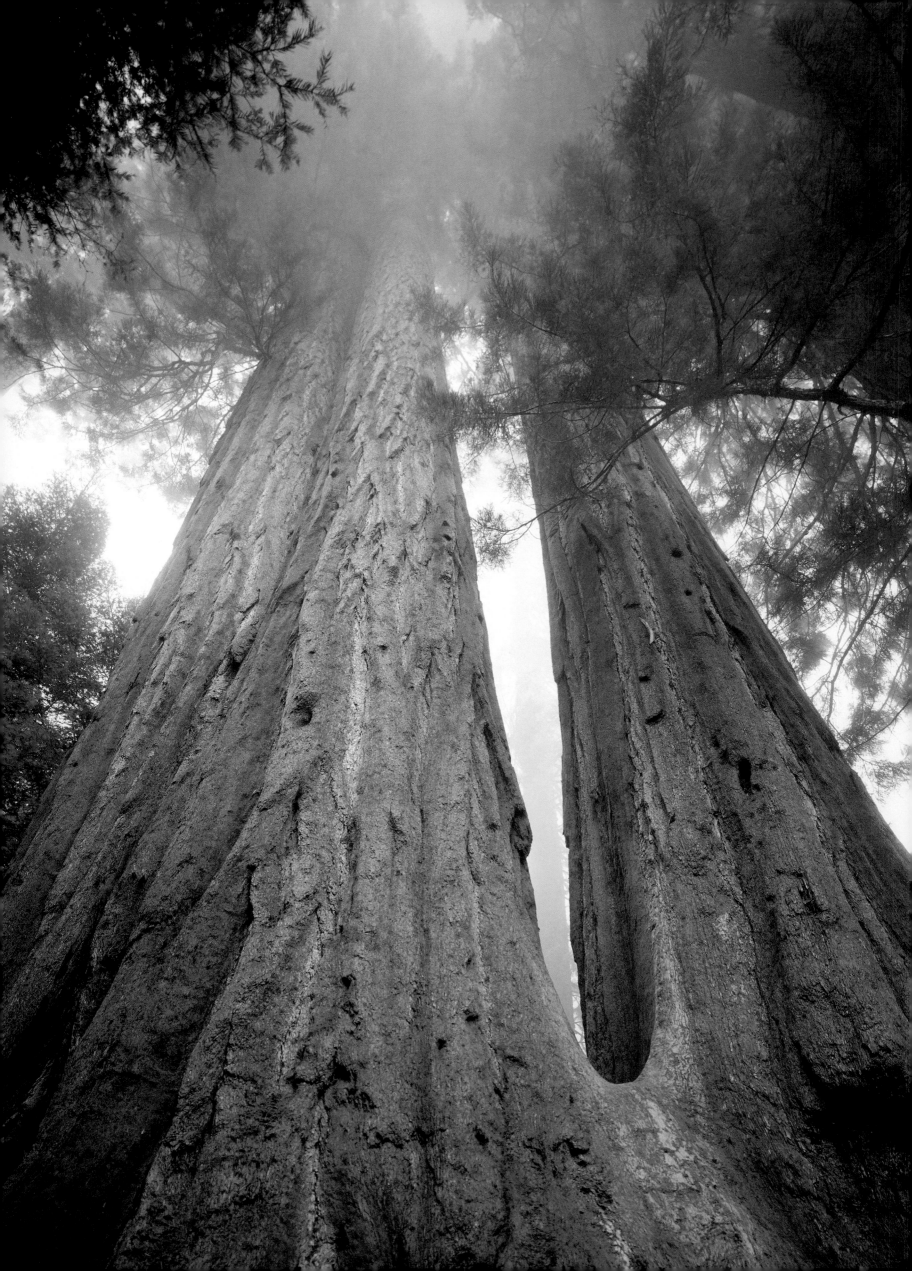

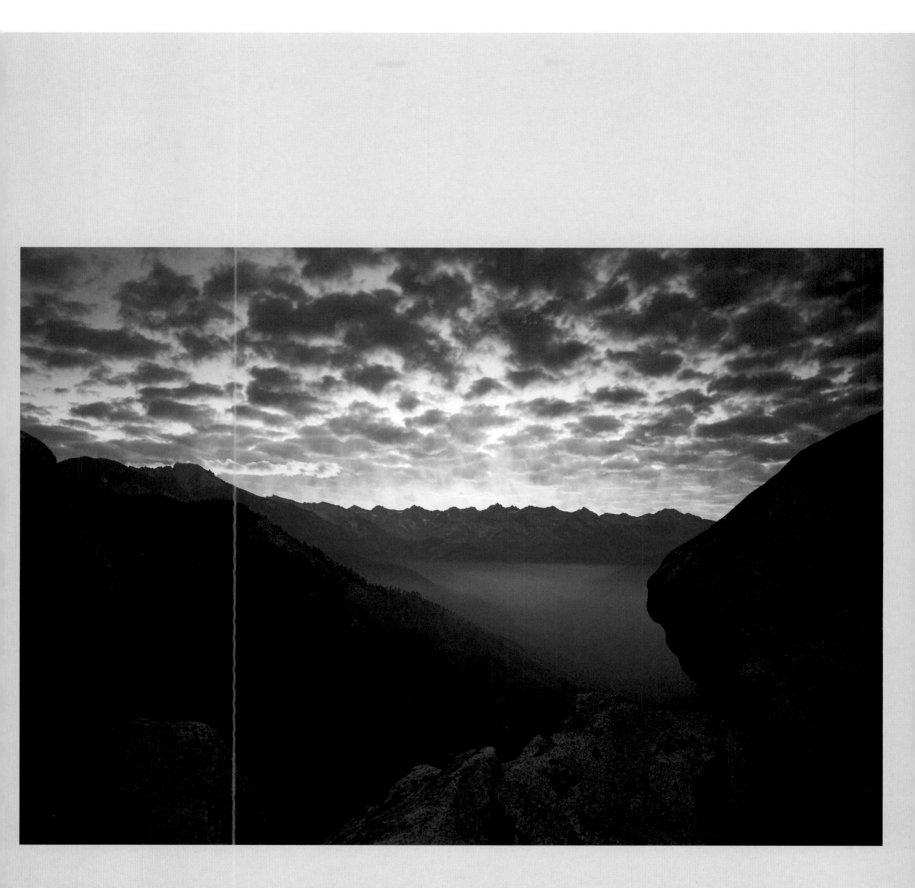

◄ IN THE GIANT FOREST SECTION OF SEQUOIA NATIONAL PARK, THE MASSIVE TRUNKS OF
SEQUOIAS REACH MAJESTICALLY INTO THE MISTS.
▲ DAWN LIGHT EXPLODES ABOVE THE GREAT WESTERN DIVIDE ALONG THE FOG LINE FROM
MORO ROCK IN SEQUOIA NATIONAL PARK.

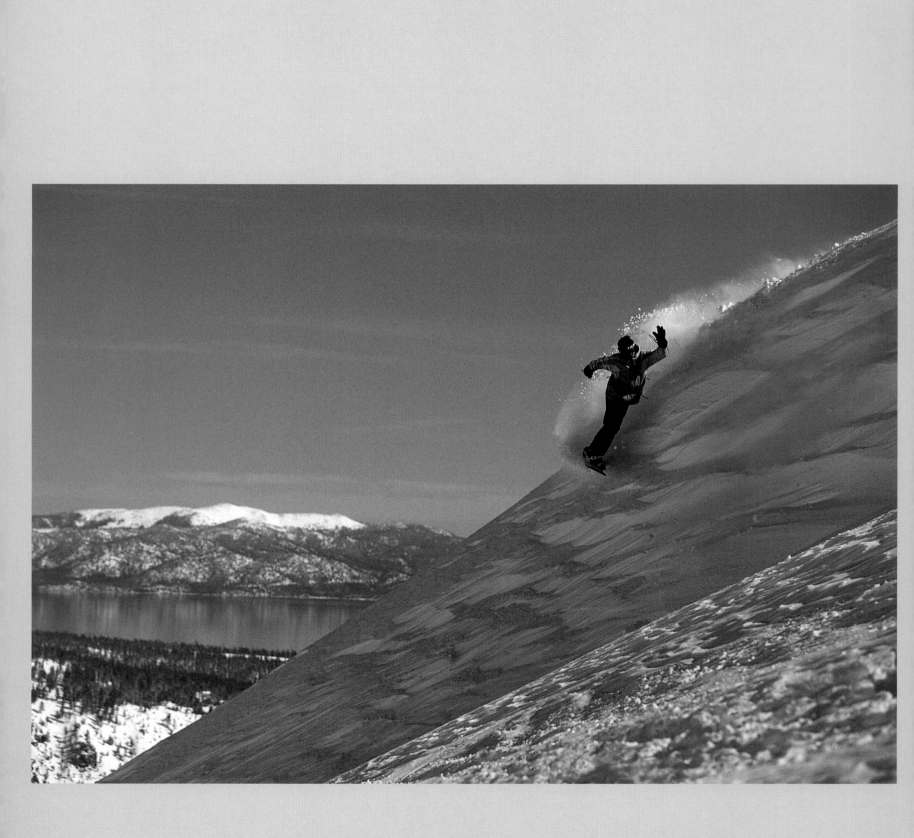

A SNOWBOARDER CARVES UP A WAVE OF WINDBLOWN SNOW

AT SQUAW VALLEY SKI RESORT. MOUNT ROSE, JUST ACROSS THE BORDER IN NEVADA,

ANCHORS THE HORIZON BEYOND LAKE TAHOE.

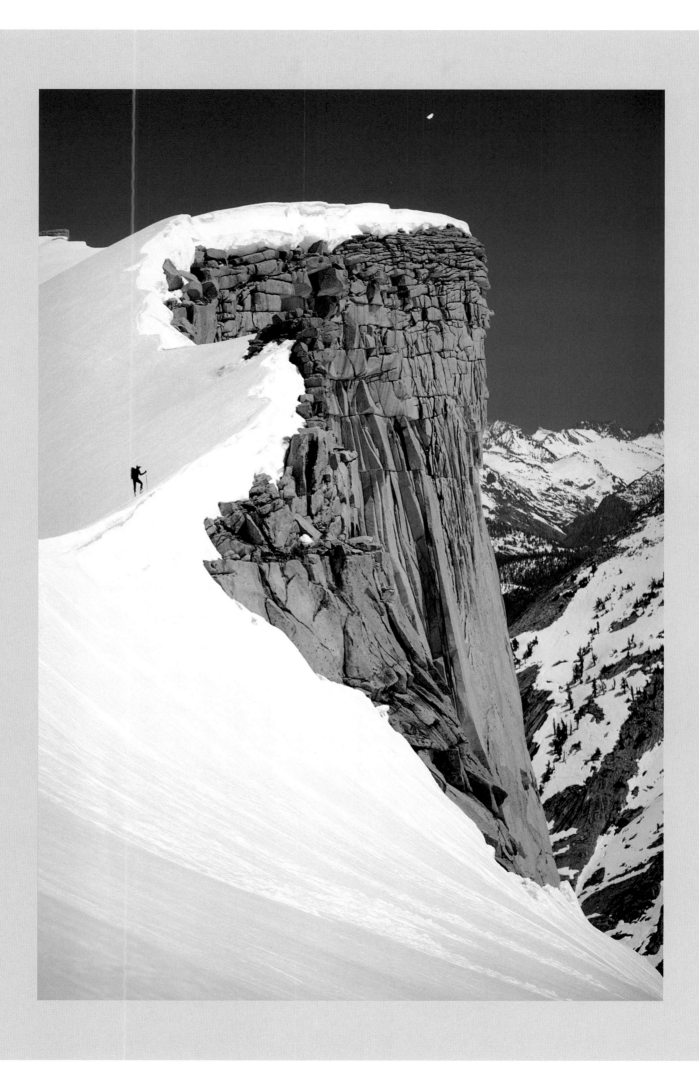

WINTER SNOW MELTS AWAY FROM THE FRACTURED, PRIMORDIAL ROCK FACE OF A CLIFF

ABOVE DEADMAN CANYON, AS SEEN FROM THE KINGS–KAWEAH DIVIDE

IN SEQUOIA AND KINGS CANYON NATIONAL PARKS.

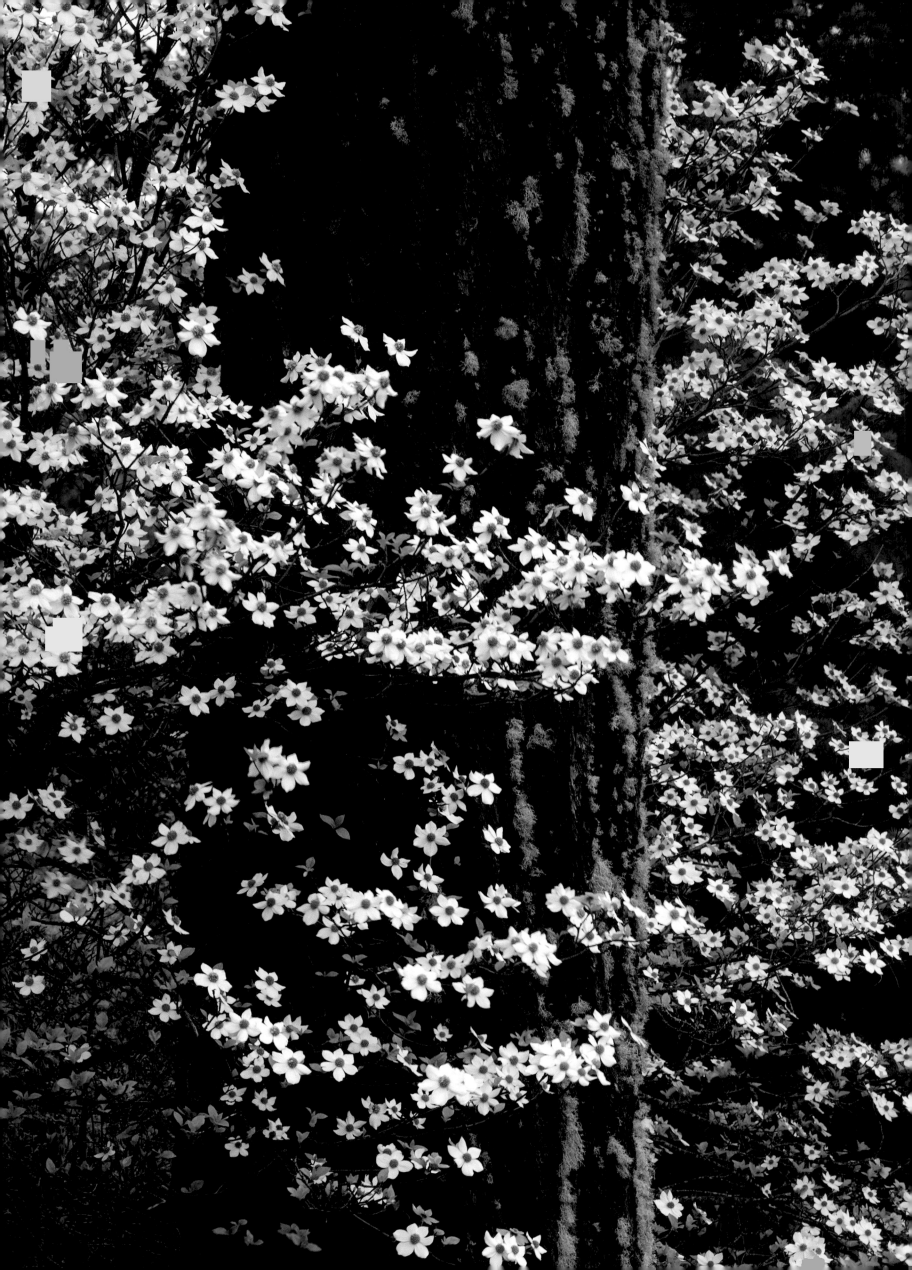

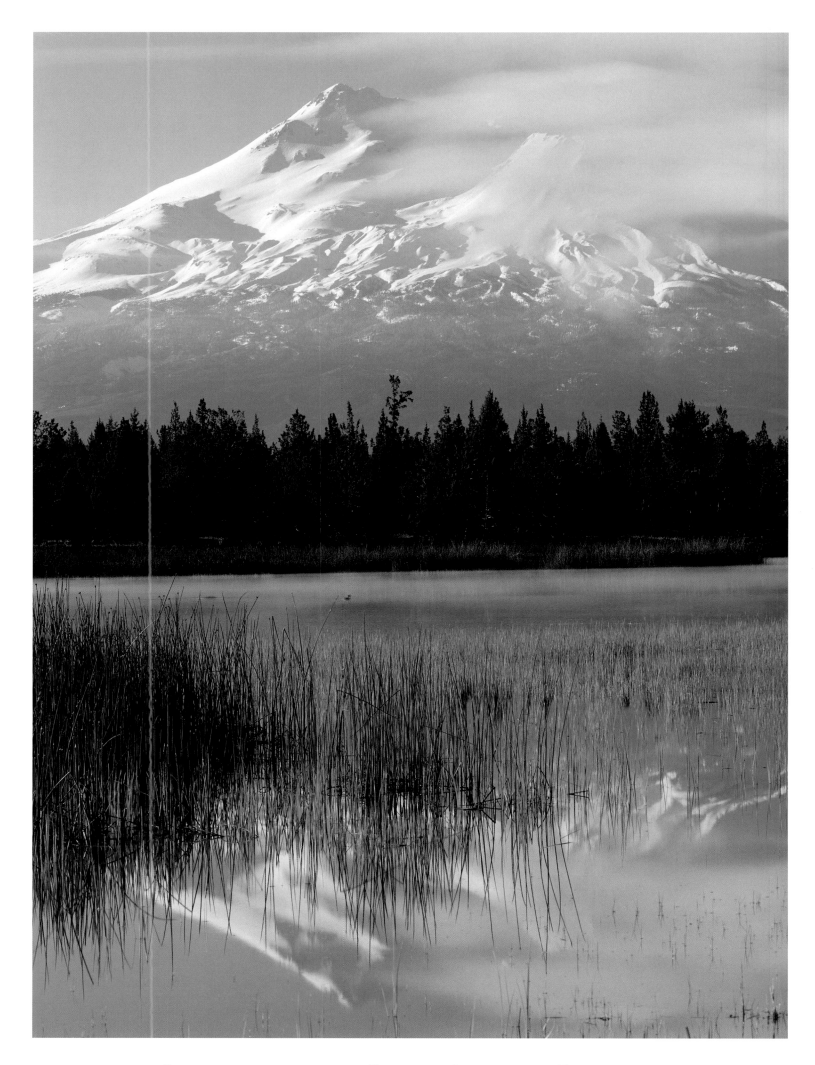

◄ Blossoms of the flowering dogwood (*Cornus nuttalii*) weave a galaxy of May
splendor around a Douglas fir (*Pseudotsuga menziesii*).
▲ The gossamer enigma of Mount Shasta (14,162 feet) and Shastina (12,330 feet) adds
mystery to the skies and pond waters along the Little Shasta River.

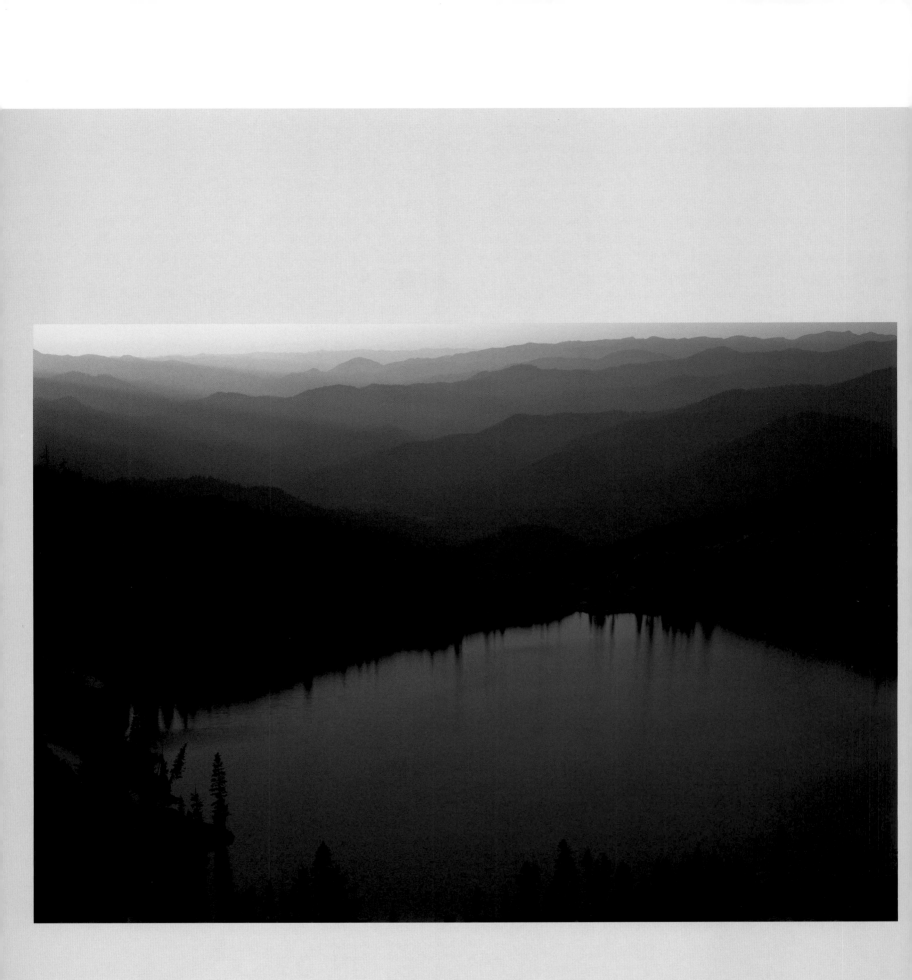

REFLECTED IN LOWER CARIBOU LAKE, SOOTHING ALPINE HUES SOFTEN THE GLACIAL LANDSCAPE OF THE
TRINITY ALPS WILDERNESS, AT THE HEADWATERS OF THE SOUTH FORK OF THE SALMON RIVER.

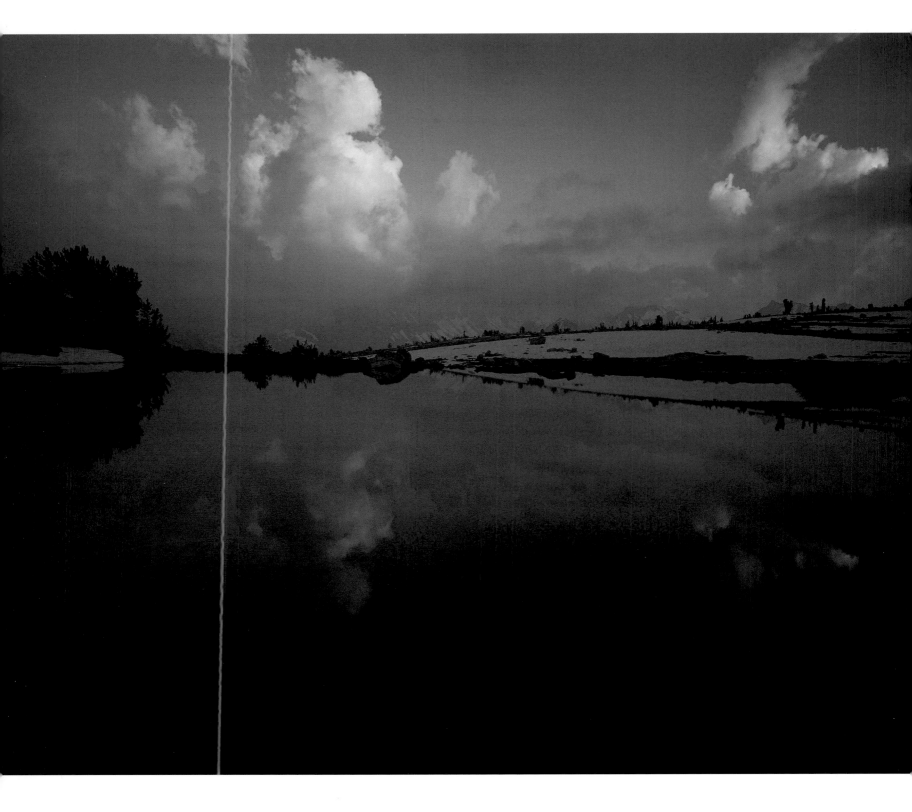

MIRRORED BY AN ALPINE POND IN PIONEER BASIN, JOHN MUIR WILDERNESS, TOWERING EVENING
CUMULUS CLOUDS SHROUD THE SNOWPACKED PEAKS OF THE SIERRA. WITH 581,000 ACRES,
THE JOHN MUIR IS THE LARGEST WILDERNESS IN CALIFORNIA.

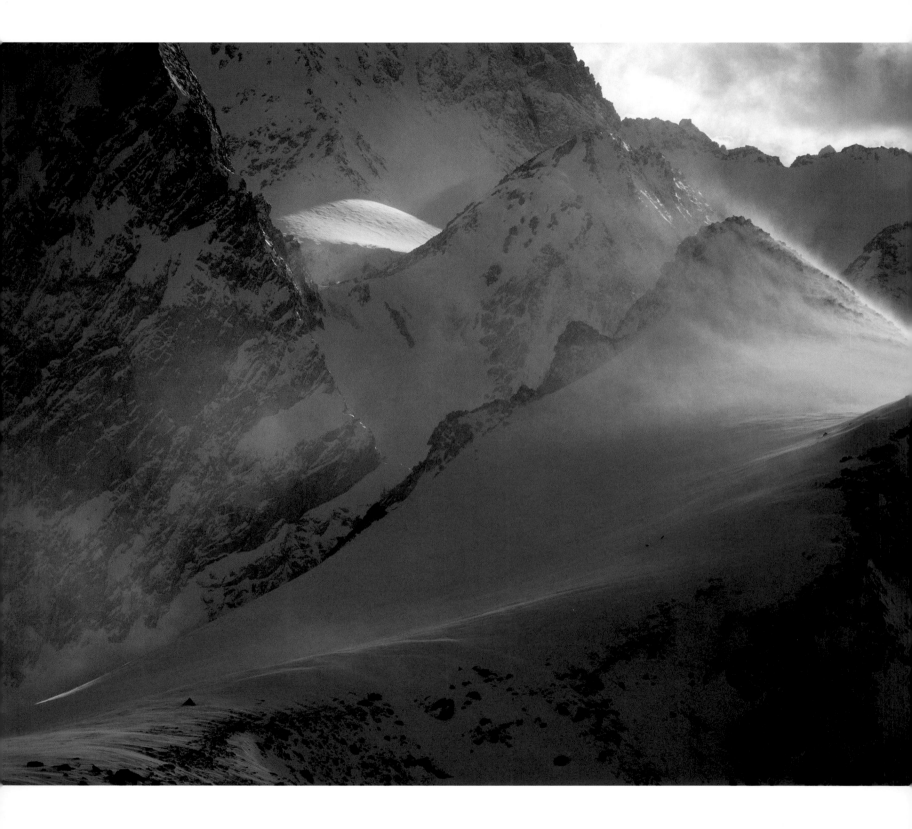

HIGH WINDS BLAST A SOLITARY TENT PERCHED ON JUNCTION PASS, ABOVE KINGS CANYON.
WITH JUST ONE ROAD LEADING INTO KINGS CANYON NATIONAL PARK, MOST OF ITS
722 SQUARE MILES IS WILDERNESS, ACCESSIBLE ONLY BY TRAIL.

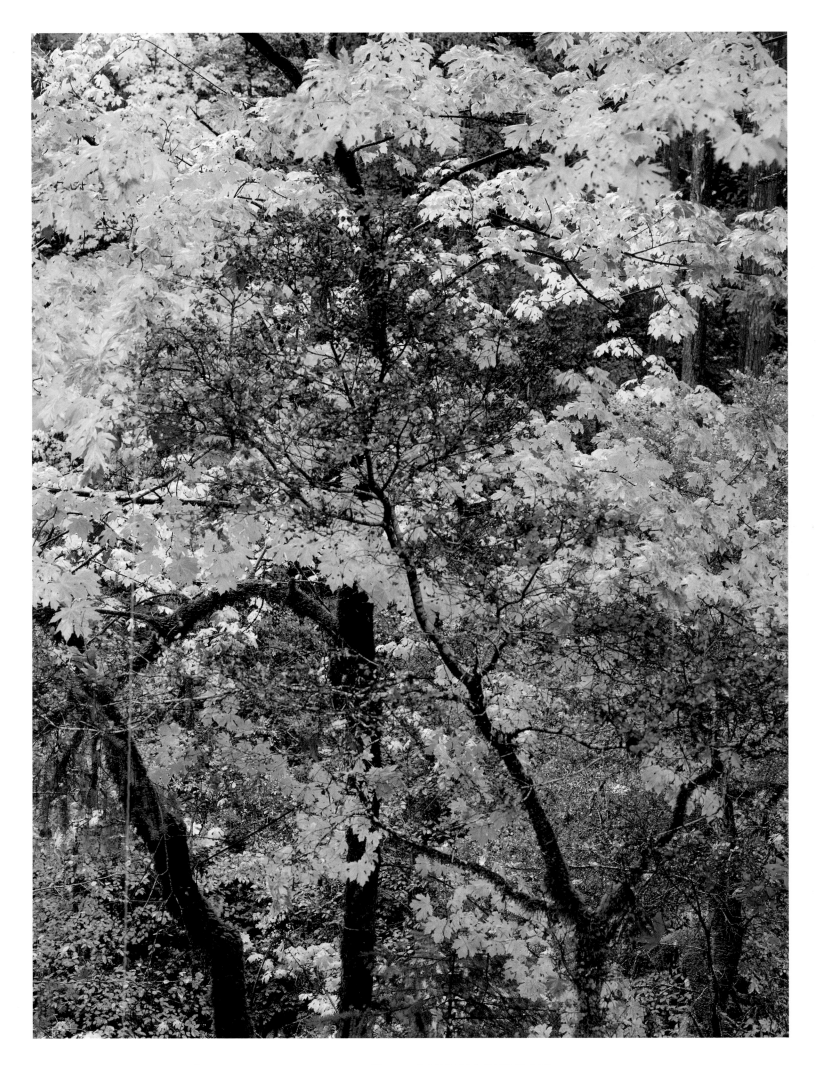

AN AUTUMN BLAZE OF BIGLEAF MAPLE (*ACER MACROPHYLLUM*) IS MUTED INTO
FLOWING WARMTH BY RAIN- AND CLOUD-DIFFUSED LIGHT ALONG THE MIDDLE FORK OF THE
SMITH RIVER, SMITH RIVER NATIONAL SCENIC AREA.

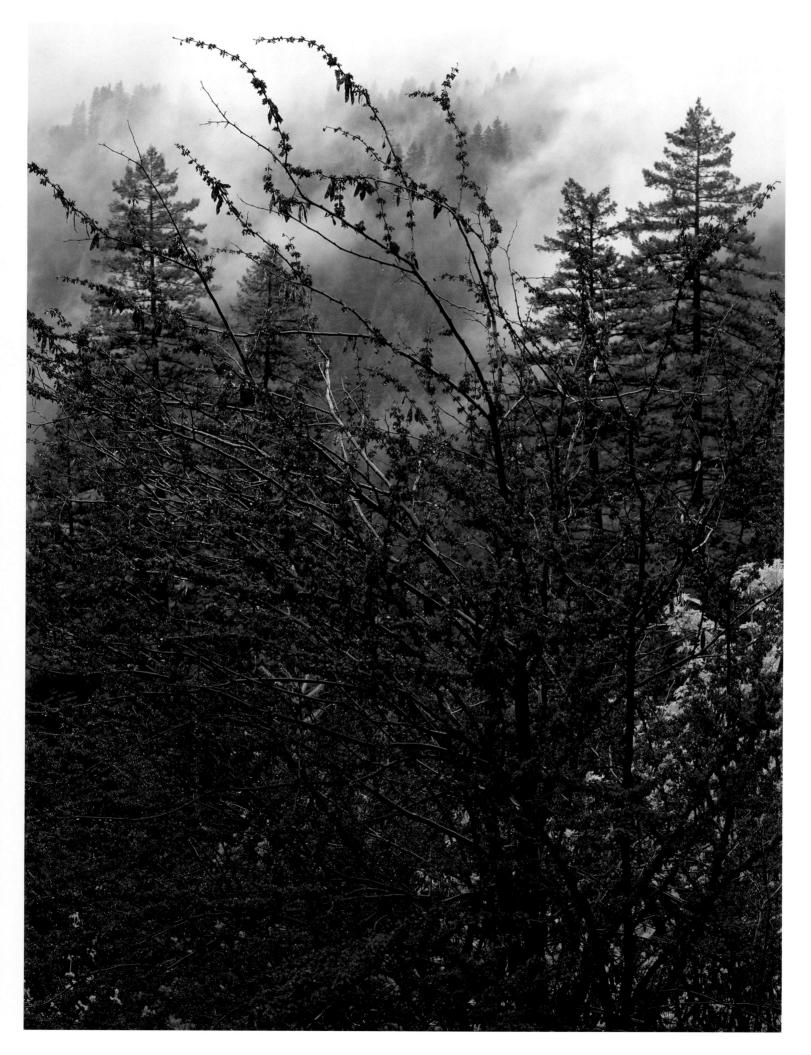

WITH ITS EXUBERANT BLOOMS, CALIFORNIA REDBUD (*CERCIS OCCIDENTALIS*)
ADDS RADIANCE TO A QUIET FOREST DAY HIGH IN THE MCCLOUD RIVER CANYON.

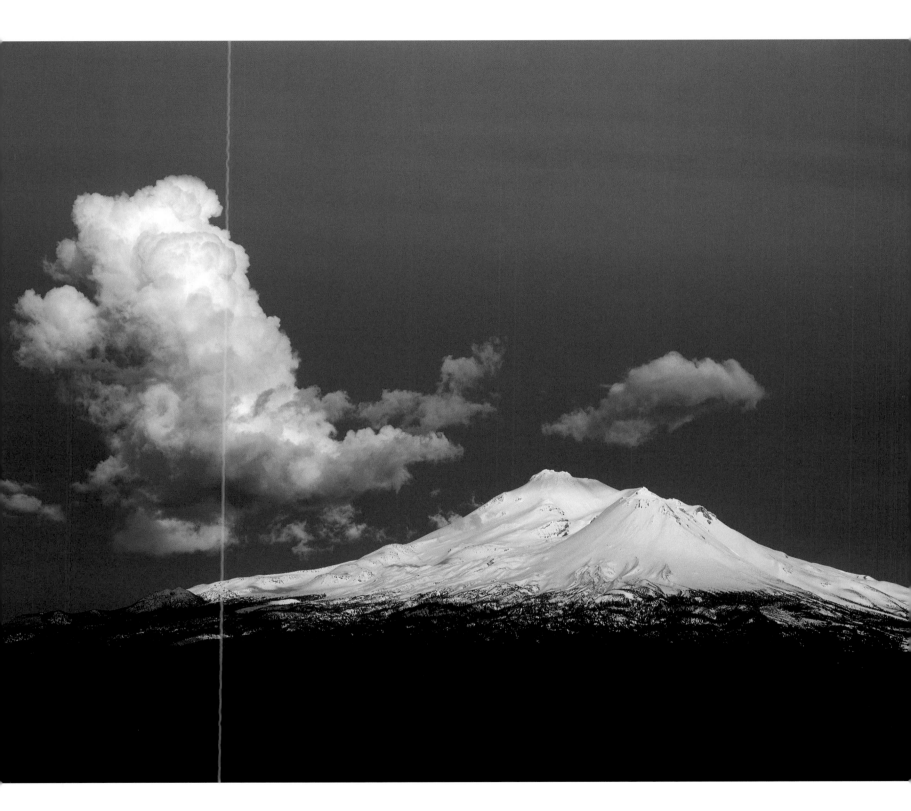

BOTH CLOUD AND MOUNTAIN SEEM TO FLOAT ABOVE THE GROUND IN THIS VIEW OF
MOUNT SHASTA, NORTHERN CALIFORNIA'S GIANT IN THE CASCADE RANGE.

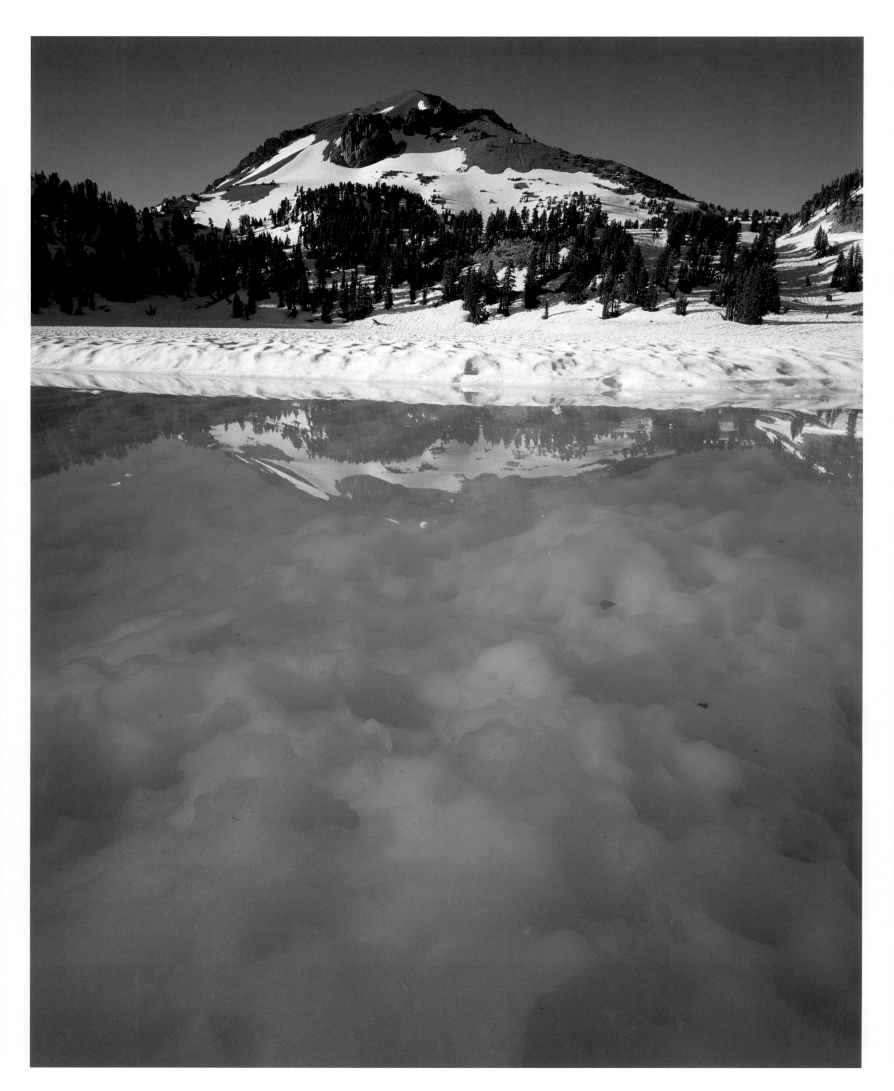

Freezing snowmelt beneath the surface of placid Lake Helen, in Lassen Volcanic
National Park, evokes the Ice Age. Nearby Lassen Peak, southernmost
volcano in the Cascade Range, last blew its stack in 1915.

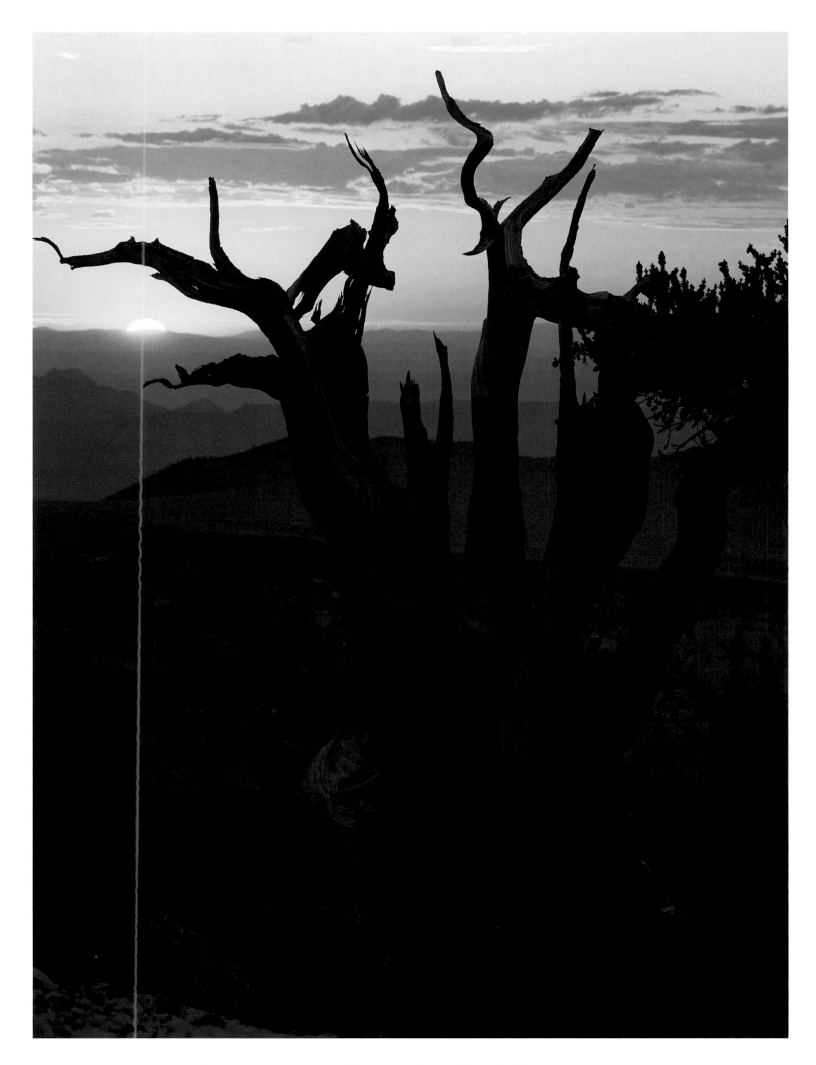

AN ANCIENT BRISTLECONE PINE *(PINUS ARISTATA)* OF THE PATRIARCH GROVE
GREETS A WHITE MOUNTAIN SUNRISE, AS MANY HAVE DONE FOR FOUR THOUSAND YEARS.
BRISTLECONES ARE THE EARTH'S OLDEST LIVING TREES.

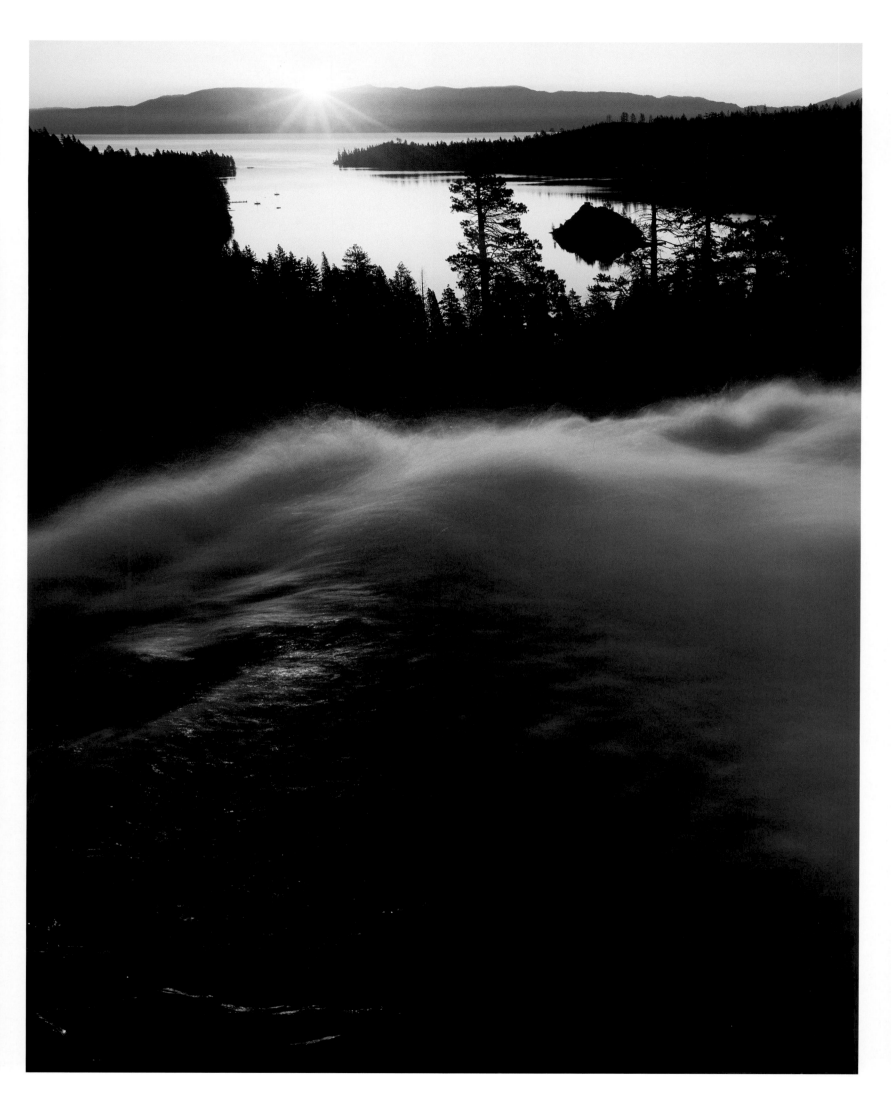

Spring snowmelt from Desolation Wilderness runs over granite cliffs on its
way into Emerald Bay on the south shore of Lake Tahoe.

IN MOUNTAIN GOLD

Climb the mountains and get their good tidings. Nature's peace will flow into you as sunshine flows into trees. The winds will blow their freshness into you, the storms their energy, while cares will drop off like the autumn leaves.
— John Muir, My First Summer in the Sierra (1911)

You are never out of sight of a mountain in California. The state is predominately mountainous, countering the cliché of sun-baked beaches, sprawling cities, and palm trees, palm trees everywhere. In fact, only Alaska has more mountains. Many California ranges are so imposing that they divert winds and squeeze moisture from Pacific cloud masses, conferring life on upwind regions and desert aridity on downwind expanses.

California's most imposing, famous, and oft-visited high-country region is the mighty Sierra Nevada, a 430-mile-long, 80-mile-wide range of lofty rock peaks that forms the north-south spine of the state. The Sierra slopes gently to the west but drops off to the east in a sheer and dazzling escarpment and is so imposing that it dramatically dictates weather patterns on both sides. Again second only to Alaska, the Sierra has the largest roadless area—2.8 million acres—in the nation.

The mass of vaulting peaks and valleys, emerald lakes, rivers and streams, alpine meadows, and evergreen forests are also an aesthetic powerhouse. John Muir, the great California environmentalist, called the Sierra the "Range of Light" for its spectacular nuances of sky color and haunting luminance throughout its many climatic zones.

If you listen, your soul will tell you when it's home.

The feeling hits me as a rush of mind music coursing up my spine like sparks from a bonfire: "Appalachian Spring," Aaron Copland's haunting symphonic riff on the old Shaker hymn "Simple Gifts." The melody lends heart-swelling counterpoint to my anxiety: in five minutes I'll run a few quick yards across this rough molar of weathered granite cliff top they call Glacier Point, to sail into thirty-two hundred vertical feet of pristine Yosemite Valley air.

Even looking over the edge of this cliff gives me the willies. Yet, with years of successful hang-glider foot launches under my belt, leaping from the same precipice to glide the void seems as safe and natural as riding a bicycle. Not that my chest isn't thudding with anticipation. A less-than-perfect launch from this cliff means sudden death.

"Appalachian Spring" reminds me it is indeed a "gift to be simple, 'tis the gift to be free." Far from the cities, whether sailing the breathless stillness of Yosemite Valley sky or soaring above California's vast deserts, grassy valleys, or coastal lands, we gain a deeper sense of who and what we are, and of what is so sacred about life itself, written in the primal scriptures of sun, sea, sky, sand, wind, and stars.

My best buddy, Marty Alameda, kneels at the head of the line, waiting for the takeoff go-ahead from the Park Service ranger. Someone from his home town of Salinas dubbed Marty the "Flying Flea" for his diminutive size: five-foot-six and 130 pounds, dripping wet.

The Flea's friendly, boyish face and gentle ways belie his background: he was once a champion bull rider and commercial pilot. Now a hard-driving hang-glider manufacturer, his uncommon flying grace and skill are anything but rodeo macho.

In California, Marty and I find flightscapes to match our wildest "skysurfer" fantasies. From our first flights together, our aerial adventures have seemed blessed with serendipity—something special always seems to happen. Call it a wink from the sky gods, but we usually get the best the day has to offer.

And being typical hang-glider pilots, ever questing for that memorable flight, we've come to the Holy Grail of "sled runs": the long, peaceful, truly spiritual glides through Yosemite Valley.

Imagine you can magically hover high above California on wings of cloth. The cool wind stings and refreshes your face as you wheel and turn high in the sunlit Sierra blue. Everywhere you look, from the top to the bottom of the state, there is mountainous terrain, from gentle coastal ridges to glacier-supporting mountain chains that rival the Rocky Mountains in height, mass, and stark, awesome beauty.

Run your eye up the Sierra, past evergreen-cloaked Lake Tahoe slopes. Pull in the glider's control bar and speed north to the Cascade Range, which invades the northern fifth of California. To the east lie the arid, earth-tone Basin Ranges, part of the Great Basin of the American Southwest.

Swing your body left to bank into the west. Beyond the Cascades' craggy, volcanic immensity you glide across a hundred miles of steep, green Klamath Range mountains. Follow them all the way to the coast, bank south, and find yourself floating above lush, rain-drenched North Coast Range forests. Ride the King Range (California's "Lost Coast," a dense scramble of high, sparsely populated terrain) all the way to San Francisco.

Glide across glittering San Francisco Bay and swing on down above ten distinct mountain groups called the South Coast Ranges. Below Monterey, behold the green-and-gold Santa Lucias of the Big Sur Coast in their steep drop to the ocean.

Feel the air grow balmier and more buoyant as you flash down the Central Coast, passing San Luis Obispo and Pismo Beach, to run up against the Transverse Ranges, an atypically east-west–running group that truncates Southern California from the rest of the state.

Race the rest of the way to Mexico over California's coastal Peninsula Ranges, which fill half of the bottom part of the state. Deep greens and olive and amber hues have given way to chaparral-covered rocky plateaus and plains, occasional high, snowy peaks, and earth browns, chalks, and sandy ochres.

Bank left again, into the burnt-out earth-tone badlands of southeast California. Nearly sixty distinct ranges make up this southern section of the Basin Ranges. The air is bumpy now—caused by thermal air columns sent up by the superheated ground. Many of the peaks below have names evocative of the Gold Rush, such as the Skedaddle, Soda, Bullion, and Old Woman Mountains and the Last Chance and Panamint Ranges. Sun- and wind-blasted, they hold the high ground above hellish wastes such as Death Valley.

One last swing, north now, to overfly volcanic cinder cones and high desert basins. The air is cool and crisp as you drift across the

pale blue eye of Mono Lake, and then you're back above the Sierra, and Yosemite Valley, that sylvan, Thor's-hammer cleft in the earth's bedrock.

Out in front of our "launch pad," dawn-shadowed Half Dome wears a corona of godbeams. Marty has just made his customary run into oblivion with a beautifully smooth takeoff. I watch his sail drift down and away from us, a silver arrow in the morning sun pointing straight at the sleeping heart of Half Dome's silhouette.

My turn.

Dean Paschall, the Park Service hang-gliding ranger, signs me off. I look at the fifty yards of rounded crystalline rock slope that ends in sheer cliff. My heart thunders so hard that I feel the pulse in my palm-grip on the control bar.

One deep breath and . . . now! "Have a good one, everybody," I call out to the ten other pilots as I take a step, two, three, then lean forward to run run RUN! The sail fills with air and lifts off my shoulders, flying its own weight. Harder, drive, drive! The harness straps tug upward and I'm quickly tippy-toe with the reduced traction. I hear the growing hiss of wind as I push harder, faster against the aerodynamic drag of the glider. No turning back now. Build that airspeed because here comes the edge! I lean farther forward, my body almost horizontal. Without the support of the glider, I'd fall right over the cliff. Keep the wings level, drive, drive! And then I'm beyond the edge—I'm flying! A quick swoop into a shallow dive and I'm greeted by the sudden joy (safety, life!) of flying-speed wind whistling through my helmet—a perfect launch! A quick glance down to step into the foot stirrup gives me an upside-down view of the immense granite wall dropping giddily to the valley floor. Vertigo grabs my stomach, and I look quickly forward.

I let loose an exultant war whoop and then rotate forward into prone position, like Superman. Jugulars pounding in my throat, breath still fast and ragged, I inhale the miracle of beauty all around me.

Below is Marty's silver glider, looking about the size of my thumb, cavorting left and right in an unmistakable dance of joy.

We are eagles!

The Cascade and Klamath Ranges of Northern California are a rugged expanse of high plateaus, volcanic peaks, and bare, frozen roils of molten lava mixed in among densely wooded forests. Still volcanically alive, they contain some of the most spectacular forest and rockwork regions in the world. The frequently unnavigable terrain is sparsely populated: there are no towns with over four thousand inhabitants.

Northern California is a wildlife paradise. Dense forests of managed timber lands and the last remaining old-growth forests in the state include Douglas fir, ponderosa pine, incense cedar, and twenty other types of cone-bearing trees. Chinook salmon and steelhead trout, mule deer, black bears, waterfowl, and upland birds thrive here. Not to mention Bigfoot, or Sasquatch, the legendary gorilla-like beast long claimed to furtively roam the rugged wilderness.

The Klamath and Cascade Ranges are a rich resource for outdoor recreation, hunting, and fishing enthusiasts. The wild, snow-melt-driven Klamath, Salmon, and Scott Rivers draw seasonal whitewater kayakers, canoers, and rafters to their hundreds of miles of moderate to downright death-defying runs. Just north of the complex of rivers, ice caves at Lava Beds National Monument entice avid cavers from around the world.

At the southern end of the Cascade Range, 10,457-foot Lassen Peak anchors the volcanic playground of hot springs and gurgling mudholes known as Lassen Volcanic National Park. A 130-mile section of the 2,620-mile Pacific Crest Trail meanders through the park, with its abundant mountain lakes and heart-swelling craggy vistas. Three wilderness areas here are wonderlands of primitive America: Ishi, named for the last known primitive Indian; Caribou, with abundant high lakes—but no caribou; and Thousand Lakes, a photographer's paradise of cliffs and buttes and nowhere near a thousand lakes. Under the spell of nature's beauty, passion often wins out over accuracy.

Then there is the Kilimanjaro of California: Mount Shasta. Climbing out of the Central Valley on Interstate 5, you first see Shasta as an isolated, tiny white cone low on the northern horizon. As you roll ever higher into the spellbinding evergreen countryside, you begin to feel part of a primitive, enchanted domain ruled by Shasta, ever floating just out of reach beyond the next tree line.

Eventually you arrive to skirt the flanks of the snow-cloaked, 14,162-foot volcano, the most massive single mountain in America and second-highest peak in the entire Cascade Range. Shasta, four volcanoes combined into one still-active giant, is seventeen miles in diameter. Its ethereal symmetry of pyramidal rock and ice faces draws challenge from five thousand climbers every year. But it is the mythical echoes of Bigfoot and stories of lost civilizations that add a glimmer of magic to the Shasta region.

Over the centuries, many people claimed to have seen golden domes built inside the mountain, populated by supernatural beings from the lost continent of Lemuria, or Mu, said to have sunk into the Pacific twelve thousand years ago. Not to be outdone by fanciful Westerners, Modoc Indian tradition tells of the Chief of the Sky Spirits, who cut a hole in the sky and shoved all the snow and ice down through it, creating the great cone. The Chief, suddenly enchanted with his creation, moved his family inside the sacred mountain. The Modocs say their fires explain the volcanic activity of Shasta.

New Age writers, poets, and philosophers, and modern shamans and spiritual seekers are still drawn to Shasta's palpable aura of mystical beauty. Local inhabitants encourage vision quests and meditative walks along footpaths that meander across small creek bridges and through hedges of horsetail fern and fragrant willow.

Too soon, we have to land. Down through the dense, shivery air I sail, my glider deftly responding to the slightest command inputs: body left for a series of left turns to take in the eternity of autumn golds, evergreens, and granite grays, then body right to ease into a long, reverent final glide to the landing spot. Across the valley, Bridalveil Fall whispers of glacial melt. Three hundred feet below, Marty's sunlit sail eases across deep indigo shadows that cloak the riparian banks of the Merced River. Emerald meadows beckon our touchdown; El Capitan holds up the sky beyond.

I watch the Flea's approach to a field surrounded by 150-foot-tall pines—even the trees here seem larger than life! His long final glide ends with a fast run—his footsteps echo in the cadenced shudder of the sail—then an abrupt, somewhat violent, nose-down stop.

"You beaked it!" I laugh out loud. Then a sober thought: if Marty beaked, so could I. The air is thin even on the four-thousand-foot-elevation valley floor. Wings have to move faster in thin air to generate

lift. Sea-level ten-mile-per-hour touchdowns become fifteen and higher here—the upper limit of human running ability. Mountain landings, always risky.

A flash of purple light off Glacier Point's smooth wall, now looming high above me, reminds me of where I began my flight just minutes ago. How did this wonder of plunging stone come to be? The mere question humbles my existence.

Three to four million years ago, little more than half a tock of the geologic clock, the Sierra was a vast two-hundred-mile-long, eighty-mile-wide, six-mile-deep block of subterranean granitic balloons called plutons lying beneath the sea-level expanse of the Central Valley. Driven by tectonic plate forces scores of miles below the surface, the block's western edge remained at sea level, while the eastern side began to rise along a north-south fault through the Owens Valley, like an opening cellar door.

Today that sheer, sharp-toothed escarpment rises more than ten thousand feet above the Owens Valley floor—and it hasn't stopped moving upward yet. This largest single mass of stone in the world marks the high, proud heart of the Sierra Nevada.

Naturalist John Muir made a life and a legend for himself roaming the Sierra. Yet for millions of yearly visitors, as for Muir even at the end of his days, it is the magnificent Yosemite Valley that remains the Sierra's crown jewel.

Yosemite is a twelve-hundred-square-mile wonderland of deep glacier-carved canyons, lofty granite peaks, high gossamer waterfalls, and placid river valleys. Summers are hot and dry, and winters wet and cool, with snow in the higher elevations from November often into June.

Its plant communities include chaparral, giant sequoia, mixed conifer, lodgepole pine, and red fir among other tree species. The valley's quiet enchantment owes much to its old-growth forests having never been logged. More than two hundred species of birds—from red-tailed hawks, peregrine falcons, and golden eagles to swifts, woodpeckers, song sparrows, and western tanagers—make the valley their home. Among the eighty recorded mammalian species, visitors often see raccoon, mule deer, marmot, coyote, and the ever-present, picnic-tracking black bear. Less visible but present are mountain lions, bighorn sheep, short-eared pikas, and wolverines.

John Muir foresaw the continuing destruction of wild places in the Gold Rush rape of the Sierra Nevada's foothills and high country and in the denuding of mountain grasslands by domestic animal herds. The Sierra Club he founded remains a major conservationist force throughout the world, while his very name has become synonymous with environmental sensitivity and activism.

The Scottish immigrant also feared the Sierra might go the way of the European Alps, transected and choked by roads, resorts, and skytrams. By marshaling political and popular awareness against shortsighted, profit-driven plunder, he fostered a legacy of long-reach environmental vision wherein we can discover, embrace, and advocate for the rich experience that nature offers. Muir's tireless efforts to preserve a pristine Sierra led directly to the 1890 establishment of Yosemite as one of the first three National Parks in America.

Within the verdant foothill-to-battlement wilderness of the entire Sierra bioregion, you find sumptuous expression of California's natural diversity and fecundity: habitats range from grassland, sagebrush, chaparral, and blue oak savannah to red fir and Jeffrey and ponderosa pine; from lush, verdant, freshwater streams to angry red, black, and brown volcanoes. Wildlife ranges from brine shrimp to California golden trout, river otters to bears and mountain bighorn sheep, California quail to grebes, seagulls, and bald eagles.

Fourteen ecological zones, one thousand plant species, and four hundred vertebrate species—roughly two-thirds of the birds and mammals and half the reptiles and amphibians in all of California—live within the Sierra watershed in the Mono Lake Basin at the eastern foot of the Sierra.

My slow-motion dance down through Yosemite's sky realm ends with a curving swoop into a fast glide mere feet above a huge meadow. The waist-high grass is a blue-green smear as I bleed off airspeed and, at the precise moment, stiff-arm the big triangular control bar hard forward. Up jumps the nose, the glider parachute-brakes, then tries to pitch forward—still too fast!—and I'm running hard, a land creature once more, racing to keep the nose from falling through like Marty's did. Finally, I slow to a walk and carry my glider over to Marty.

"Good landing," he says cheerfully, beaming like a kid.

"Thanks. What a flight!"

"Un-be-lievable!"

"Nice 'beak' you pulled there, pal."

"Oh, you saw that."

"Bird's-eye view. You owe me a root beer."

Flying above, driving through, or walking among the minimal roads and sheltering trees of Yosemite Valley challenges our straight-line travels, summons the high, wide peace of our innermost existence. Turned away for a time from the hypnotic compulsion of racking up highway miles, we are again free to listen for the cry of the hawk, free to imagine its life of flight woven among the brooding stone monuments. In the spaces between Yosemite heartbeats, we might seek out some delicate summer shade at the foot of a lodgepole pine, to discover a daub of blue lupine and sunny buttercups, and perhaps recall the sweet faces of children and thus the fragile delicacy of all life.

Once we sought to bend even the mountains to our awesome industrial will. Over time, we may yet allow them to restore us to the deeper awe and sanctity of nature.

FISHERMEN ENJOY A WARM OCTOBER DAY ON JUNE LAKE IN THE SIERRA NEVADA.

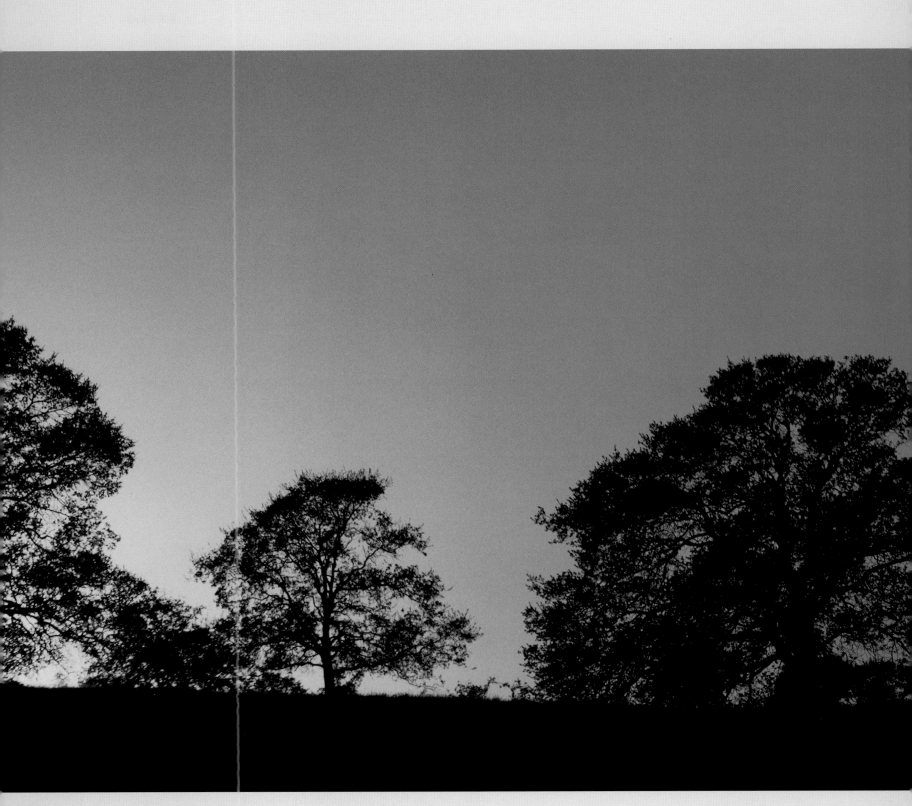

A SEPTEMBER SUNSET IN THE RED HILLS NEAR CHINESE CAMP CELEBRATES THE FULL-CANOPIED
MAGNIFICENCE OF OAKS. THIS STRETCH NEAR THE STANISLAUS RIVER IN THE WESTERN SIERRA
MOTHER LODE COUNTRY IS TYPICAL OF CALIFORNIA'S OAK-BLESSED HILLS AND VALLEYS.

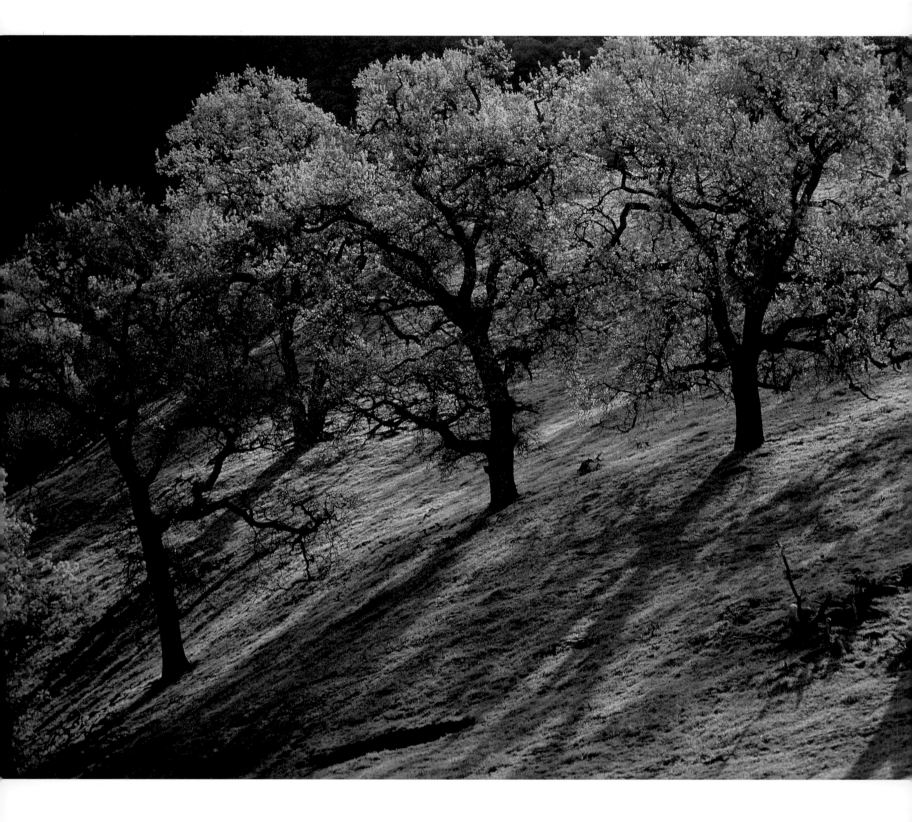

EVEN ADJACENT TO LOS ANGELES, ON THE SLOPES OF THE SANTA MONICA MOUNTAINS,

OAKS GRACE THE LAND WITH AN ETERNAL PASTORAL BEAUTY.

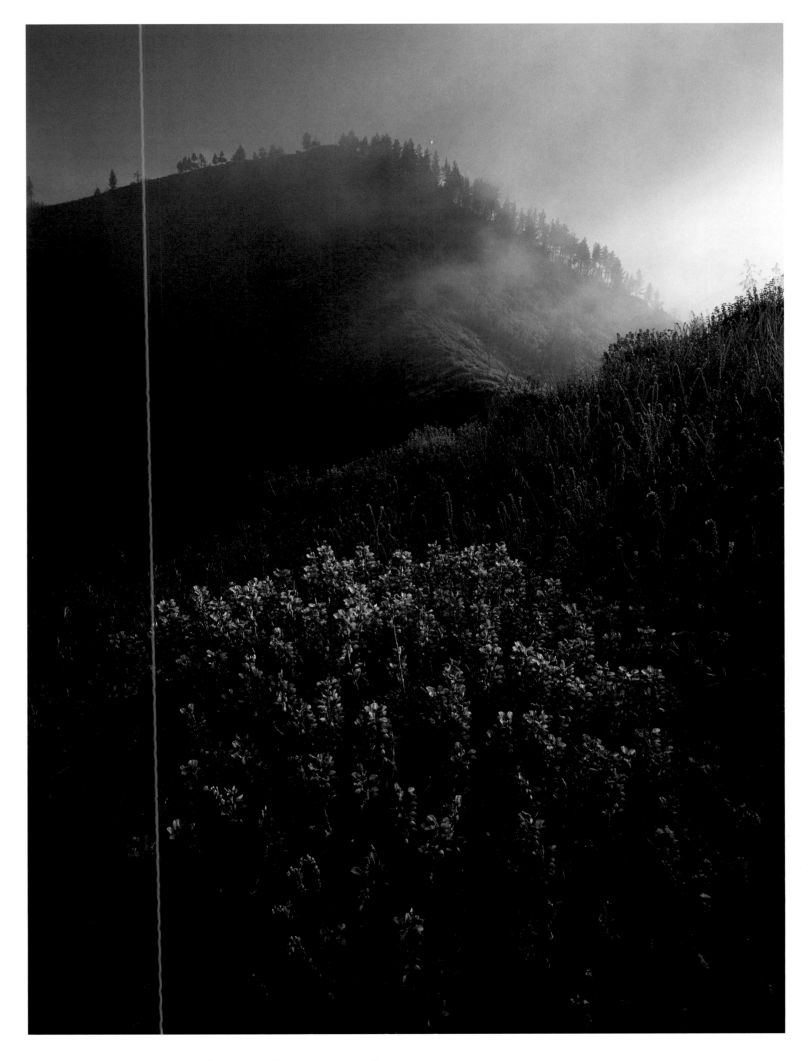

BUSH LUPINE *(LUPINUS ARBOREOUS)* ECHO COLORFUL HIGHLIGHTS IN
THE COOL VAPORS AROUND THE CHAPARRAL AND FORESTED FIGUEROA MOUNTAIN,
IN THE SAN RAFAEL WILDERNESS OF LOS PADRES NATIONAL FOREST.

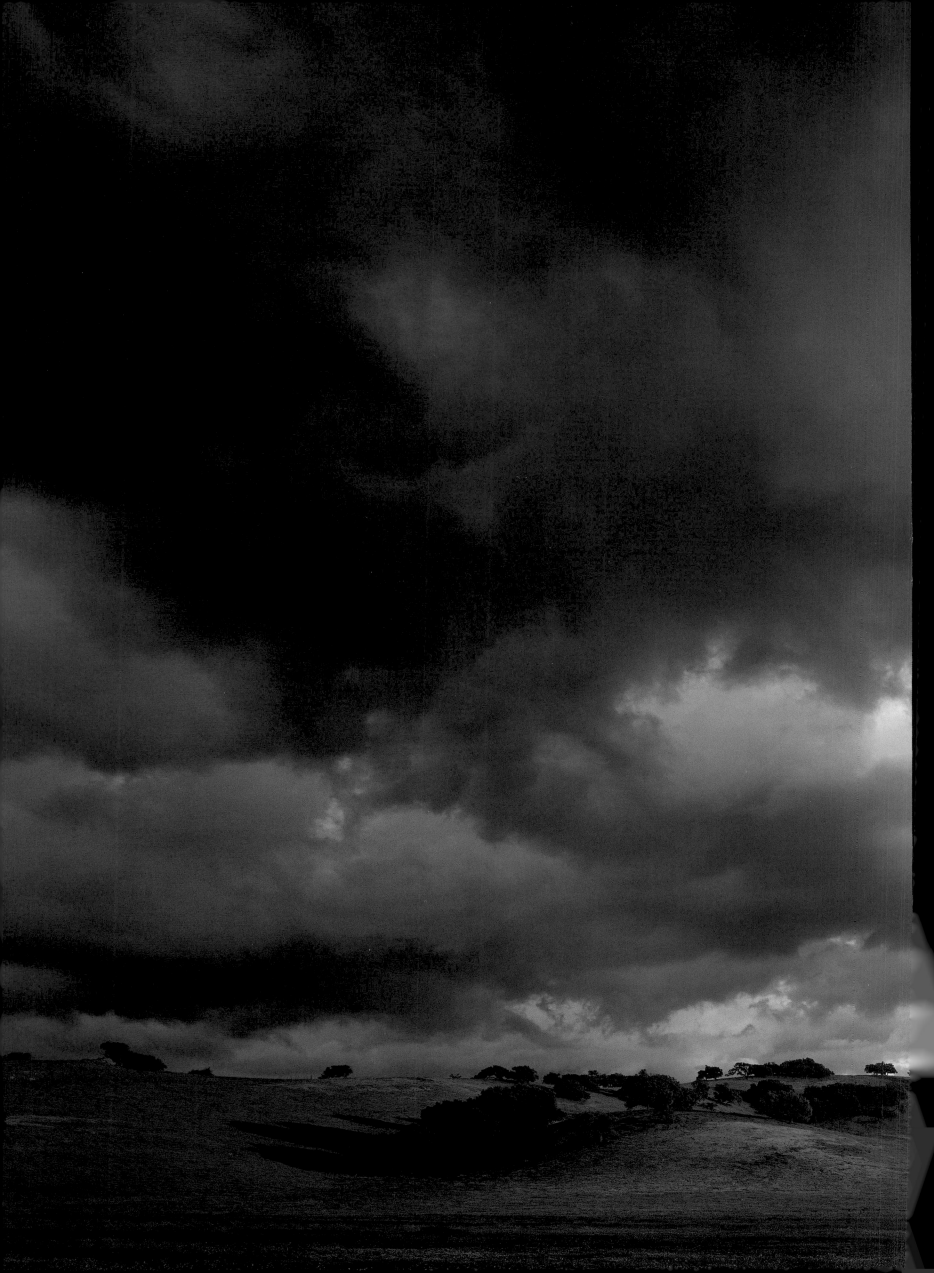

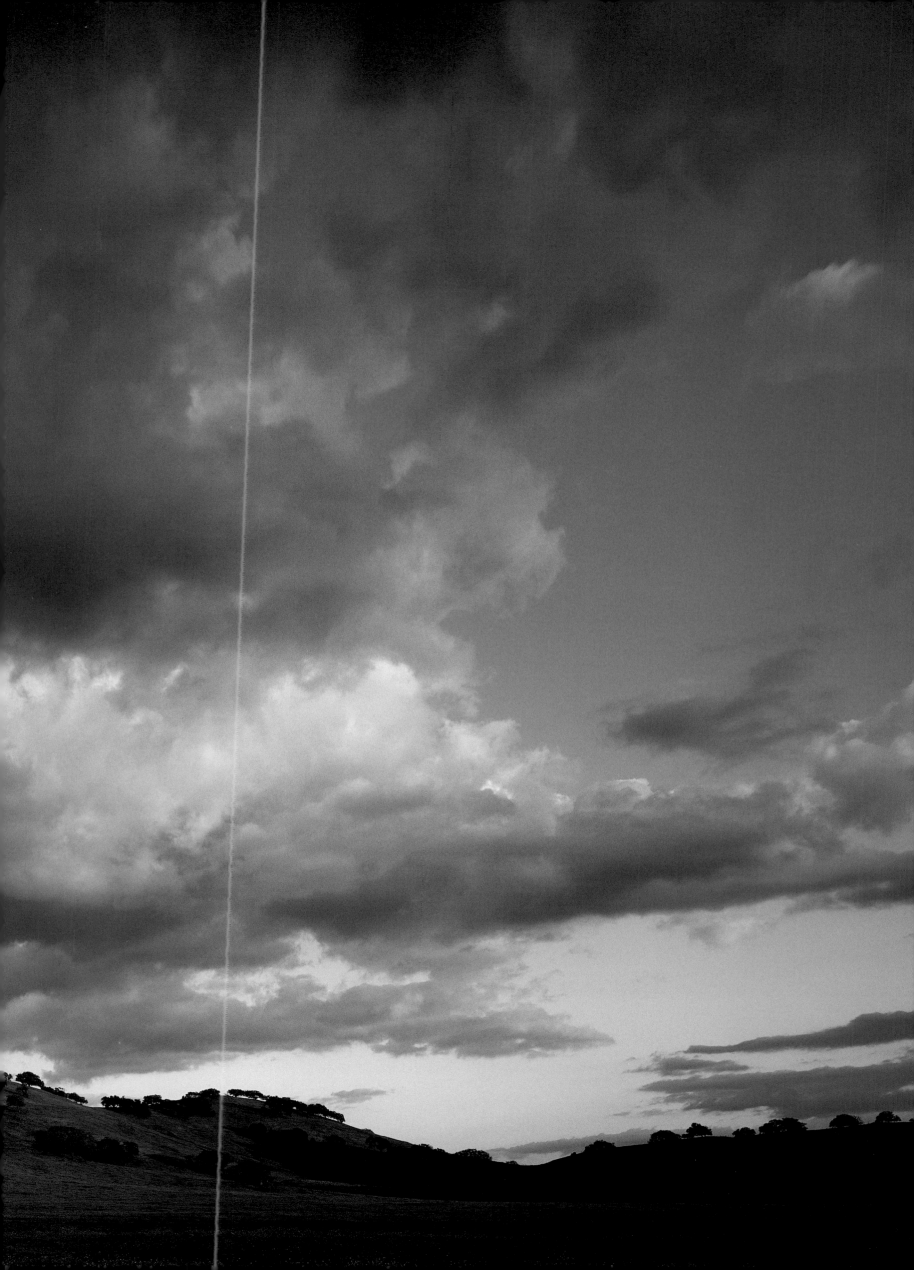

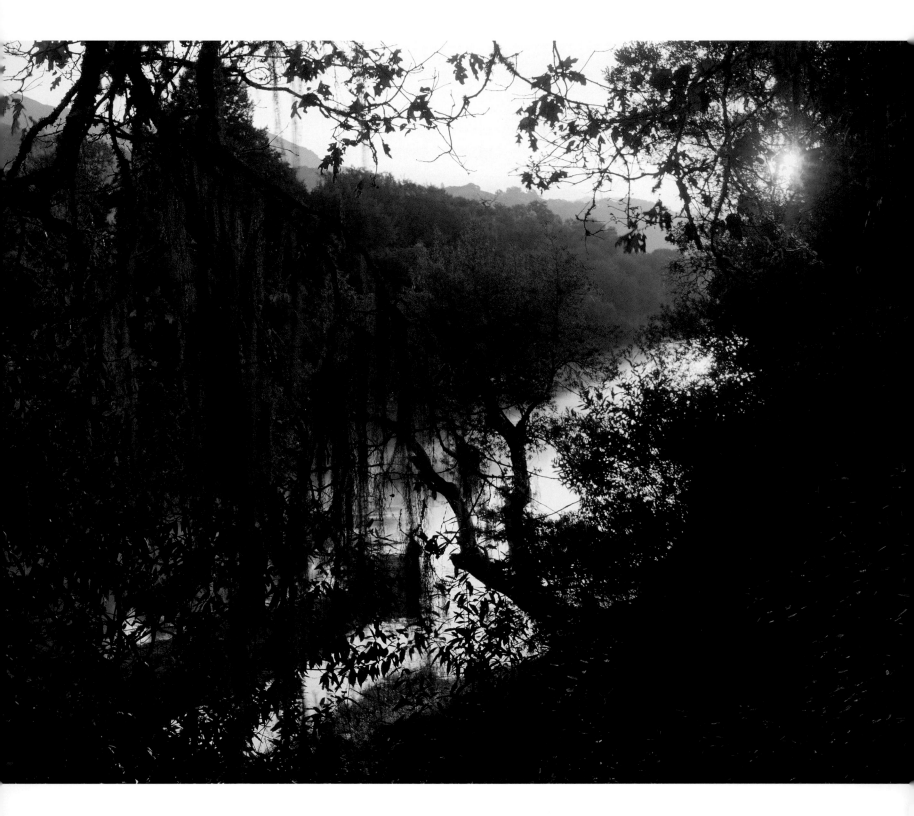

◄ ◄ Oak trees accent the flowering springtime hills in Pacheco Pass State Preserve
along the Diablo Range in Santa Clara County.
▲ An October sunrise highlights oaks and Spanish moss along the Russian River in the
Alexander Valley, one of six wine-growing regions in Sonoma County.

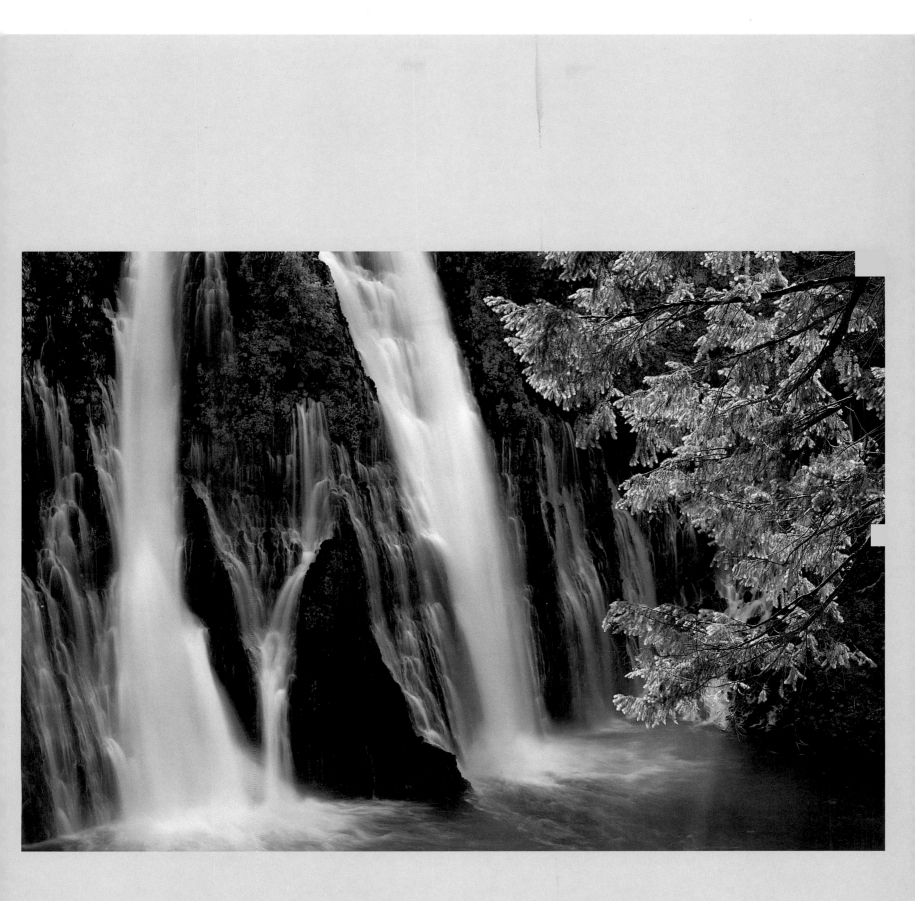

WATER SEEPING FROM MANY HOLES IN THIS POROUS LAVA, LADEN WITH FERNS,
CREATES A VERDANT WEEPING WALL, MCARTHUR–BURNEY FALLS MEMORIAL STATE PARK.

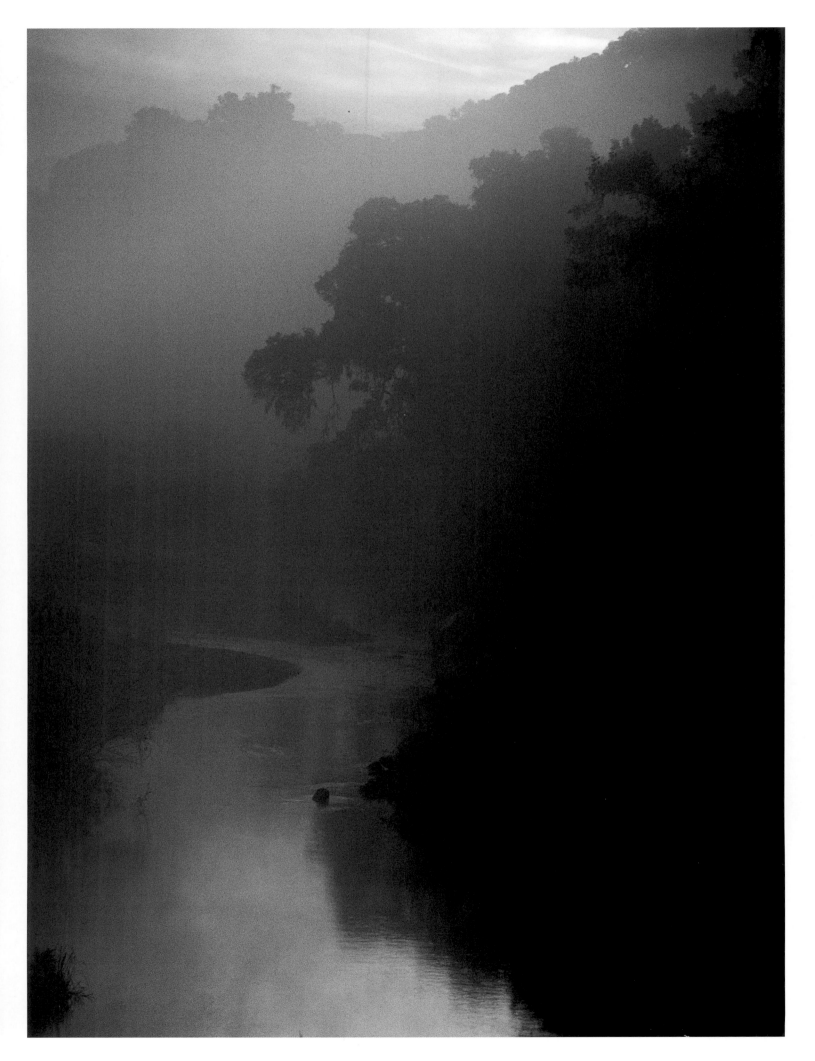

THE ROSY DAWN PERMEATES THE FOGGY SHROUD OF THE SANTA YNEZ RIVER NEAR THE POPULAR

DANISH-THEME TOURIST TOWN OF SOLVANG, IN SANTA BARBARA COUNTY.

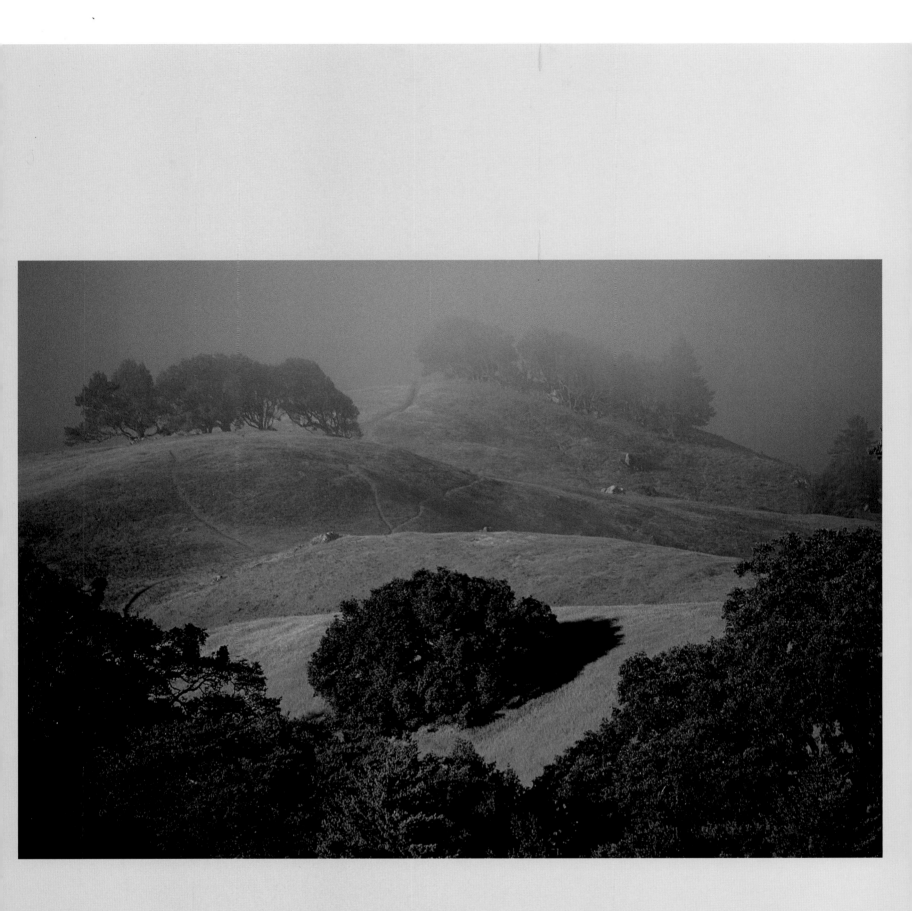

MORNING FOG DEEPENS THE RICH GREEN GRASS AND OAK COLORS OF SPRING WITHIN
MOUNT TAMALPAIS STATE PARK. THIS SIXTY-THREE-HUNDRED-ACRE MARIN COUNTY PARK RISES
MORE THAN TWENTY-FIVE HUNDRED FEET ABOVE NORTH SAN FRANCISCO BAY.

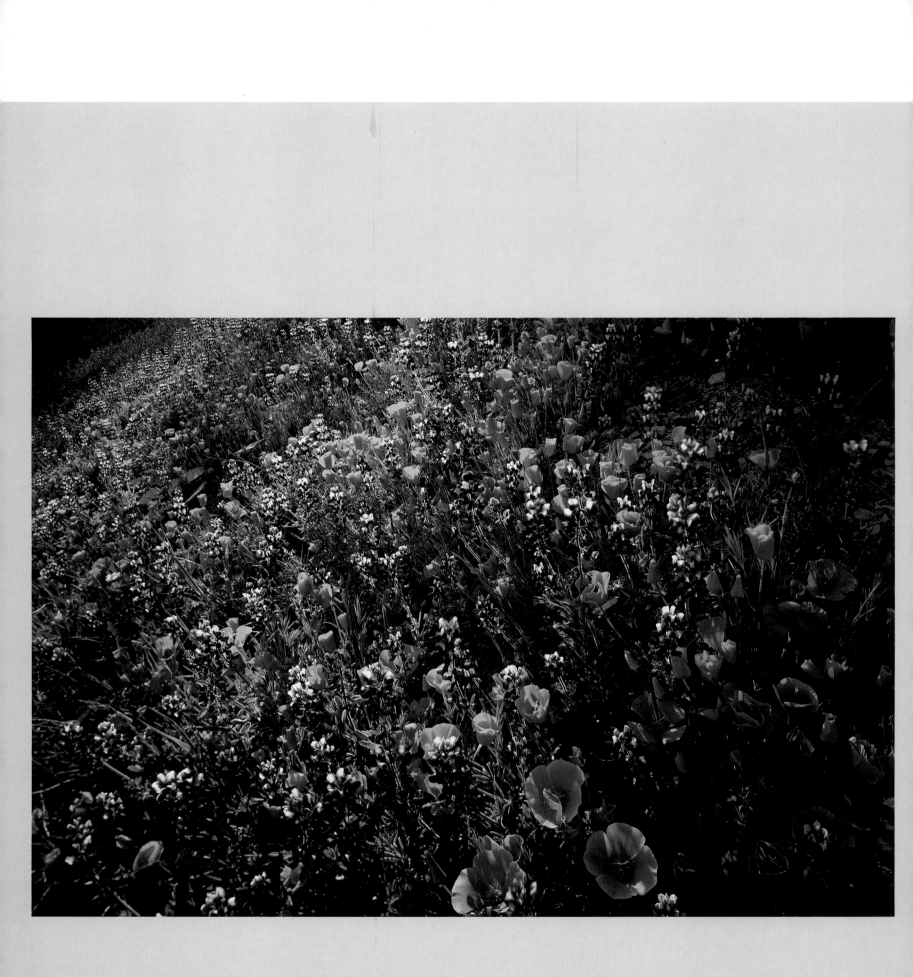

▲ A SPRING EXPLOSION OF GOLDEN POPPIES *(ESCHSCHOLZIA CALIFORNICA)*, THE STATE
FLOWER, SHARES A HILLSIDE WITH LUPINE IN THE LOS PADRES NATIONAL FOREST.

► A CARPET OF GOLDFIELDS *(LASTHENIA CHRYSOSTOMA)* HIGHLIGHTS A RIDGELINE
OF BLUE OAKS ON FIGUEROA MOUNTAIN IN SANTA BARBARA COUNTY.

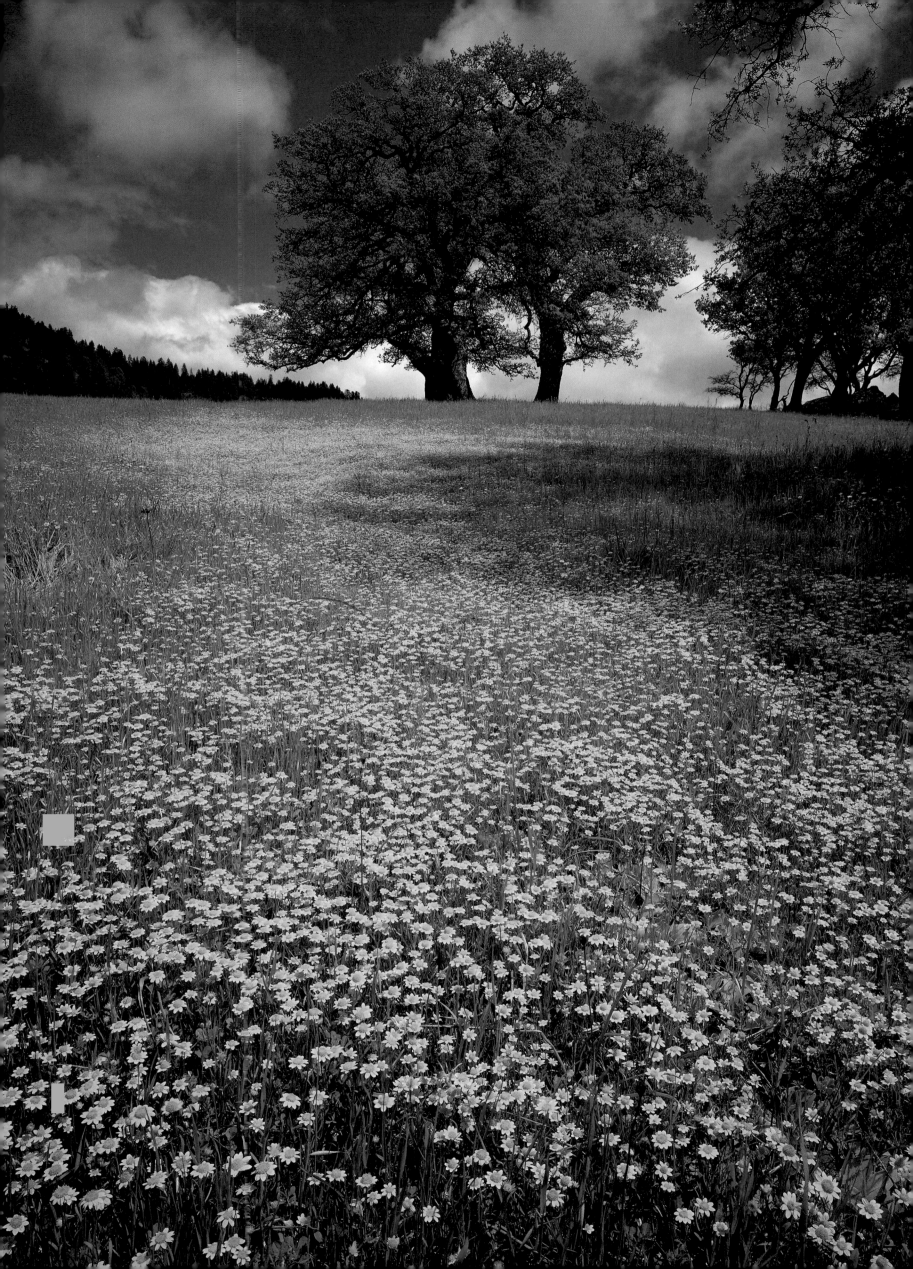

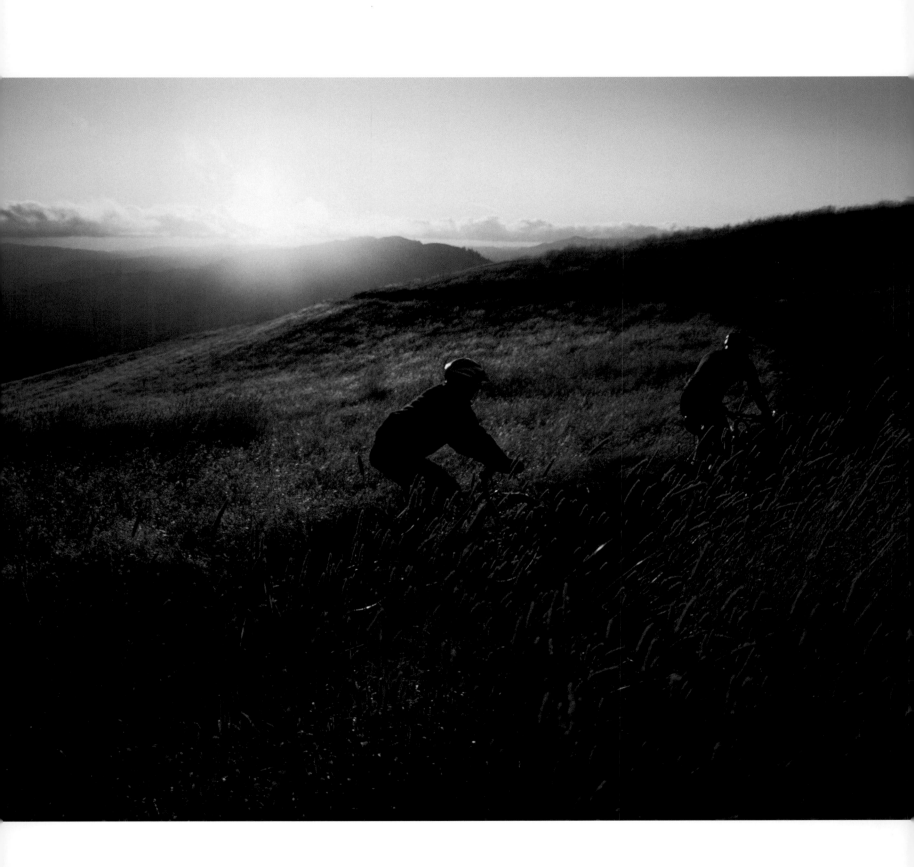

San Francisco Bay Area mountain bikers enjoy the afternoon ambience along the Open
Space Preserve that divides the coast from the southern part of the bay.

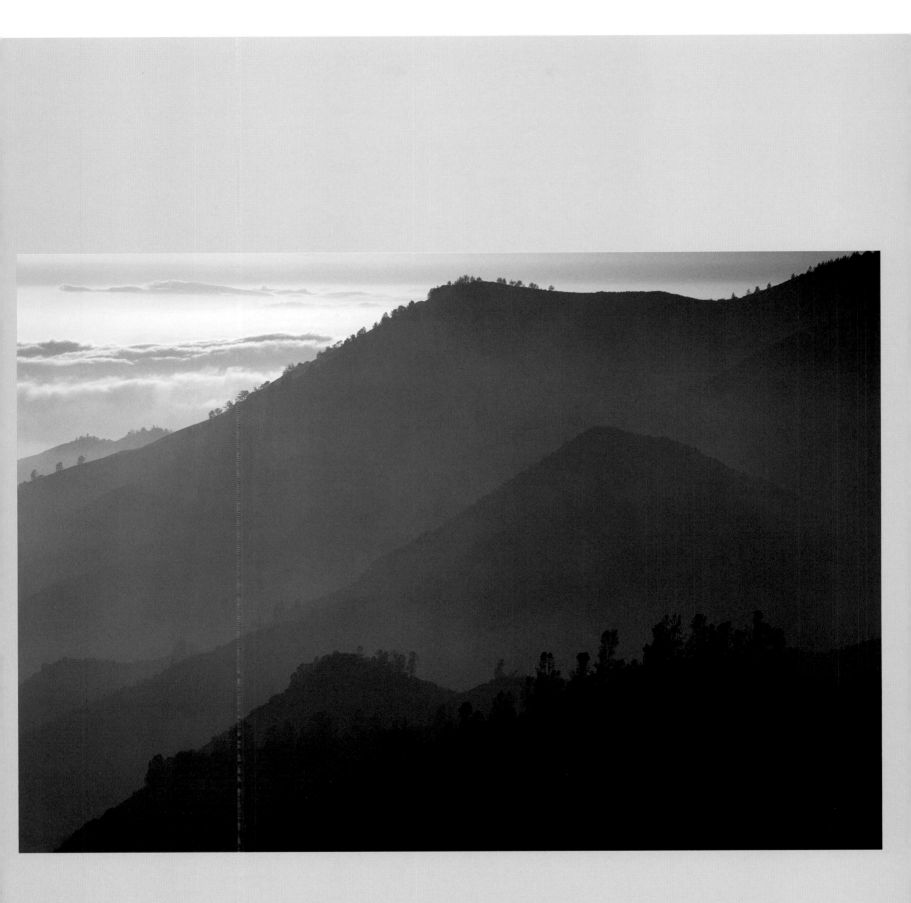

EVENING LIGHT ILLUMINATES THE FOG-SHROUDED RIDGES ABOVE THE
SANTA YNEZ VALLEY. LOCATED IN SANTA BARBARA COUNTY, THE SANTA YNEZ VALLEY HAS
MADE A NAME FOR ITSELF AS CALIFORNIA'S OTHER WINE COUNTRY.

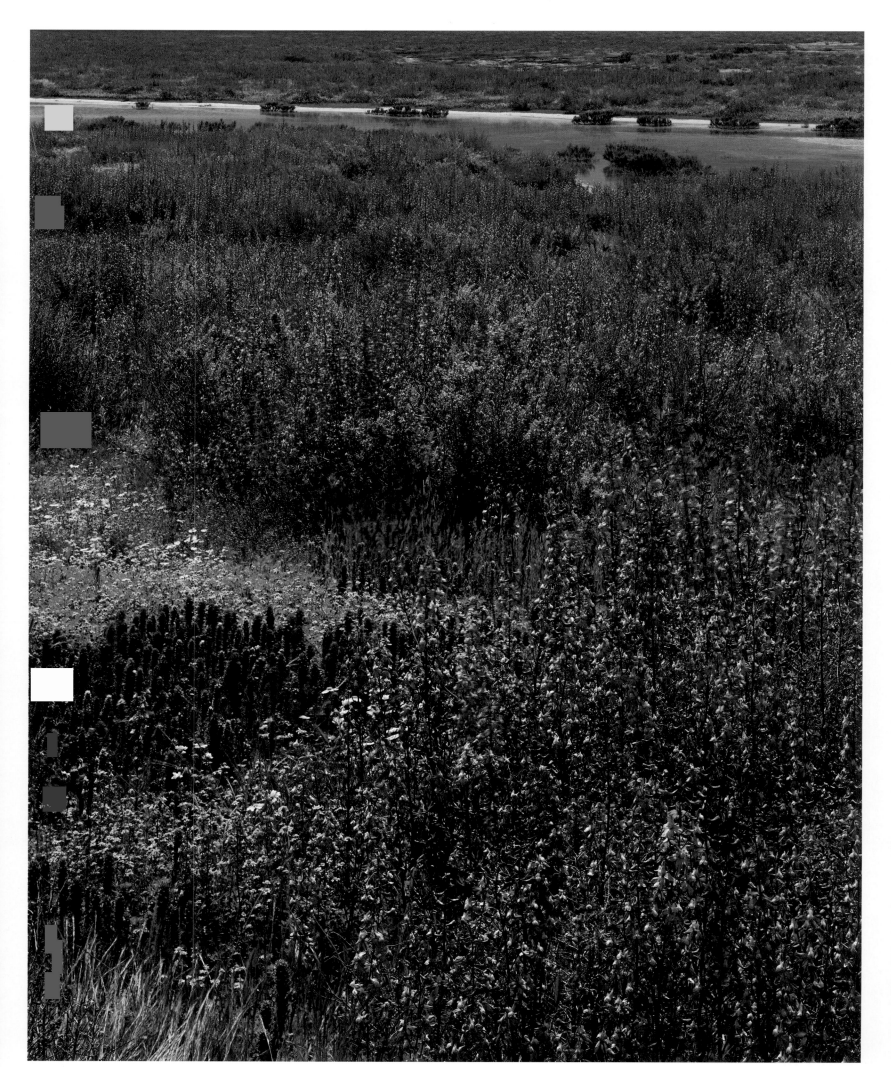

A SPRING RIOT OF INLAND BLUE LARKSPUR *(DELPHINIUM PATENS)* AND

OWL'S CLOVER *(ORTHOCARPUS PURPURACENS)* DOMINATES THE WILDFLOWER MIX AROUND

SODA LAKE, CARRIZO PLAIN, SAN LUIS OBISPO COUNTY.

TURNING LEAVES FRAME THE ENTRANCE TO A HISTORIC HOME IN COLOMA, HOME OF THE MARSHALL
GOLD DISCOVERY STATE HISTORICAL PARK, ALONG THE SOUTH FORK OF THE AMERICAN RIVER.

TWO YOUNG EXPLORERS SEE HOW IT WAS DURING GOLD
RUSH DAYS IN COLOMA, NEAR SUTTER'S MILL.

A MINING STAMP MILL RELIC AND A TAILING WHEEL RECALL
THE HEADY DAYS OF GOLD FEVER IN THE MOTHER LODE
NEAR JACKSON IN AMADOR COUNTY.

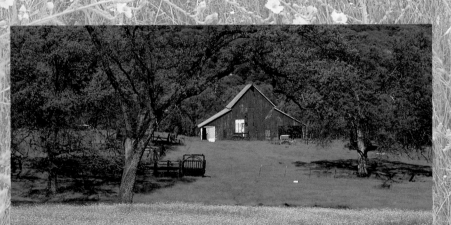

A WORKING BARN ANCHORS THIS IDYLLIC COUNTRY VIEW IN
MARIPOSA COUNTY, MOTHER LODE COUNTRY.

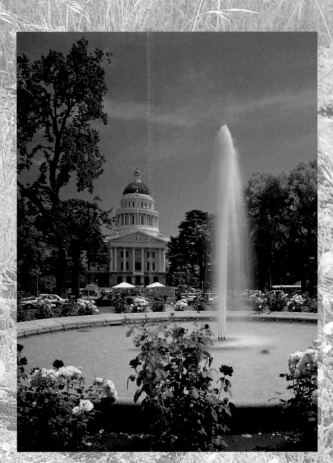

THE STATE CAPITOL BUILDING IN SACRAMENTO
IS A POPULAR TOURIST DESTINATION FOR ITS HISTORY
AND ITS BEAUTIFUL SURROUNDING GARDENS.

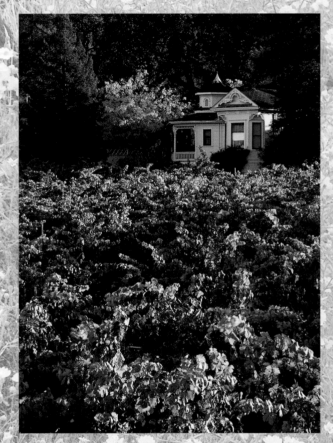

A NAPA COUNTY VINEYARD IS COMPLETE WITH A HOUSE
FOR WINE TASTING, NESTLED IN OCTOBER SHADE.

THE CABERNET GRAPES OF OCTOBER ARE READY FOR HARVEST IN NAPA VALLEY,
IN THE COAST RANGE, NORTH OF SAN FRANCISCO BAY.

BACKGROUND: GRANITE BOULDERS HIDE IN SEPTEMBER GRASSES AND FLOWERS
IN THE MADERA COUNTY FOOTHILLS OF THE WESTERN SIERRA.

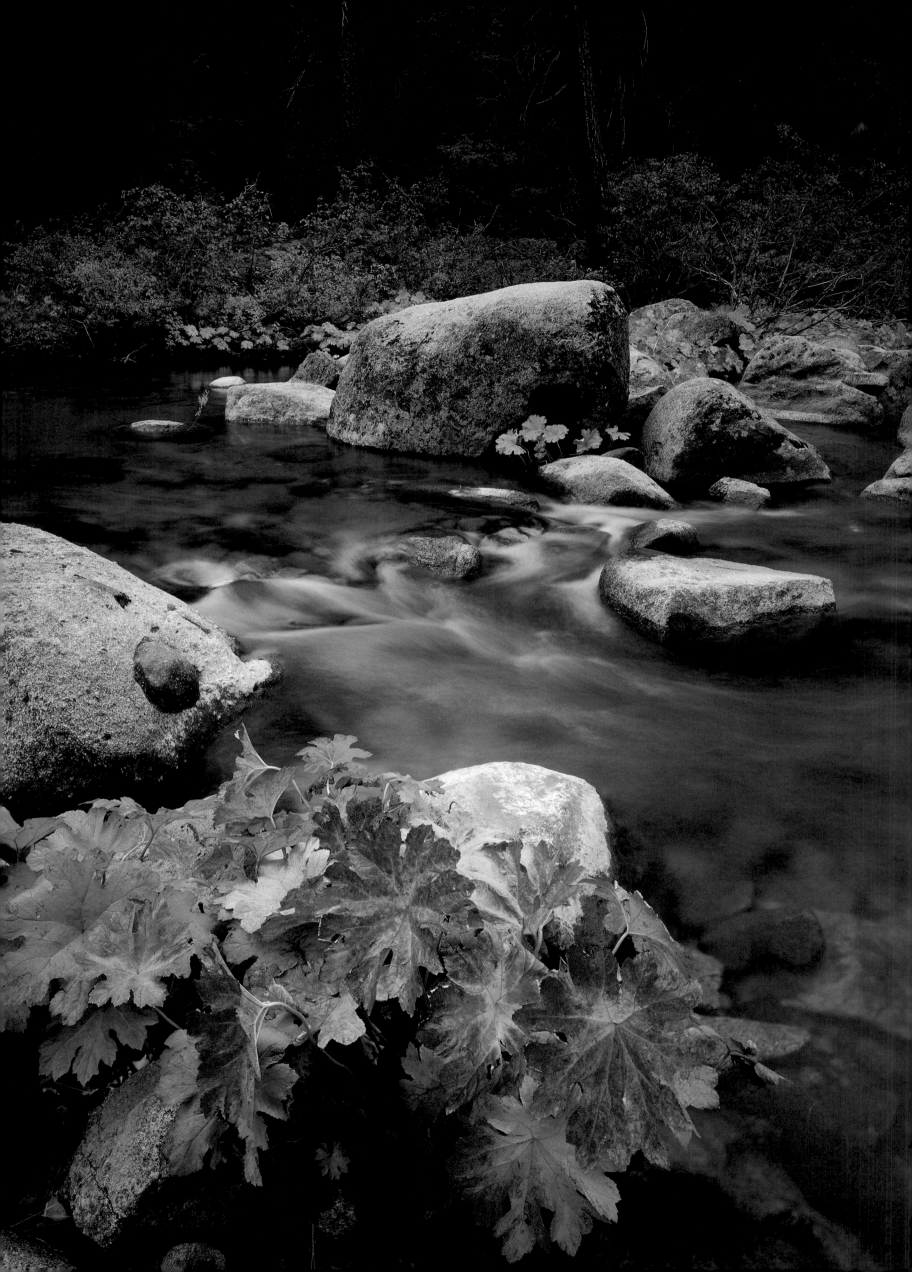

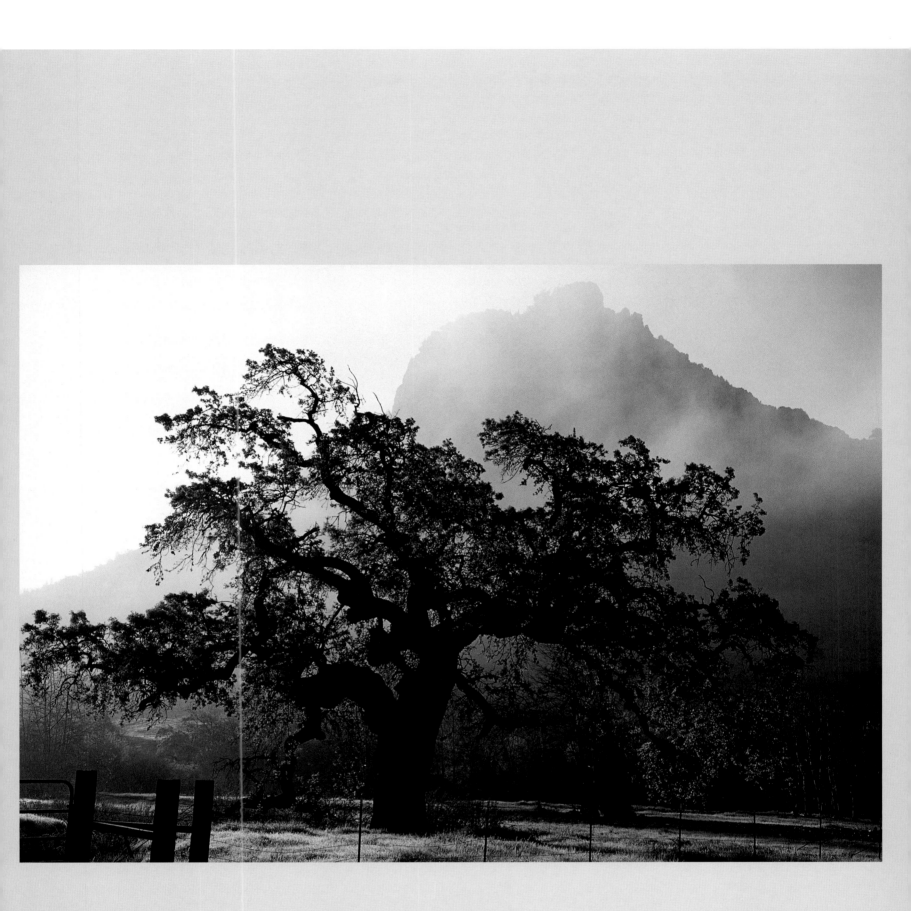

◄ Indian rhubarb *(Darmera peltata)* graces whispering waters along the

Silver Fork of the American River, El Dorado County.

▲ The magic of the oak is enhanced by morning fog along Pacheco Creek, Diablo Range.

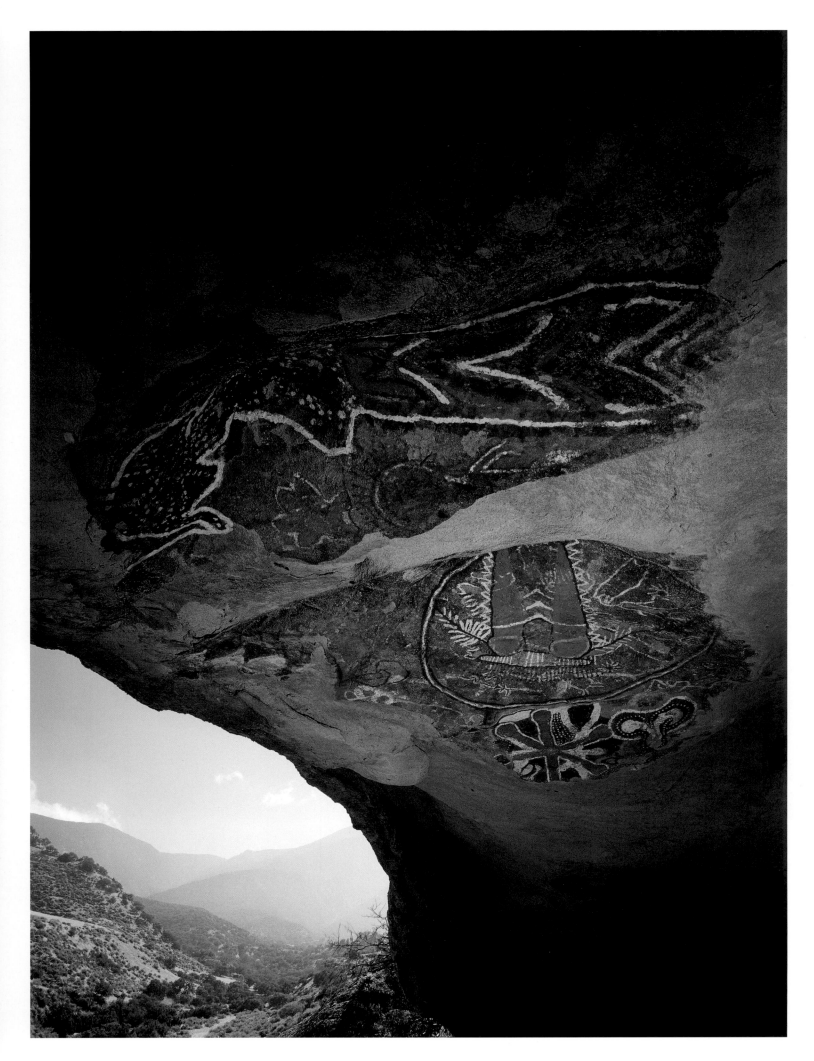

These Chumash ceremonial paintings probably were created during the Mission Period (1769–1834). This San Emigdio Painted Cave is in the Chumash Wilderness of Los Padres National Forest.

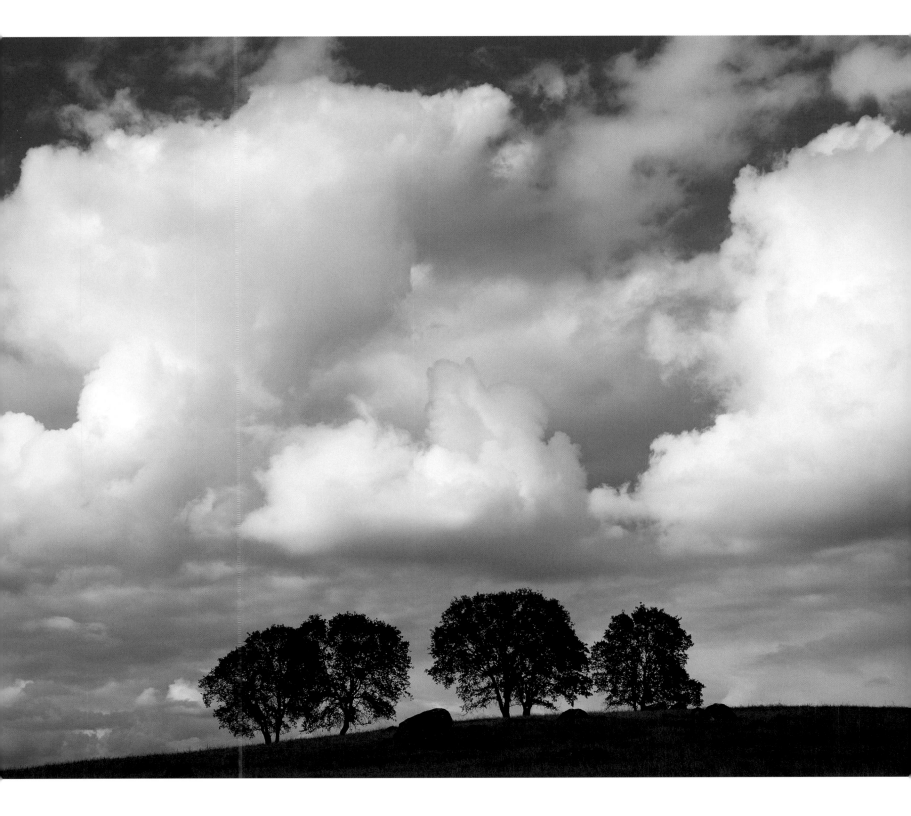

BLUE OAKS KNIT A SPRING CUMULUS SKY TO THE GREEN VELVET PASTURE LANDS OF TUOLUMNE

COUNTY NEAR SONORA, SIERRA FOOTHILL COUNTRY WEST OF YOSEMITE.

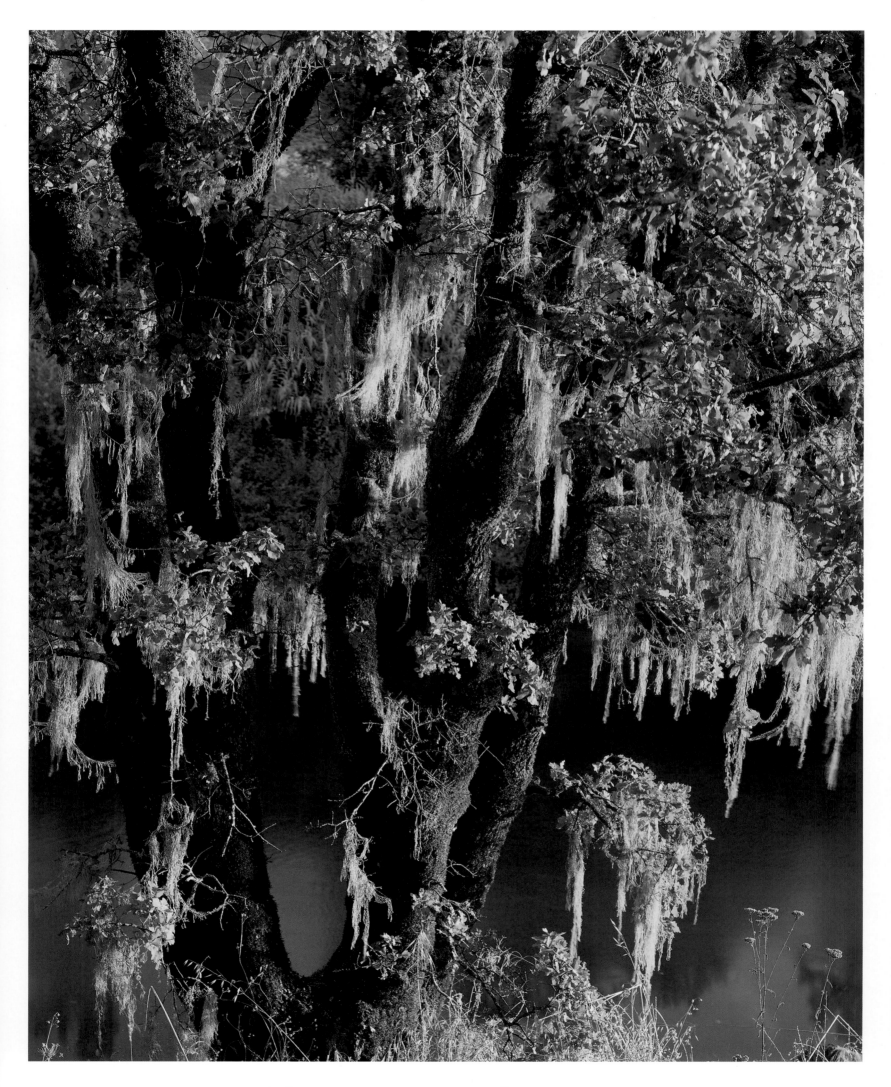

An October sunrise warms a mix of oak and Spanish moss along the
Russian River in Alexander Valley.

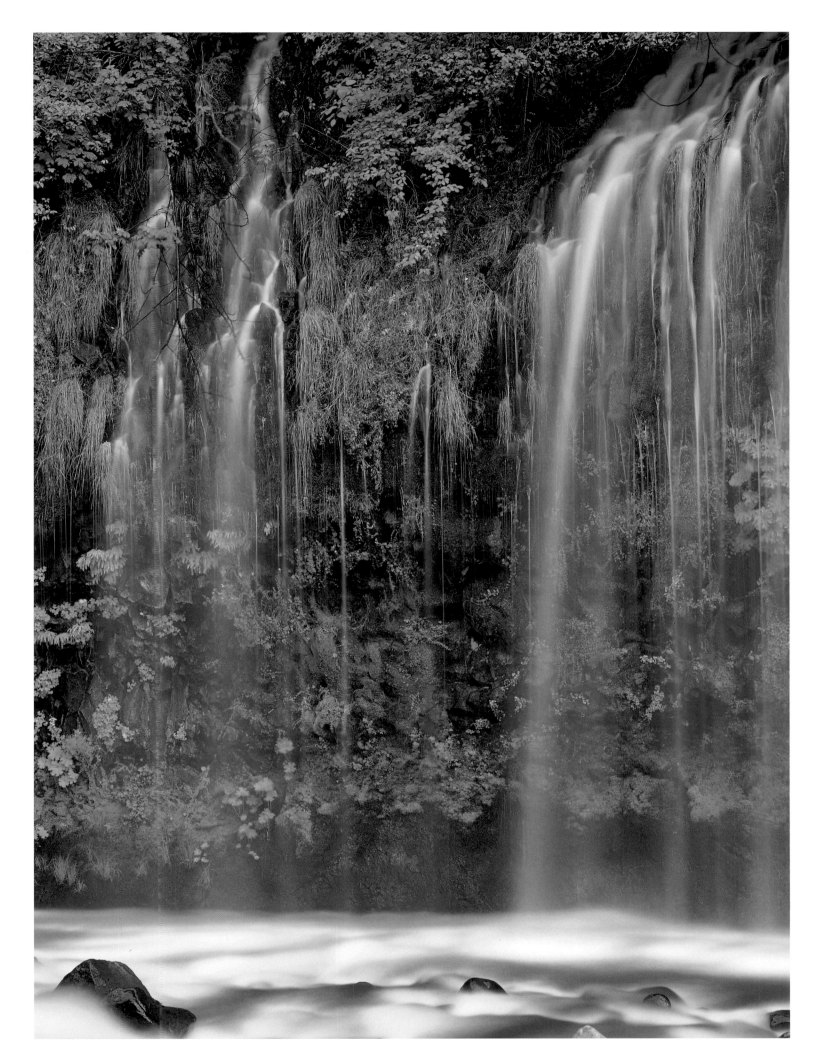

THE SPRING WATERS OF MARYMEAR FALLS FROM NEARBY MOUNT SHASTA
FLOW OUT OF POROUS VOLCANIC ROCK ALONG THE UPPER SACRAMENTO RIVER,
WHICH FLOWS BY ON ITS SOUTHERLY JOURNEY TO THE SACRAMENTO DELTA REGION.

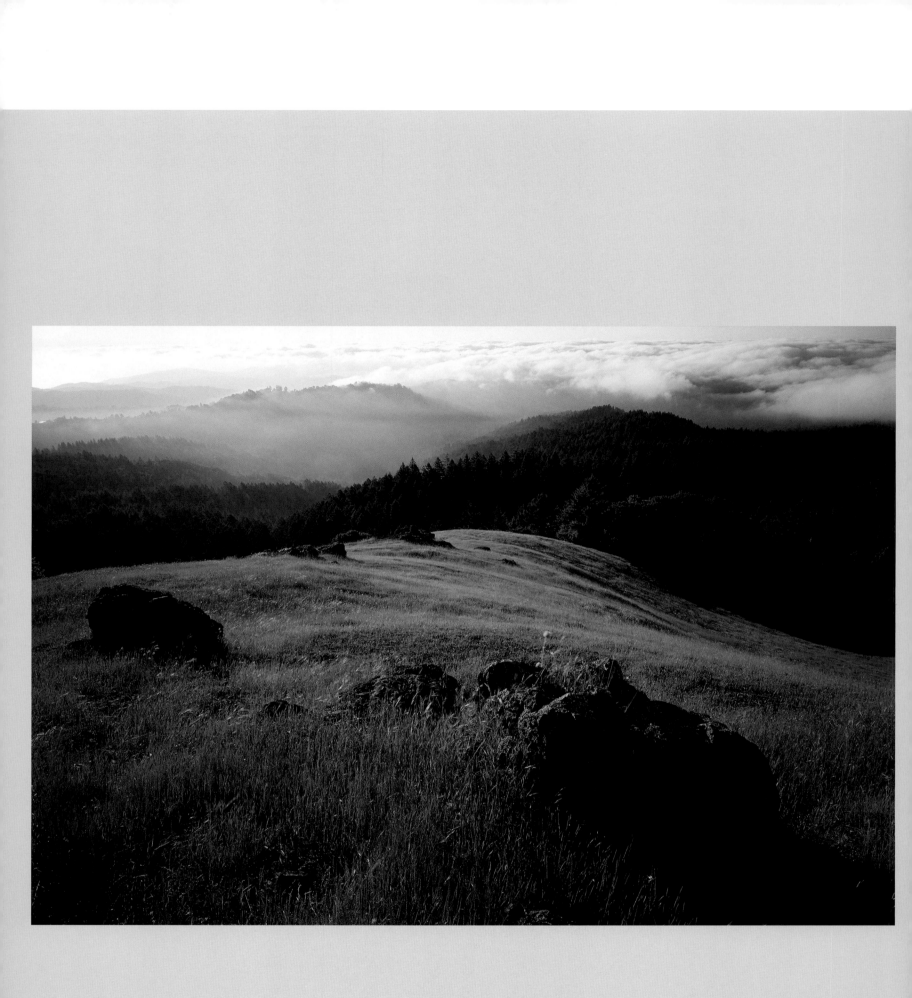

▲ This inviting view south toward San Francisco is seen from Mount Tamalpais State Park.

► Autumn maple and oak branches host an intricate design of Spanish moss

(Tillandsia usneoides) in Capell Valley, Napa County.

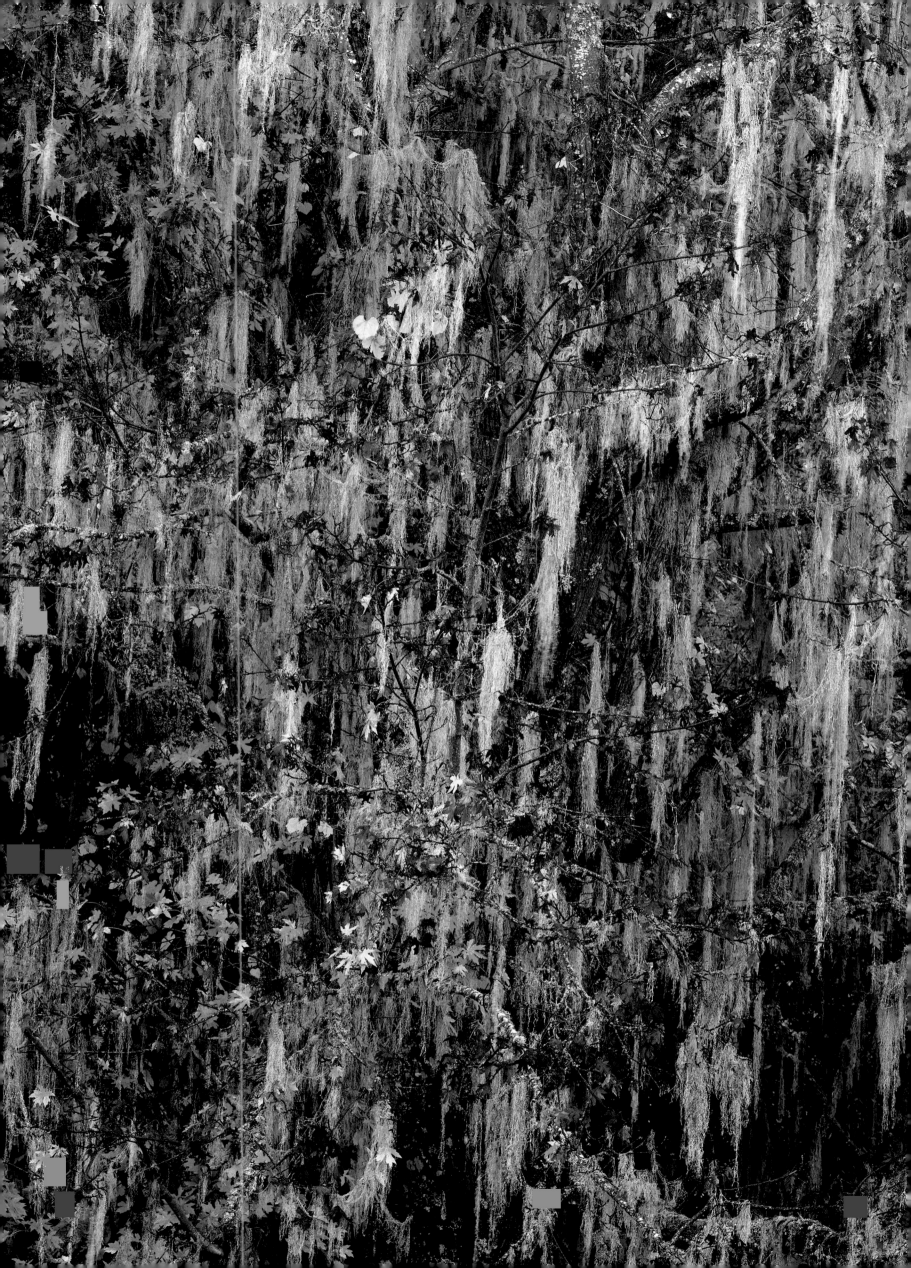

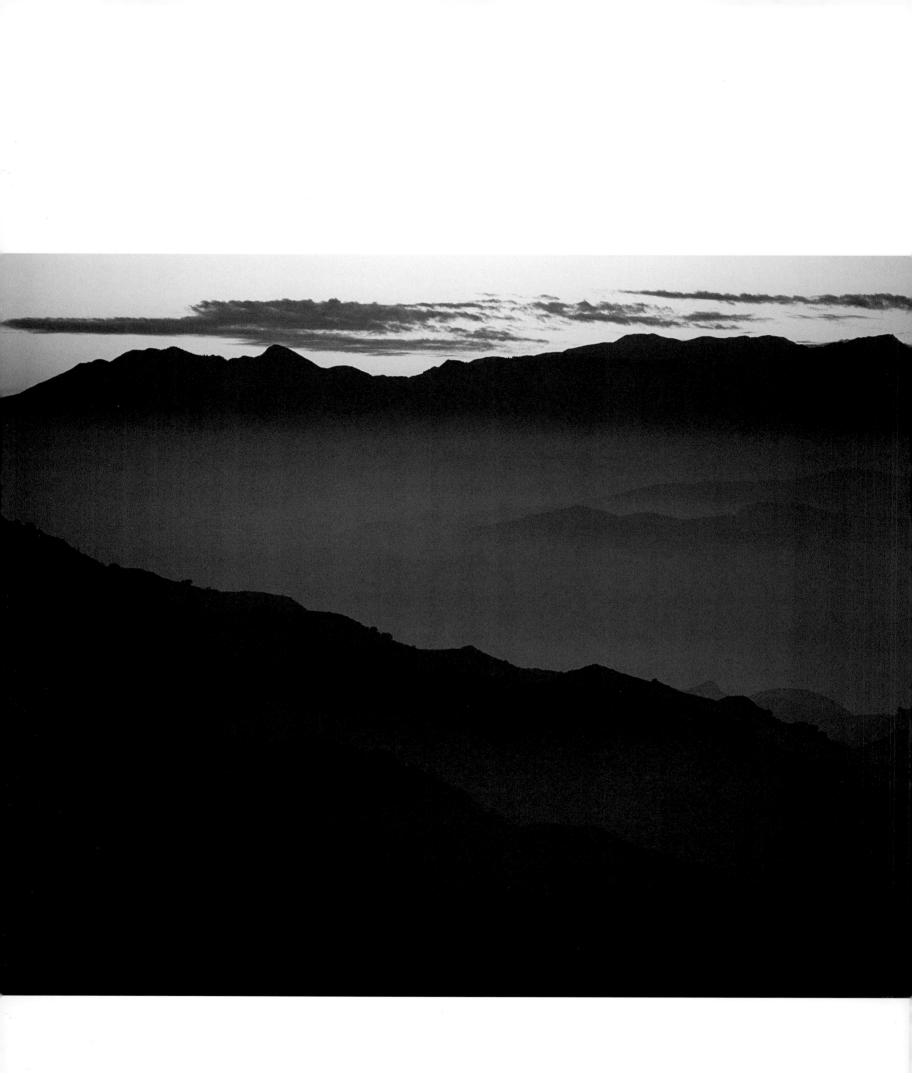

MARINE HAZE, CARRIED INTO THE FILLMORE VALLEY BY ONSHORE WINDS,
TURNS SUNSET LIGHT INTO ALLURING PASTELS, CUPPED BY THE COASTAL SIERRA MADRE MOUNTAINS.

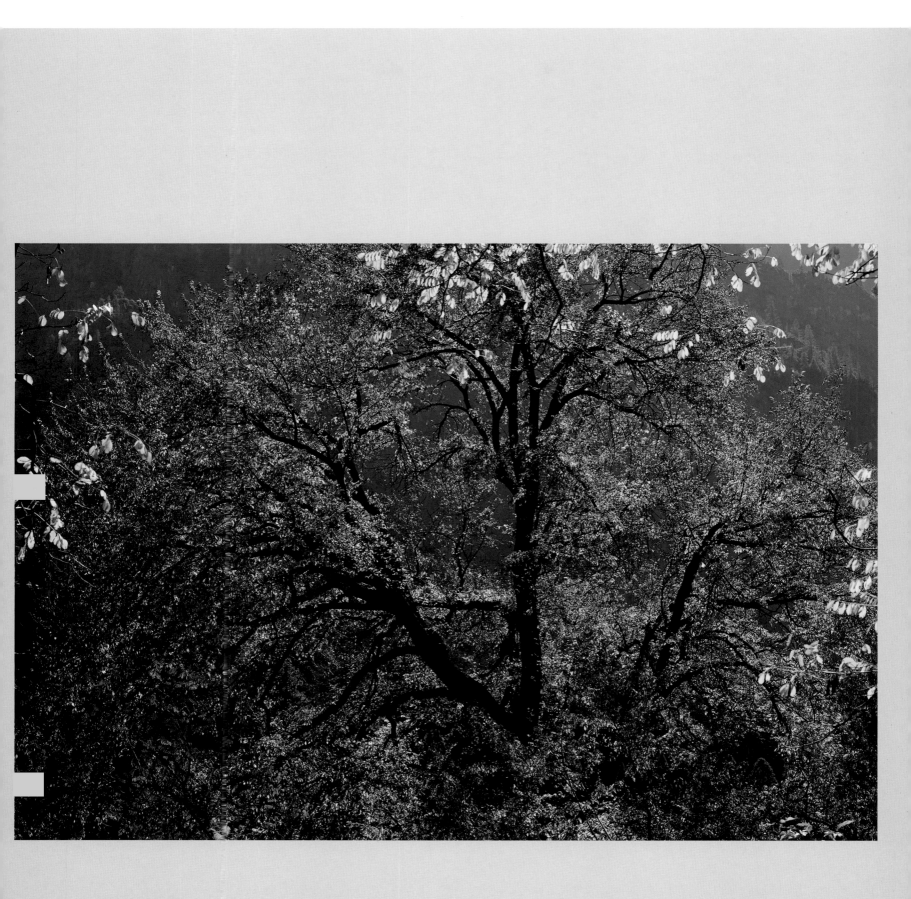

THE GRACEFUL BRANCHES OF A BLACK OAK *(QUERCUS VELUTINA)* ARE ILLUMINATED BY

FALL COLORS IN YOSEMITE VALLEY.

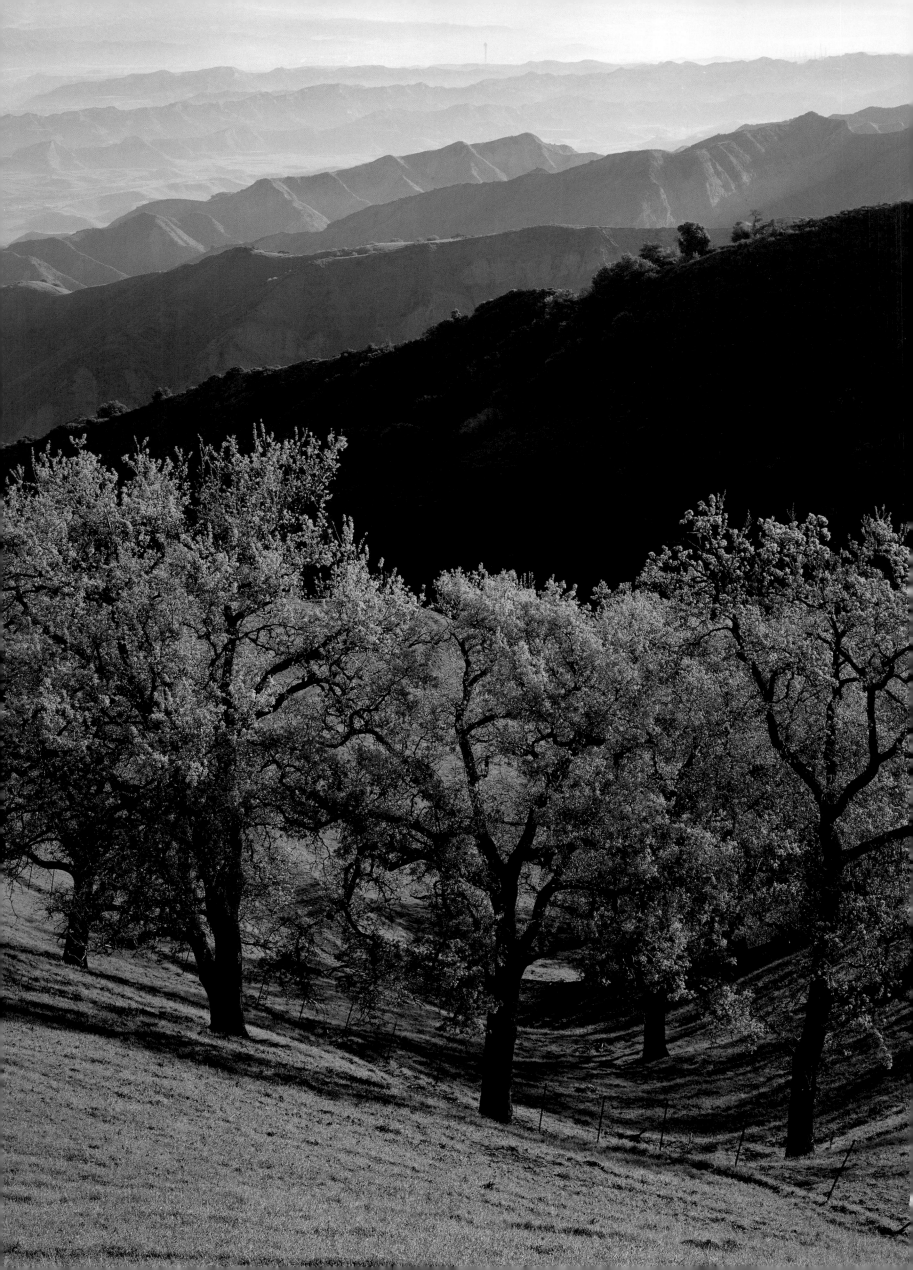

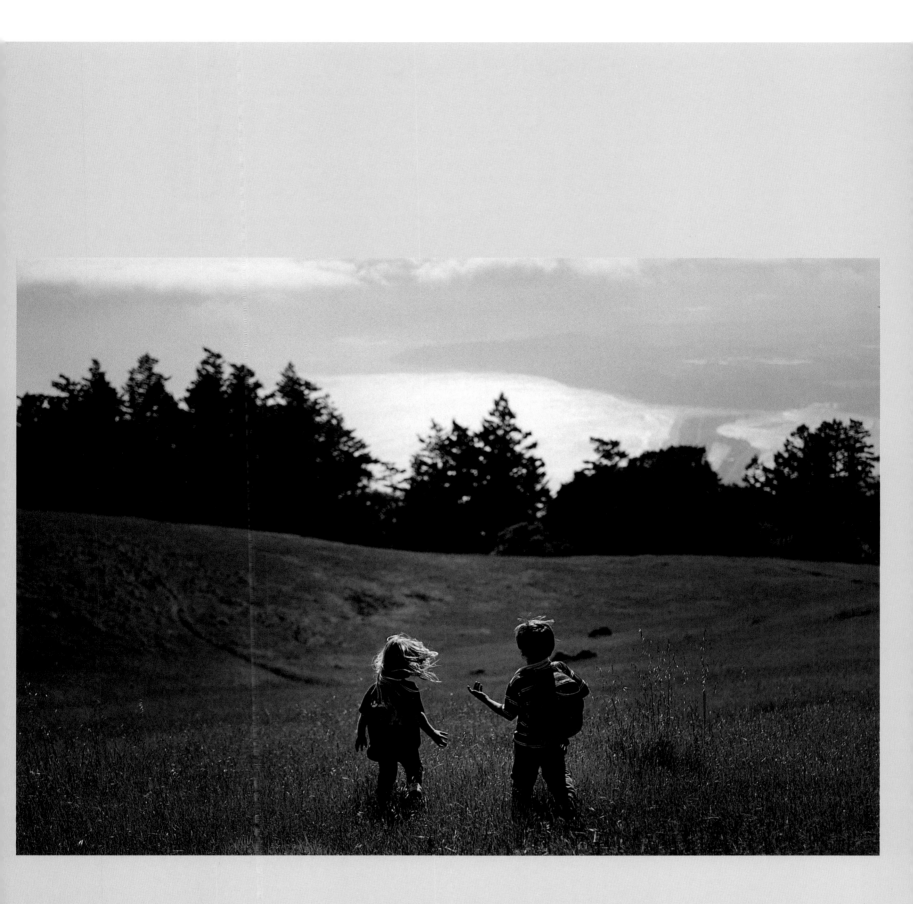

◄ OAK-RICH SLOPES OF THE SIERRA MADRE MOUNTAINS SPILL ACROSS THIS SOUTHERN
PANORAMA THAT LOOKS INTO THE DISTANT LOS ANGELES BASIN.
▲ CHILDHOOD MEMORIES FLOURISH IN THE GRASSY MEADOWS OF MOUNT TAMALPAIS STATE PARK.

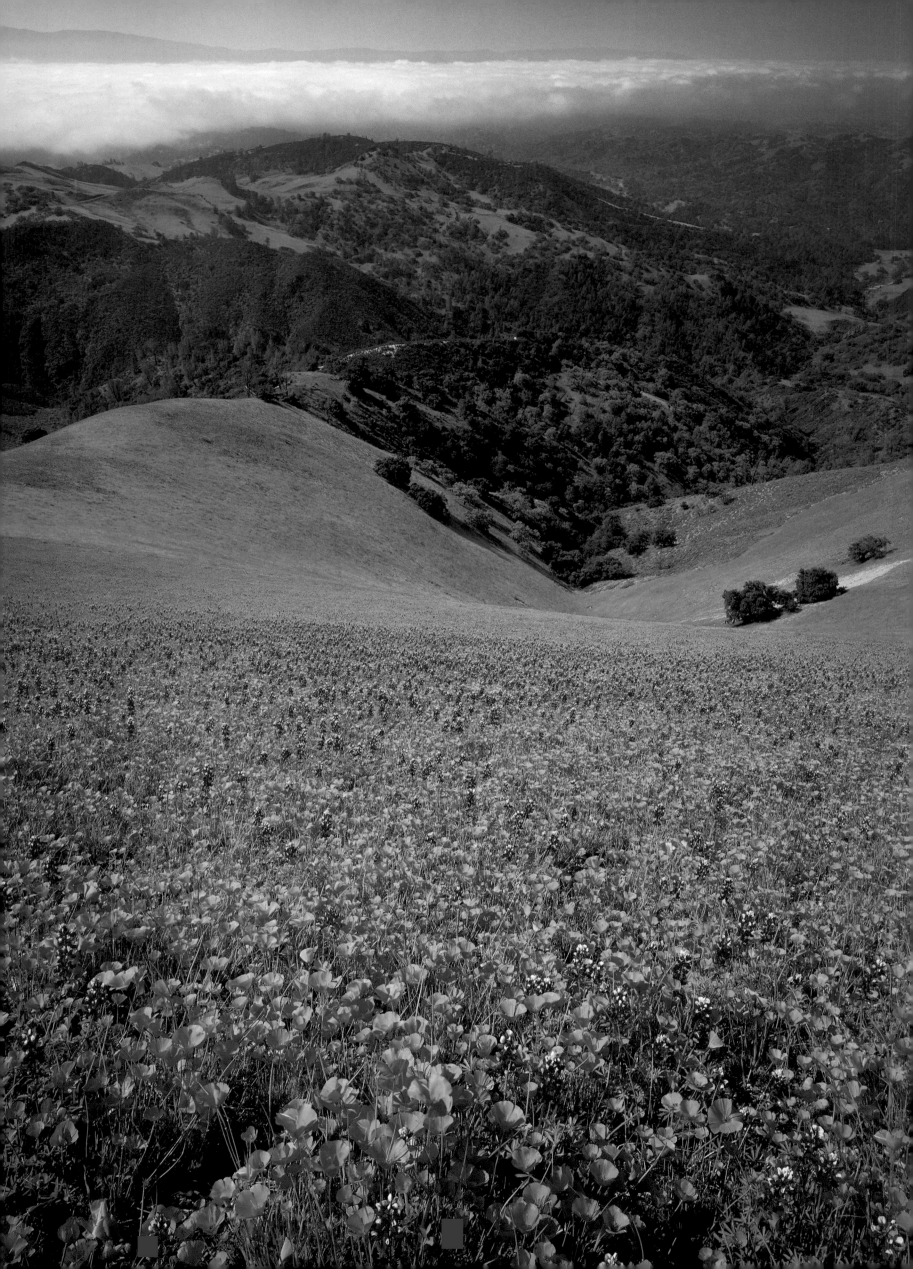

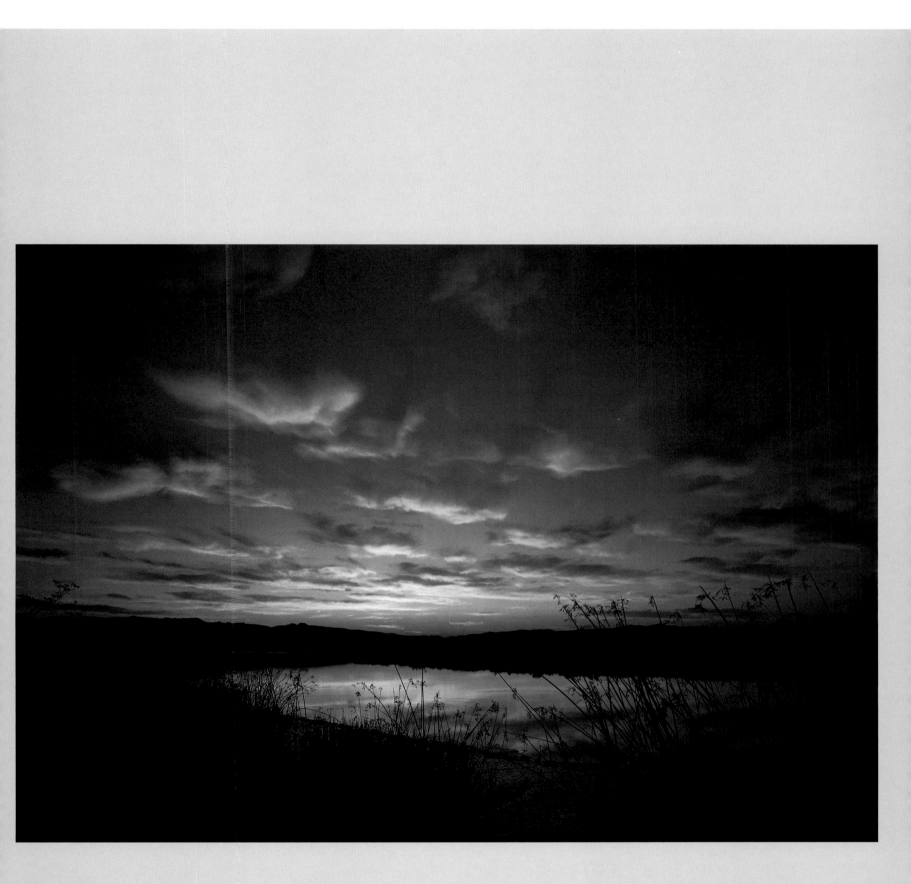

◄ As if held at bay, encroaching fog banks roll into the western Santa Ynez Valley below this lush
Zaca Peak slope, wild with California poppies and lupine.
▲ Giant bulrushes (*Scirpus californicus*) conduct a symphony of sunrise colors in
wetlands of Napa River tidal waters, Napa/Sonoma Marsh Wildlife Area.

OF OAKEN DREAMS

At every step the country improved in beauty...[It] is smooth and grassy...and in the open valleys...around spring heads, the low groves of oak give the appearance of orchards in an old cultivated country.

— John C. Frémont, from 1845 logs detailing his expeditions to California

Woven into the fabric of California's large-scale landscape pageantry are soft, soothing pockets of pastoral poetry that frame and soften the intense, dramatic impact of the mountains. These expanses of gently rolling foothills, lush deciduous woodlands, verdant agricultural valleys, and bowers of flowers offer a sentimental refuge for the senses.

Nostalgic reminiscences of bucolic California often center around visions of oak groves anchoring the rise and swell of golden grass hills and expansive ranch lands. As we roll down two-lane and dirt roads that wind through undulating summery dreamscapes, oaks and their attendant grasses invite a yawning ease to our passages from mountain ridge to valley floor, from coastal cliff to desert sands.

Among the profusion of California's scenic icons there is no more splendidly Arcadian view than a solitary, massive live oak, its dense ball of leaves as wide as it is tall, standing strong and alone in a sea of blond oatgrass and mature foxtail. Morning ground fogs swirl around gray-black, rough-bark trunks that link the flat-bottomed canopy to the earth. Bees hum through the autumn velvet of the oak's grassy carpet, seeking the nectar of mariposa lilies. To walk among a grove of widely dispersed oaks is to rekindle the bone-deep safety of holding your favorite grandfather's big, rough hand. Oaks remind us, in their guardian-like vigor, that it is the natural order of things that we wear our solitary existence with pride, courage, faith, and humility. Rooted to our summer soil, each of us stands unique and beautiful.

Thanks to its Mediterranean climate of cool, wet winters and hot, dry summers, California has been blessed for millions of years with an abundance of oaks. A rich variety of species, eighteen in all, thrives throughout most of the state's climatic zones, from coastal ridges and lowlands to mountain heights. Exactly half the species are deciduous and evergreen tree oaks. Their descriptive names often locate them: coast live oak, island oak, canyon oak, interior live oak, blue oak, valley oak. The remaining types are varieties of the hardy, ground-hugging shrub oaks that cover roughly 1.5 million acres. They tend to favor drier areas than their lofty cousins and wear names that also hint of their natures

and environs: scrub oak, leather oak, desert scrub oak, deer oak, island scrub oak, coastal scrub oak.

Sitting against this venerable valley oak, I feel as if I'm drawing life force right from its trunk. Hot, turbulent air over the Gabilans east of Salinas en route to the Central Valley town of Porterville has taken its toll on my empty stomach. Woozy and nauseous, I've broken off the long flight to rebalance my equilibrium beneath this shady, sheltering canopy.

I swoon, carried away by an idyllic silence touched only by the buzzing of autumn insects and warm, dry gusts rustling the stiff branches above. Dozing, I imagine I hear the sound of the earth itself droning up through my bones. Then the sound becomes real—it's Marty, doubling back to find me.

He chops throttle, circles into a diving turn, levels out just above ground, and then touches down smoothly on the dry-grass meadow. His bird rolls right up next to mine. He pulls off his helmet, looks at me, then just grins.

"You look a mite green."

"Not all of us have cast iron stomachs," I groan.

"Need some water?"

"Thanks, just had an apple. I'll be all right."

He unclips his lap and shoulder harness, climbs out, and stretches out the kinks. Squatting on his haunches like an Indian scout, he looks out and down from our higher perch into the hazy valley beyond.

"Boy," he says finally, "some country." Overhead a red-tailed hawk makes a single, shrill cry. Marty looks up at it, raises his eyebrows in that typical expression of boyish surprise, and smiles.

"Looks like he agrees!" Marty loves hawks. They seem to love him too. Frequently during soaring flights, they sidle up to park off his wingtip, holding formation for long minutes.

Oak acorns were a primary nonmeat source of food for California's native tribes, such as the Hupa and Yurok of the North Coast, the Miwok of the western Sierra, and the Chumash of the Central and South Coast. For their Spanish, Mexican, and American conquerors, oaks provided fuel, tools, and building materials for homes and furniture, wagons and wheels.

The historical drama of the Gold Rush gets higher billing than the concurrent devastation of oak lands throughout the state. In 1835, when Richard Henry Dana, author of *Two Years Before the Mast,* collected oak firewood from 760-acre Wood Island within San Francisco Bay, he noted that the island was densely populated by species *Quercus,* right down to the water's edge. Twenty-five years later, the island was completely bare of oaks and had been given an ironic name, considering all the trees that now lived only in memory: Angel Island.

Today, grape growers in Napa and Sonoma Counties face the well-mobilized political wrath of environmental groups when they cut down surviving oaks to plant more vineyards. Some enlightened growers make a point of planting around the oaks, modeling a posture of conservationist sensitivity.

But enough oaks survive and thrive throughout the state to endure as an iconic staple of the pastoral landscape. In the woolly comfort they lay upon the open land, we have an ongoing enticement to settle for a time into their generous shade and contemplate eternity, or simply enjoy the heady pleasures of wine, bread, cheese, and fruit, spread on a red-and-white-checked picnic tablecloth.

The last thing you expect while flying at fifteen hundred feet is the sweet, pungent redolence of green onions.

My stomach is back where it belongs, and Marty's taken the lead as we skylark across the agricultural cornucopia of California. The grand checkerboard of Central Valley farmland below stretches to all four horizons, brought up most dramatically in the east by a hazy massif: the mighty Sierra.

This is our first big ultralight trip, 150 miles in all. At forty miles per hour, that's a half-day adventure. Ultralights are recent evolutions of hang gliders, little more than aluminum-tube-and-sailcloth airplanes with rear-mounted snowmobile engines swinging big pusher propellers. Strapped into our fabric seats out in front of all the hardware, nothing blocks the wind, the view, the detritus of the air— bugs, dust, leaves—or these heady ground-born smells, delivered aloft by sun-warmed thermal air bubbles.

I breathe in the surprisingly sensual bouquet of the green onions, flushed with elation: to wing with the ease of birds across this patchwork womb of plenty. To be blessed with such freedom. What more can we ask of life?

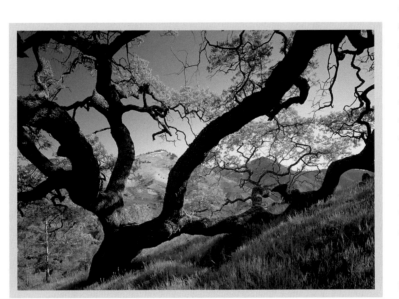

Imagine for a second that we're back in our magical glider and can see all of California below us, stretching seven hundred miles from north to south. Running along the eastern length of the state, the Sierra looks like a sinuous, curving human spine. So regarded, California the body looks west, with the area from heart to loins filled by a vast torso: the great Central Valley, agricultural mother lode of America.

The Central Valley is the most singular, homogeneous example of the state's open lands. Once upon a time, just a few decades ago, writes Marc Reisner in *Cadillac Desert*, "traversed by the miners on the way to the mother lode was an American Serengeti—a blond grassland in the summertime, a vast flourishing marsh during the winter and spring. The wildlife, even after a century and a half of Spanish settlement, was unbelievable: millions of wintering ducks, geese and cranes, at least a million antelope and tule elk, thousands of grizzly bears."

Because the Central Valley was once a swamp during a distant prehistoric age, it is today so flat you are hard pressed to find any sense of contour throughout much of its expanse. The Sacramento River flows from Lake Shasta in the mountainous north to the valley's broad Sacramento– San Joaquin Delta at midstate. From the southwestern slopes of the Sierra, the San Joaquin River flows northward into the same massive delta. There the two rivers join the waterways that run to San Francisco Bay.

Sacramento, the state's capital, thrives and grows at the northern end of the delta, just thirty miles from where the two rivers meet. The city also serves as a censorial demarcation: north of Sacramento, only one city, Redding, has more than seventy-five thousand people. The vast majority of California's thirty-three million inhabitants live in Sacramento and in the coastal cities arrayed like jewels from San Francisco to the Mexican border.

The climate of the Central Valley is similar to Egypt's: so hot in the summer that the trunks of fruit and nut trees are often painted white to protect them from sunburn. Yet although summer temperatures above 100 degrees Fahrenheit are common, frequent cooler nights relieve the oppression of the noonday sun.

Half an hour later, we're screaming along right on "the deck," mere feet above ground. We play steeplechase with farmhouses, utility lines, haystacks, and tall, lonely rows of eucalyptus. Set free from the grid-work of roads, our southeast course makes a diagonal transit of one field after another. Sheer rectilinear anarchy, and it's delicious.

"Zoomies" are the best part. When trees, buildings, or power poles loom, up and over and down the other side we go, in a stomach-floating parabola. What a rush!

Green and golden grasses, marshy wetlands, and millions of acres of wildflowers once covered the Central Valley. Beginning in earnest during the Gold Rush, drawing on the abundant wealth of water from its delta, California's agricultural industry eventually outstripped in yearly revenue even the heady bounty of mined gold. Today, more than five hundred thousand acres of rice alone are grown here every year—enough of a bumper crop that one hundred million dollars' worth was sent to Japan recently to alleviate a crop failure. And that's just one handful from the valley's golden horn of plenty.

Two-thirds of the Central Valley's water naturally occurs in its northern part, yet most of its richest tillable loam is in the lower regions, where the majority of crops are grown. In response, civil engineers, over a span of 150 years, engaged in a colossal series of dam- and aqueduct-construction projects that would send the water to fast-growing agricultural and population centers where it was most needed. A major tragedy to conservationists like John Muir was the dam that drowned the glorious Hetch Hetchy Valley, just north of Yosemite Valley, in 1934. Although the reservoir it created still supplies water to San Francisco, so long and bitter was the fight over the Hetch Hetchy's demise that studies are under way today

◄ A PROFUSION OF CALIFORNIA POPPIES BLOOMS IN THE DICK SMITH WILDERNESS.

▲ A LARGE VALLEY OAK FRAMES ZACA PEAK IN LOS PADRES NATIONAL FOREST.

considering the feasibility of emptying Hetch Hetchy and restoring, in time, its pristine magnificence.

In the century since, the cement furrows of the California, All American, Los Angeles, and Colorado River Aqueducts were laid down to collect the life-giving coastal, northern, and Sierra mountain runoff and send it to distant crops in the Central and Imperial Valleys, and to quench the thirst of Los Angeles's exploding twentieth-century population.

Soil runoff from the Coast Range, which forms the Central Valley's western wall, brings a gold mine's wealth of earth rich in nine of the world's ten soil groups. Thus a bonanza of produce—plums, oranges, avocados, grapes, strawberries, peaches, tomatoes, lettuce, barley, almonds, broccoli, walnuts, sugar beets, and potatoes—as well as cotton, flowers, nursery products, and hay.

Thanks to the ideal growing conditions and rich land of the northern and central coasts, winemaking, first begun in California in 1697, has become yet another growth industry. Wines from the Golden State rival and often surpass many traditional European offerings in quality and reputation.

Less than a hundred years ago no human had ever flown a heavier-than-air machine. Now, racing alongside the Flying Flea in a contraption that evokes the Wright brothers' airplanes, I'm thanking the sky gods for this gift of wings.

We fly as if linked by a golden cord. Ground-skimming across a vast field of blurring corn, we zoomie over a road-lining stand of cypress, then make a sharp, climbing bank to chase a flight of crows. They scatter, and we dive back on course, punching through a cloud of dust from a yellow tractor. The farmer looks up, gawking . . . then grins and waves. It's like the barnstorming days of the 1920s all over again.

Up and over a stand of eucalyptus, now a dash across what looks like a radish field, and so it goes. Suddenly, I'm Spencer Tracy piloting a B-25 in the movie 30 Seconds Over Tokyo, *wave-hopping the 1942 Pacific all the way to Japan.*

A high-bank, tight turn to skirt a big oak at the back corner of a white farmhouse brings a sudden tableau into view, gone almost before it registers: a dark green pickup and two figures at the back of the truck. Mind snapshot: the wide-eyed faces of a young farmhand and his comely sweetheart, rudely shocked by the sudden roar of our flight through the middle of their connubial tailgate party.

I laugh out loud, wondering if Marty saw it.

Ambling through these safe havens, you find a rich diversity of wildlife and mild weather. In the southwest corner of the Central Valley, running along the infamous, earthquake-producing San Andreas Fault, lies the Carrizo Plain Natural Area. Reclaimed from the profuse grid of vast agricultural combines and surviving small farms that mark the rest of the valley, the preserve is an attempt to restore 180,000 acres of the valley's original ecosystem. The Carrizo Plain serves as a serene

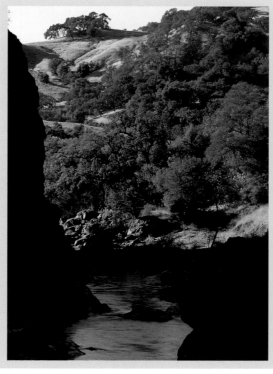

reminder of how much the landscape has changed in only 150 years—and how preservation of wild areas can help us rekindle our spiritual connection to the earth.

I'm in trouble. The sky color has ebbed from cobalt to an impenetrable charcoal. I can't see Marty's ship, and that's too spooky—any second I could crash right into him without warning. As it is, I can barely make out the big power lines crisscrossing dark gray fields below. Definitely time to land.

Throttle back. There, that gray smudge of dirt field below. I spiral down, level out five feet off the deck, line up with the plowed rows of earth, chop the power, and bounce roughly to a stop. Whew. Thank the Maker.

Twenty minutes later, lying on top of the sleeping bag pulled from inside the zippered fabric wing, I survey this hushed sanctuary. My safe harbor is protected on all four sides by tall, distant shadow-walls of what look like slender poplars.

I hope Marty made it down okay.

A crunchy granola bar and some water are my only fare, but I'm content. Under the wing's gossamer moonshadow, ears alert for threatening sounds and mosquitoes, heavy warm air is all the comforter I need as the dun furrows release the heat of day. Life has never felt so immediate, nor earth so sacred. This is what aviators knew at the dawn of flight—the joy of simple freedom, wrapped in the abiding mystery of the great out-of-doors.

Wildflowers explode all over the hillsides near the Carrizo Plain. Once, pronghorn antelope, tule elk, gray wolves, and grizzly bears roamed those hills too. The grizzlies and wolves are extinct throughout California now, but pronghorns and tule elk have been reintroduced to the Carrizo area and are thriving, along with populations of kitfox, squirrel, kangaroo rat, and the blunt-nosed leopard lizard.

Pesky tumbleweed remains. Although not a native plant—it came here as stowaway seeds trapped in the short-hair hides of Mediterranean cattle—the Wild West wouldn't seem right without its rolling icon of desolation.

Within the Carrizo Plain lies a valuable natural resource for migrating birds: thirty-three-mile-long Soda Lake. The alkaline lake has a seasonal life, with foot-thick alkaline salts left behind when the water evaporates in times of severe drought. The water returns every winter, surrounded by a garland of wildflower fields in the spring, only to disappear again by August.

Similar wetlands along the Pacific Flyway, which arcs from Alaska to Mexico, from the Pacific Coast to the Rocky Mountains, are vital for sustaining massive yearly waterfowl migrations. A sobering note: one-third of all endangered species live in or use America's wetlands, half of which have disappeared in only two hundred years of encroaching civilization. Five million wetland acres have been eliminated in

California alone since 1850. Since the state's wetlands winter 60 percent of the migrating ducks and geese in the Flyway (20 percent of all U.S. waterfowl), fewer wetlands mean fewer surviving bird populations.

Another sign of California's growing sensitivity to and respect for its primitive history is the Carrizo Panel. The ninety-foot rock wall profusely decorated with pictographs and pictograms marks a two-thousand-year-old native spiritual center. Groups of Chumash Indians paid homage to their gods and the changing of the seasons here. Protected within the Carrizo Plain, it remains a holy place for modern Native Americans and a place for contemplation for all spiritually sensitive people. It reminds us that within ritual, we can renew and celebrate our respectful relationship with all the world's cultures.

In the morning, blasting up through five hundred feet of altitude, I spot Marty's ultralight, parked under an oak in the very next field to mine! Time for some fun. I cut the engine to a quiet idle and push forward in a high-speed dive straight for his encampment, hoping he won't hear the sound of my flight until it's too late.

Six feet above the deck I level out, closer . . . closer . . . Now! and I give her the gas. RRRAAAAANNNNNGGGG! screams the engine. Marty jerks bolt upright out of a dead sleep, eyes big as pancakes. I let out a howl of glee like a moonstruck coyote, chop the power, and land.

As I walk up to his cozy encampment, Marty throws me one of those sheepish "Okay, you got me" looks. Good old Marty, never blows his stack about anything.

We swap details of last night's scary landings; then he asks me, "Hey, did you see the two in the pickup?"

"You bet!"

Belly laughs. Life is good.

Life remains good throughout California's grasslands, high meadows, rich farmlands, and country byways that lie waiting along its highways and two-lane roads. Tulelake, the northernmost town in the state, is an island valley surrounded by mountains. The high plain of marshes and agricultural valleys is home to just a thousand people, yet still serves as an icon for Down Home California with its many 4H Clubs, livestock shows, line-dancing weekends, and Sunday quilting bees.

Jump seven hundred miles south to border town Calexico, California, and you might as well have warped to another planet. Calexico anchors the Imperial Valley, a vast five-hundred-thousand-acre sprawl of lush green crop land sprung full blown from the Colorado Desert thanks to aqueduct-transported water. Calexico endures 115-degree summer days to harvest one of the richest agricultural regions in the world.

Both add their hues to the tapestry that is oak and grassland California. These gentler lands provide a perfect setting for quiet communions with nature or a repatriation to the enduring family values of hearth and home. In the choral voice of California's sturdy oaks and yielding grasses, sensuous hills and placid marshes, powder-blue skies and summer rainstorms, Earth sings a beguiling song of welcome.

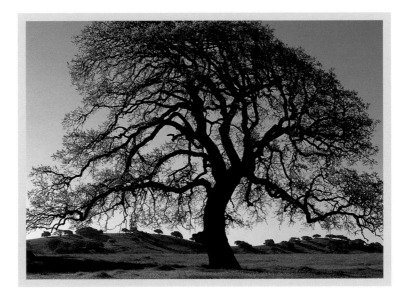

◄ THE RUSSIAN RIVER FLOWS THROUGH ALEXANDER VALLEY.

▲ A SCULPTED OAK STANDS ALONE IN THE MEADOW OF PICACHO PASS.

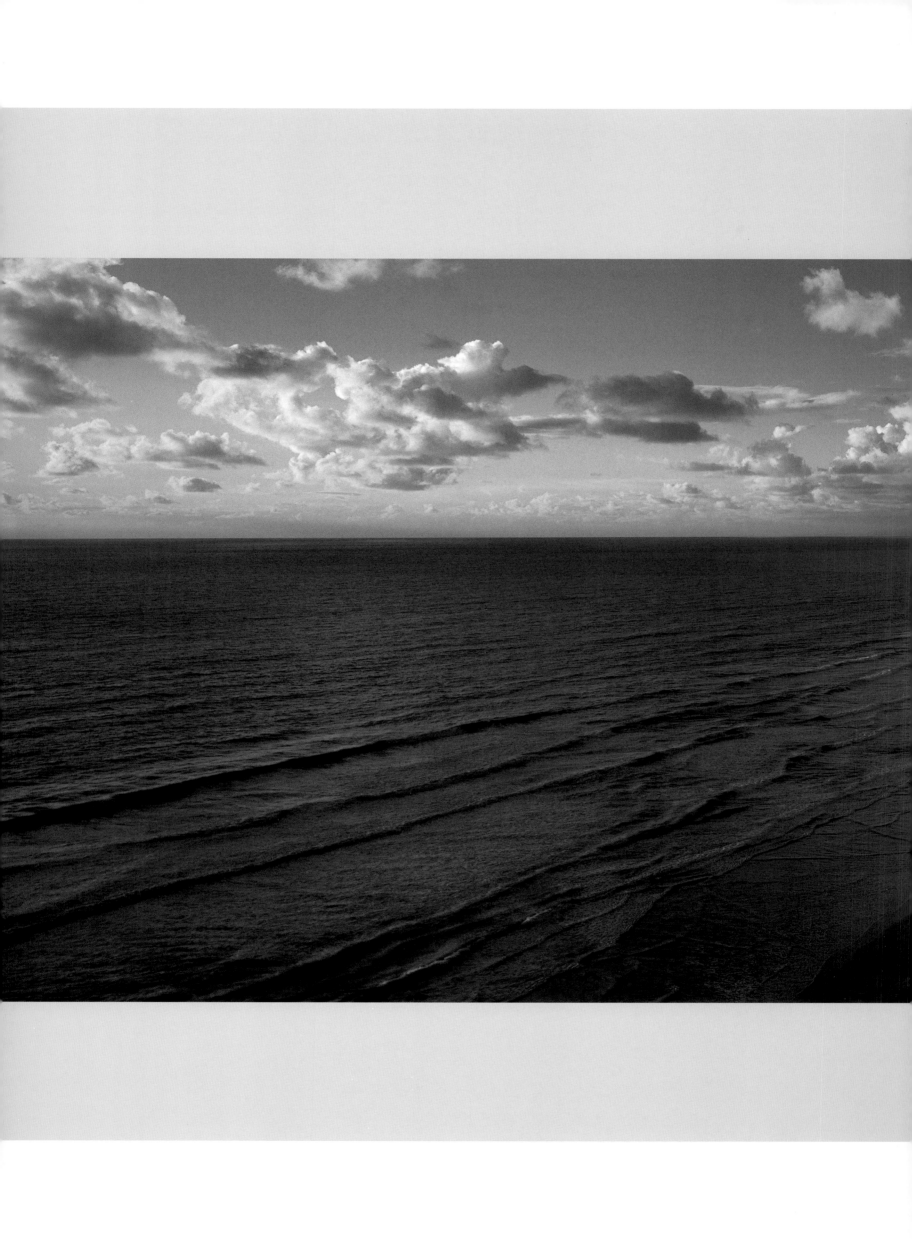

C O A S T

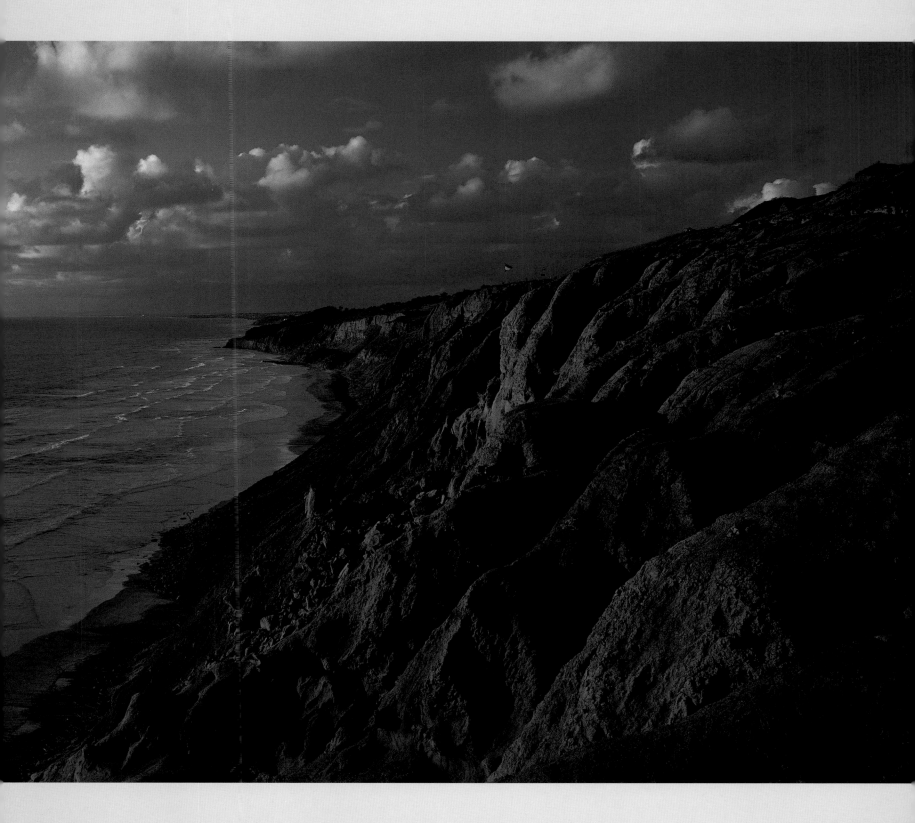

EVENING CUMULUS CLOUDS SAIL THE CHILLY SPRING SKIES ALONG THIS FAVORITE
SAN DIEGO AREA SOARING SITE, TORREY PINES STATE PARK.

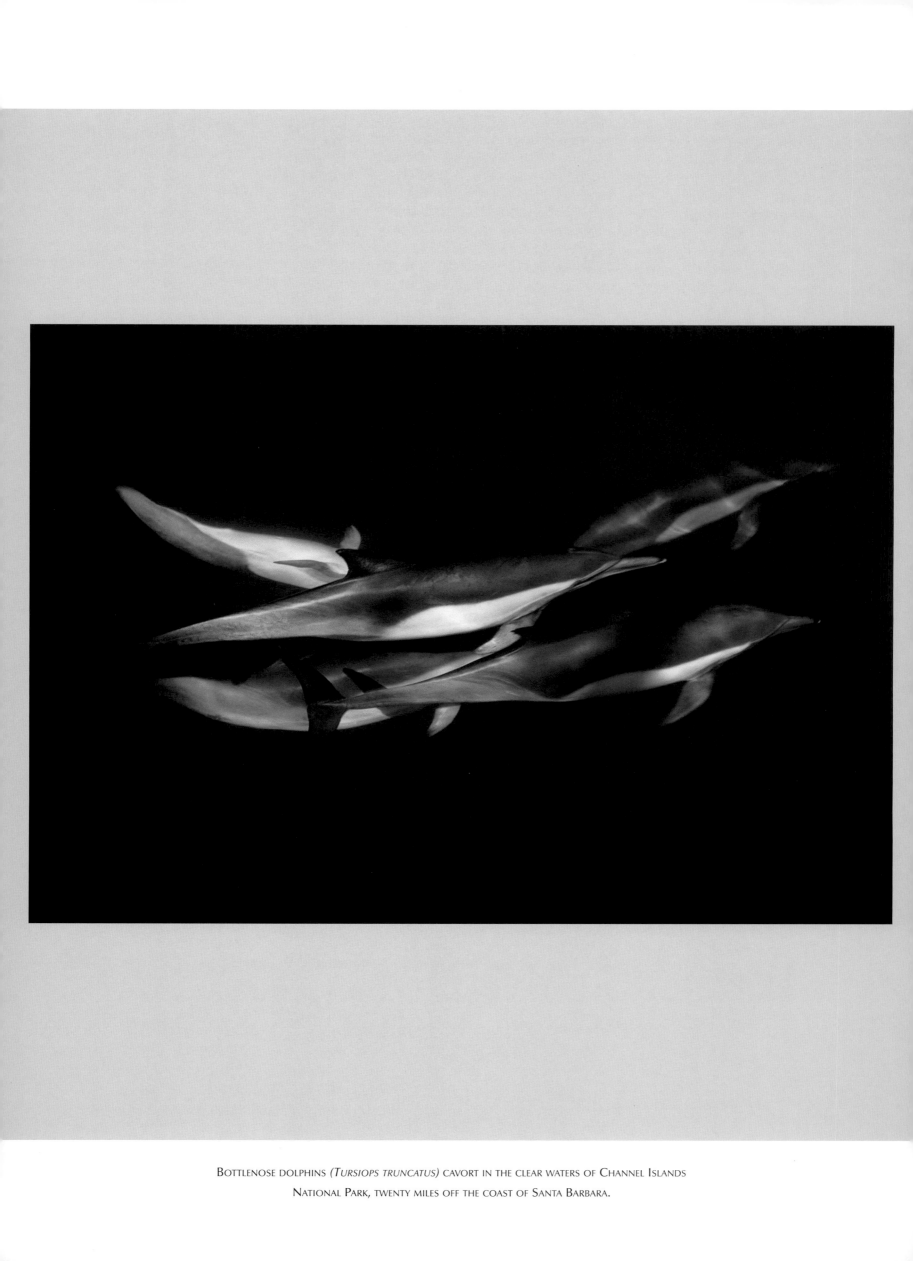

Bottlenose dolphins *(Tursiops truncatus)* cavort in the clear waters of Channel Islands National Park, twenty miles off the coast of Santa Barbara.

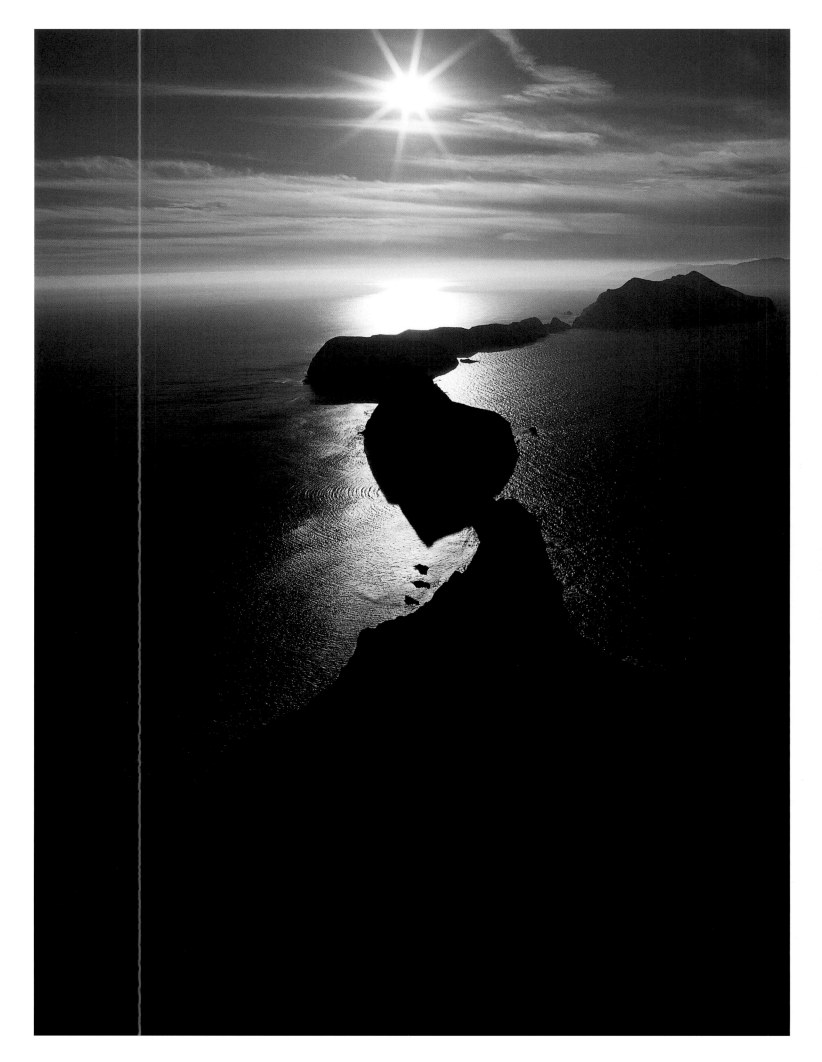

SUNDOWN SHADOWS LINK THE EASTERNMOST ISLANDS OF THE PRISTINE CHANNEL ISLANDS CHAIN,
OFF THE SANTA BARBARA COAST. LOOKING WEST, ANACAPA ISLAND IS IN THE FOREGROUND,
WITH SANTA CRUZ ISLAND IN THE DISTANCE.

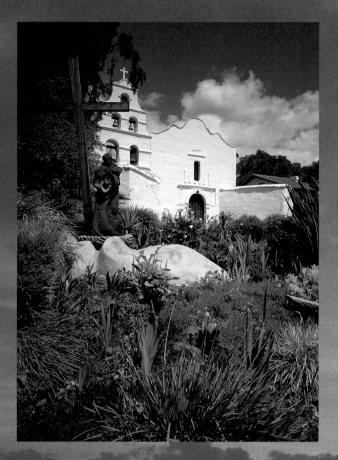

MISSION SAN DIEGO DE ALCALA WAS FOUNDED BY SPANISH MISSIONARY FATHER JUNÍPERO SERRA IN 1769. IT WAS THE FIRST OF CALIFORNIA'S TWENTY-ONE CATHOLIC MISSIONS.

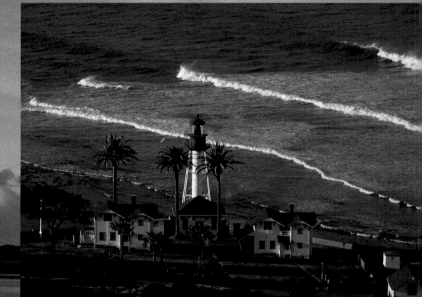

SAN DIEGO'S ORIGINAL POINT LOMA LIGHTHOUSE, BUILT IN 1854, WAS ONE OF THE FIRST EIGHT LIGHTHOUSES ON THE PACIFIC COAST. IT WAS REPLACED IN 1891 BY THIS SKELETAL TOWER CONSTRUCTED NEAR SEA LEVEL.

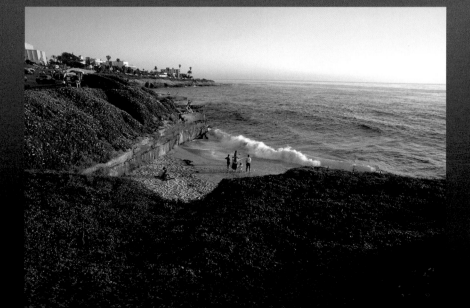

A FAMILY GATHERS AT THE LA JOLLA BEACH SHORE FOR A LAST GLIMPSE

ON SEPTEMBER 28, 1542, SPANISH ADVENTURER
JUAN RODRIGUEZ CABRILLO LANDED AT SAN DIEGO BAY
TO BEGIN HIS EXPLORATION OF THE WEST COAST.
THIS MONUMENT COMMEMORATES THE EVENT
AT CABRILLO NATIONAL MONUMENT.

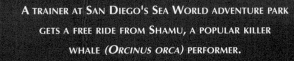

A TRAINER AT SAN DIEGO'S SEA WORLD ADVENTURE PARK
GETS A FREE RIDE FROM SHAMU, A POPULAR KILLER
WHALE (ORCINUS ORCA) PERFORMER.

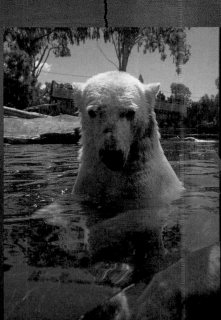

SPECIES HOMO SAPIENS (KID SIZE) GOES EYE TO EYE WITH URSUS MARITIMUS
AT THE SAN DIEGO ZOO.

BACKGROUND: ENCHANTING MORRO BAY LIES JUST A FEW MILES WEST OF THE
MISSION TOWN SAN LUIS OBISPO ON THE CENTRAL COAST.

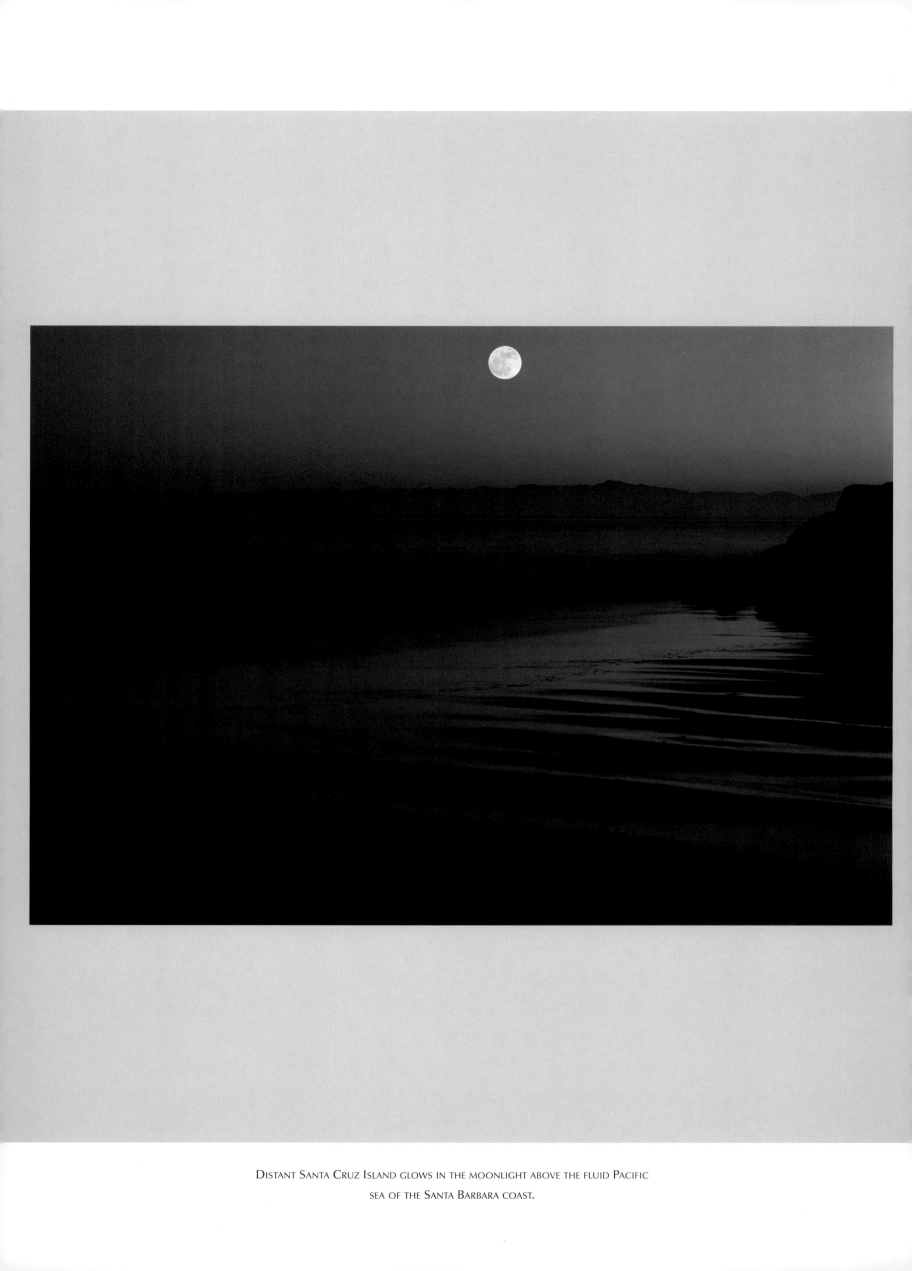

DISTANT SANTA CRUZ ISLAND GLOWS IN THE MOONLIGHT ABOVE THE FLUID PACIFIC
SEA OF THE SANTA BARBARA COAST.

THIS VIEW OF THE J. PAUL GETTY MUSEUM IS SEEN FROM THE COURTYARD, AT THE
GETTY CENTER IN LOS ANGELES.

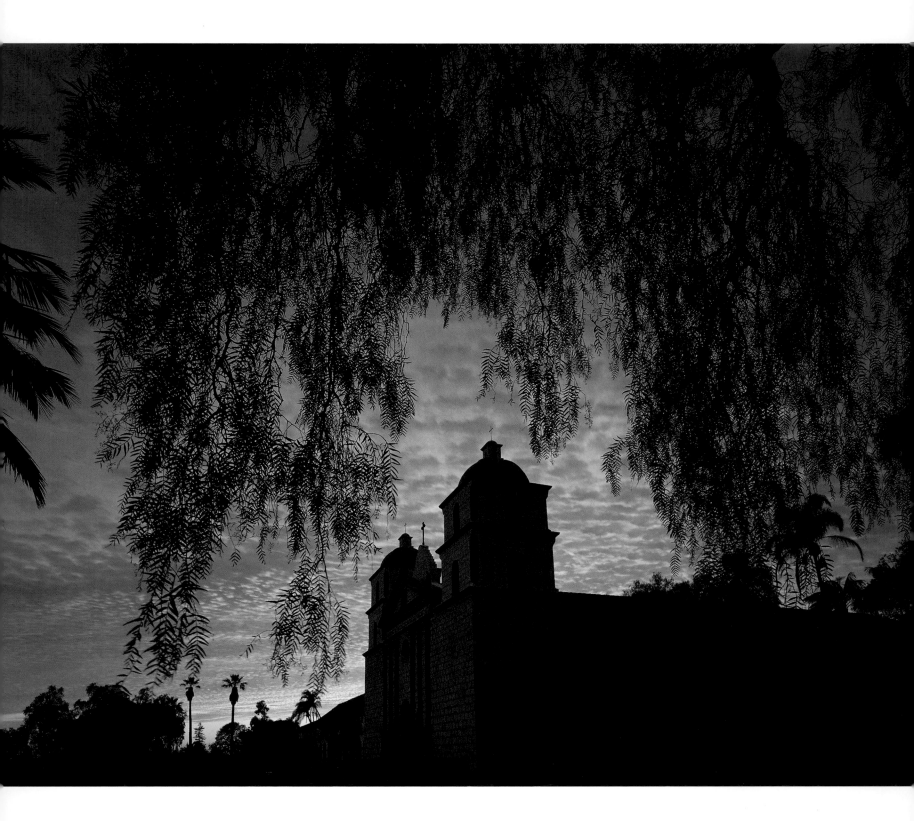

BENEATH A BENEVOLENT TREE CANOPY AND A SHELTERING SUNSET SKY,
MISSION SANTA BARBARA, BUILT IN 1782 BUT DAMAGED IN SIX MAJOR EARTHQUAKES SINCE,
STANDS PROUDLY RENOVATED AND OPERATIONAL TODAY.

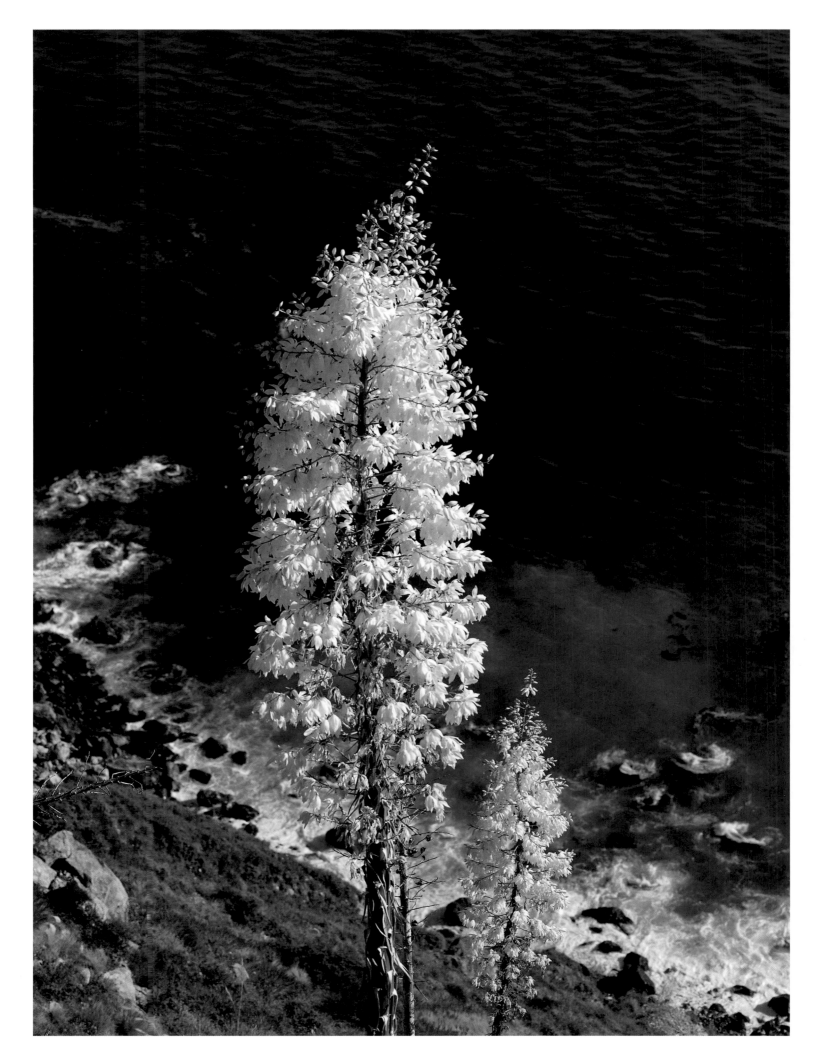

WHIPPLE YUCCA *(YUCCA WHIPPLEI)*, WITH ITS TEN-FOOT STALKS AND BELL-SHAPED BLOSSOMS,
ADDS A WARM CONTRAST TO THE BLUE PACIFIC, ALONG THE BIG SUR COAST.

A FAMILIAR SIGHT FOR SOUTHERN CALIFORNIANS IS THE UBIQUITOUS PALM TREE, SEEN IN VARIOUS

FORMS SILHOUETTED BY A SANTA CRUZ ISLAND SUNSET OVER THE SANTA BARBARA CHANNEL.

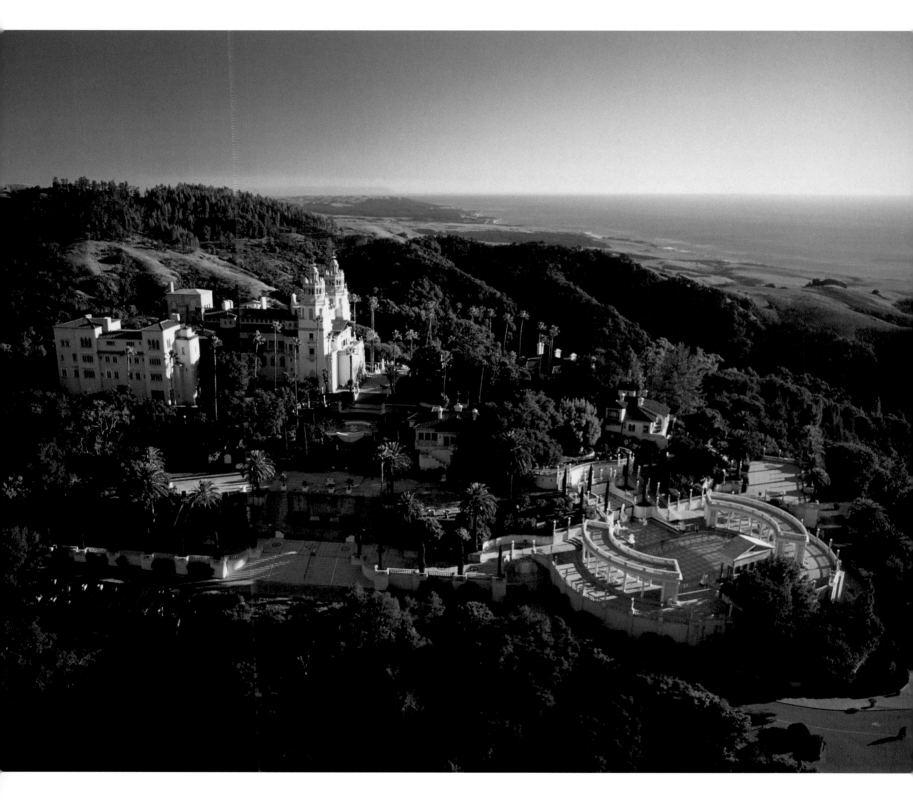

HEARST CASTLE, BUILT BY NEWSPAPER TYCOON WILLIAM RANDOLPH HEARST,

IS A 127-ACRE HILLTOP ESTATE OF GARDENS, TERRACES, POOLS, AND A 130-ROOM MANSION

COMPLETE WITH ART AND ANTIQUITIES FROM AROUND THE WORLD.

SEALS IN THE MONTEREY HARBOR CATCH THE
MORNING SUN RAYS.

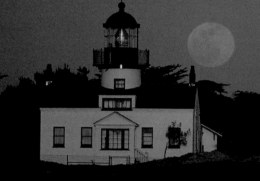

POINT PINOS LIGHTHOUSE, BUILT IN 1855, IS THE OLDEST
ACTIVE LIGHTHOUSE ON THE WEST COAST.

ORANGE SEA NETTLES SWIM AT THE MONTEREY BAY AQUARIUM.

GARIBALDI AND SEASTARS THRIVE OFF
CHANNEL ISLANDS NATIONAL PARK,
SANTA BARBARA ISLANDS.

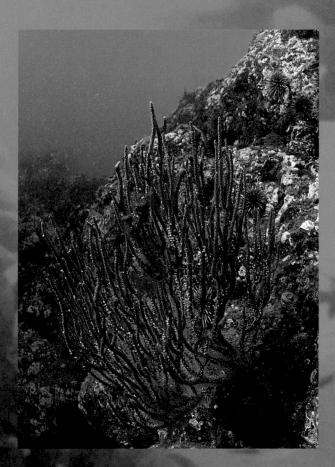

SOFT CORAL, SEA URCHINS, AND SEA SLUGS SHARE THE
ROCKY BOTTOMS ALONG ANACAPA ISLAND.

CHILDREN PLAY ALONG THE SURF AT GOLDEN GATE NATIONAL RECREATION AREA.

BACKGROUND: KELP REACHES TO THE SURFACE FROM SIXTY FEET BELOW
IN CHANNEL ISLANDS NATIONAL PARK.

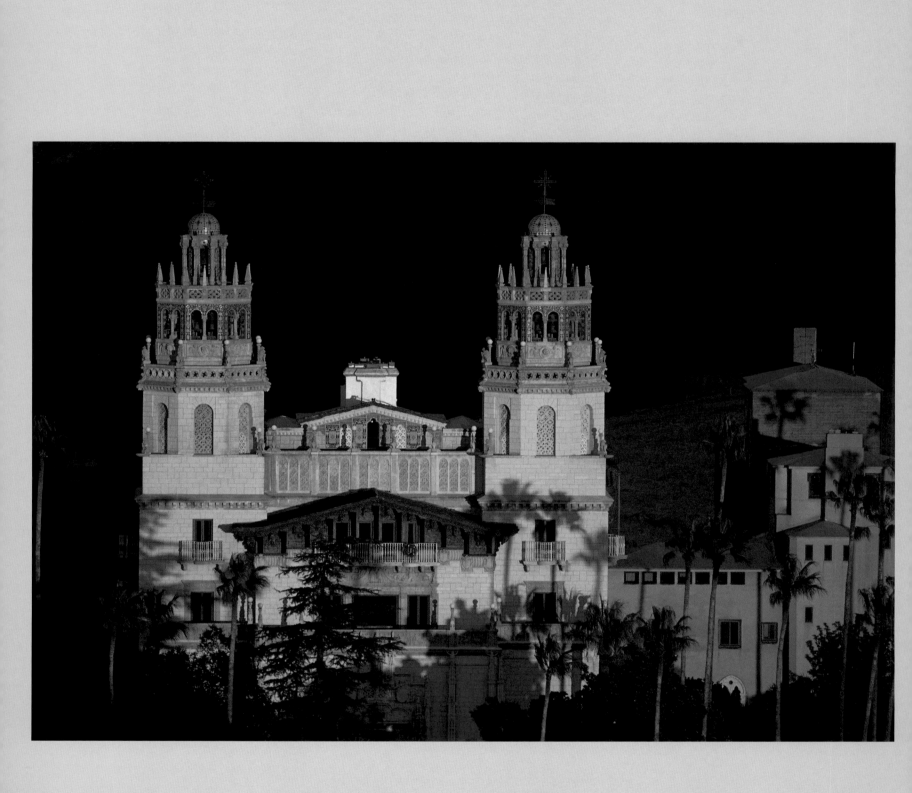

The twin colonnades of Hearst Castle's 137-foot-high Mediterranean revival mansion,
Casa Grande, were part of a massive project that took from 1922 to 1947 to complete.
It is the focal point of the San Simeon State Historical Monument.

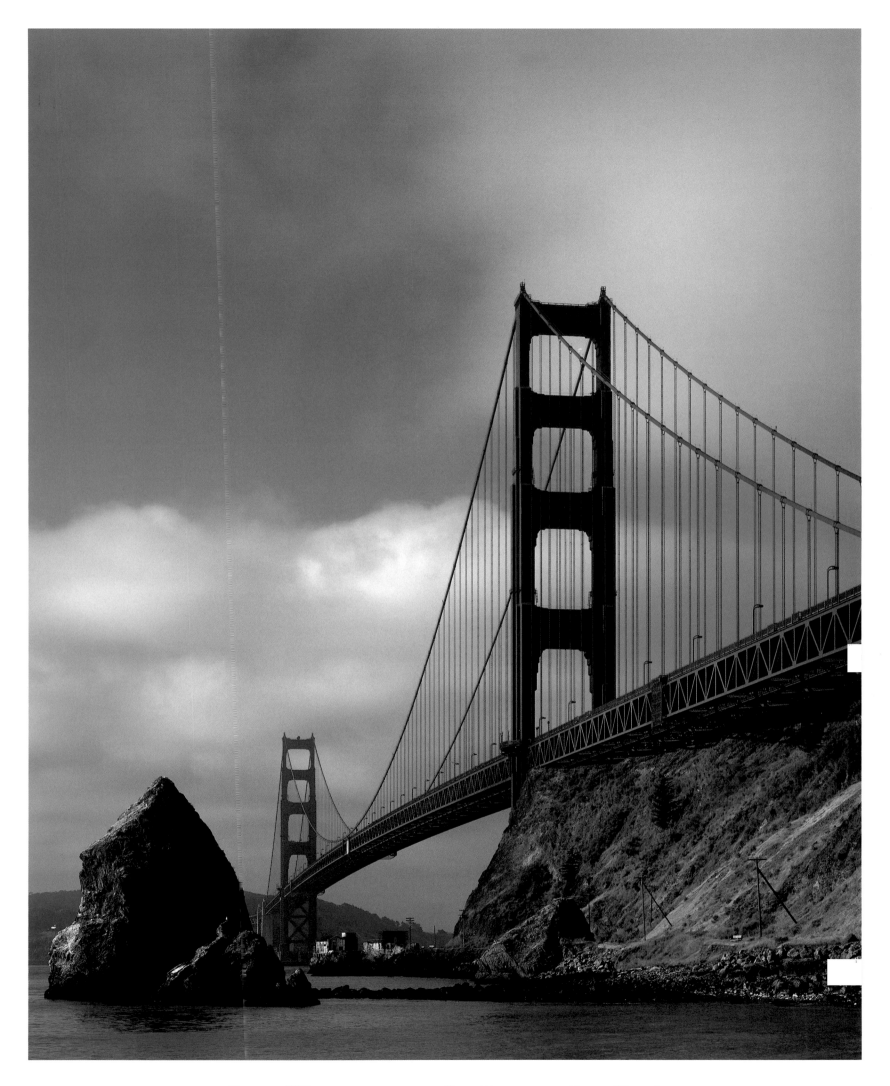

OPENED IN 1937 AND HAILED AS ONE OF THE "SEVEN WONDERS OF THE MODERN WORLD,"
THE GOLDEN GATE BRIDGE SPANS 4,600 FEET OF SAN FRANCISCO BAY.
ITS SUSPENSION TOWERS REACH 746 FEET, AND THE SEA CLEARANCE IS 220 FEET.

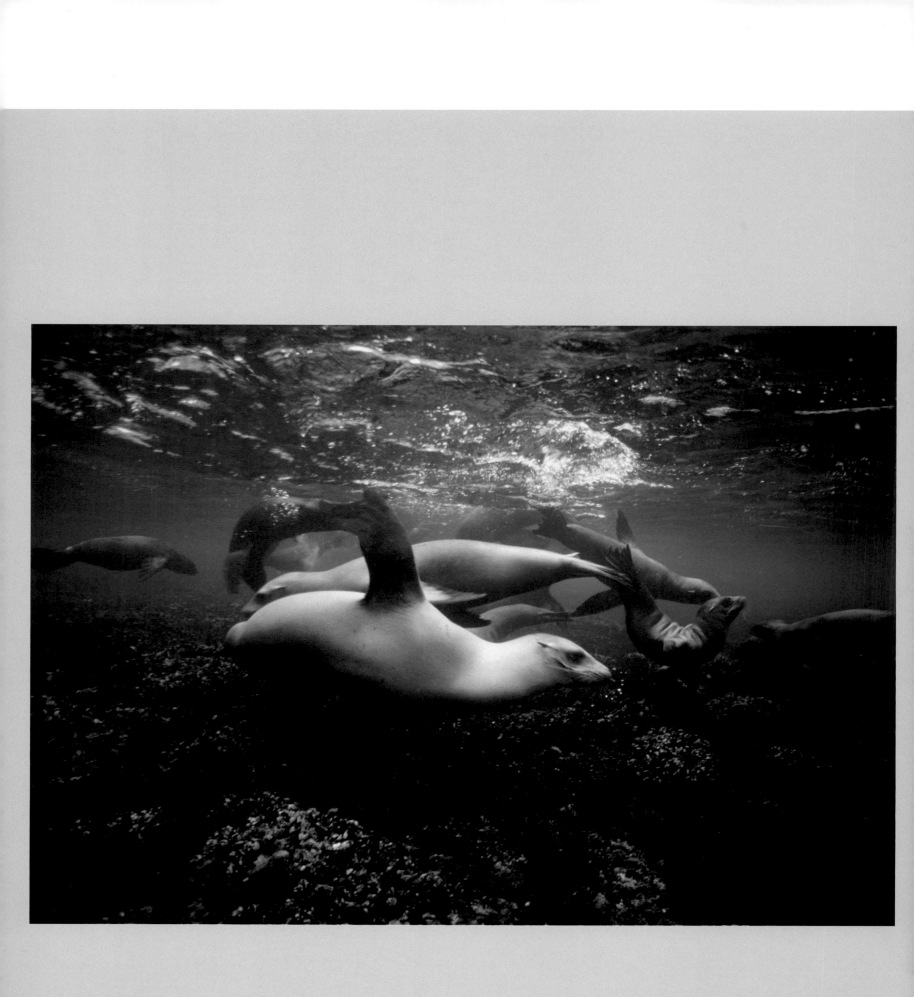

▲ A BABY SEA LION (*ZALOPHUS CALIFORNIANA*) GETS SWIMMING LESSONS BELOW THE ROOKERY
ON THE EAST END OF SANTA BARBARA ISLAND, CHANNEL ISLANDS NATIONAL PARK.
► THE TIMELESS MEETING GROUND OF PACIFIC WAVE SURGE AND COASTAL ROCK IS CAPTURED AT
SUNSET ALONG THE BIG SUR COAST HEADLANDS OF GARRAPATA STATE PARK.

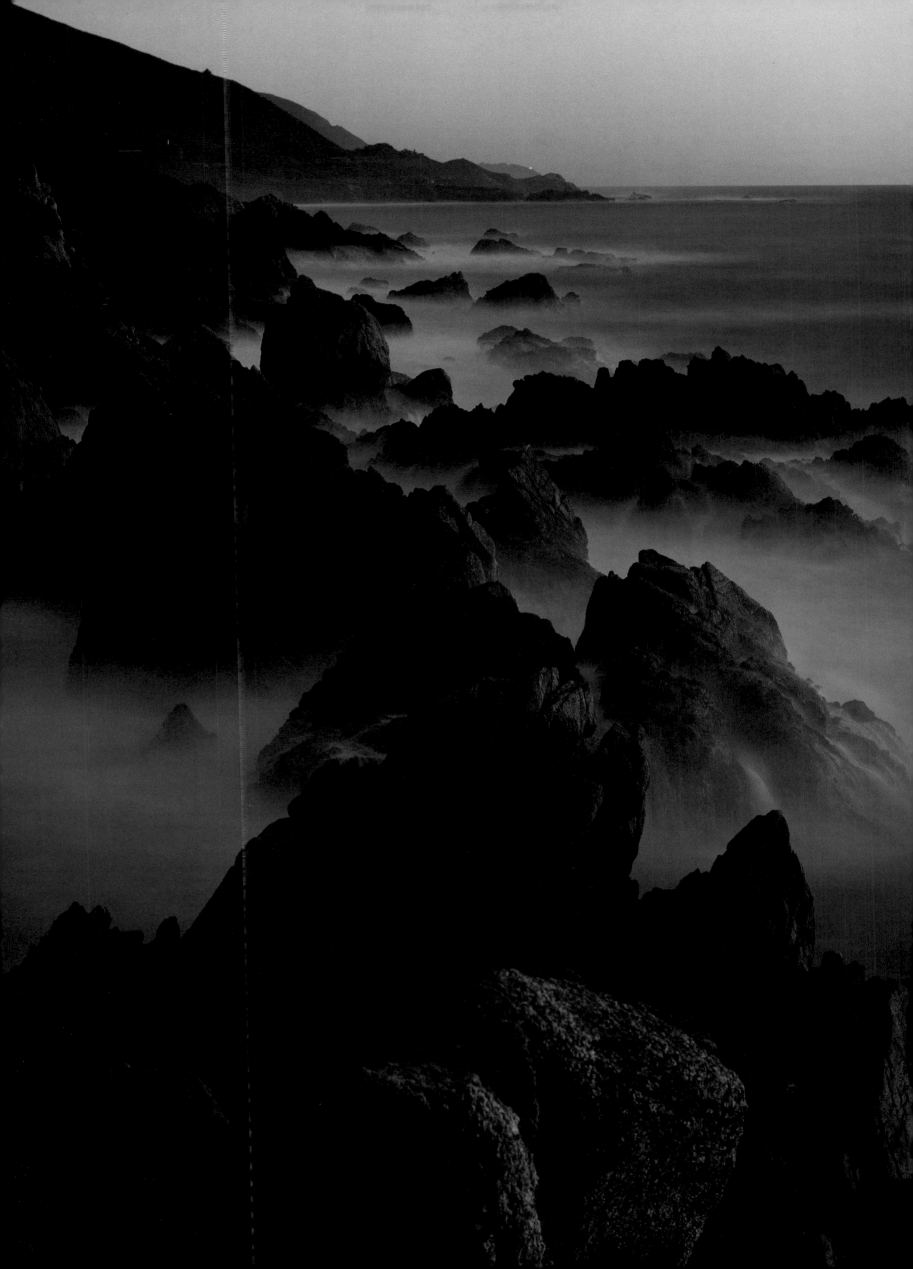

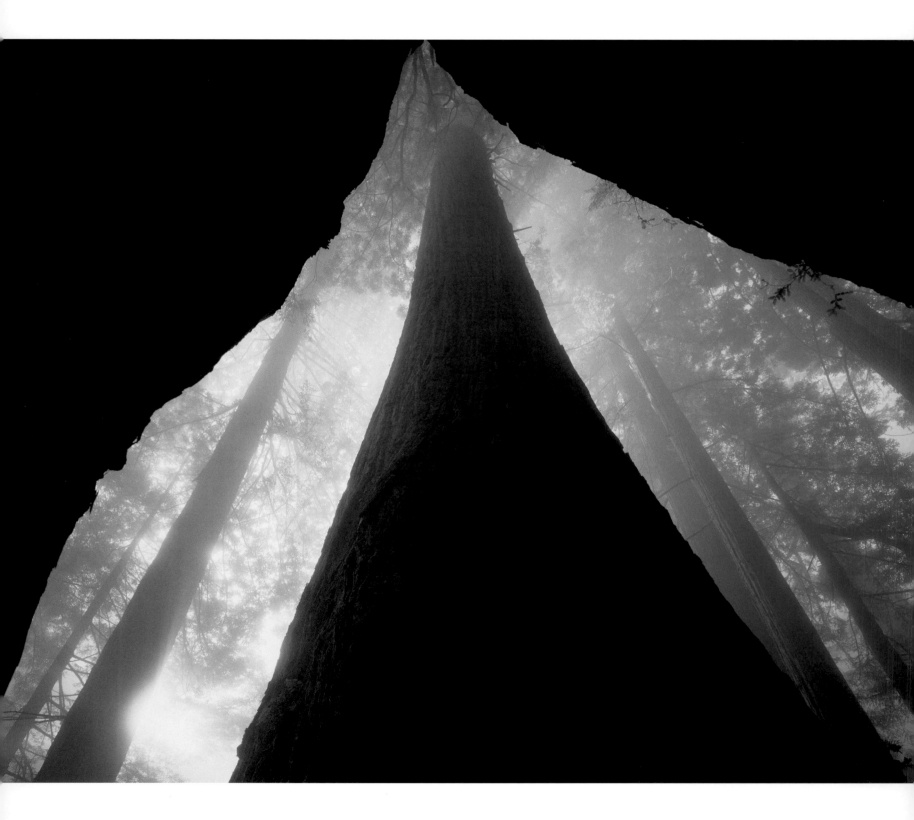

THE NEGATIVE SPACE CREATED BY THE TRUNKS OF TOWERING SEQUOIAS IS FILLED WITH A FOGGY
TRANSLUCENCE OF NEIGHBORING TREES IN THE DEL NORTE COAST REDWOODS STATE PARK,
AN INTEGRAL PART OF REDWOOD NATIONAL PARK NEAR CRESCENT CITY, ON THE NORTH COAST.

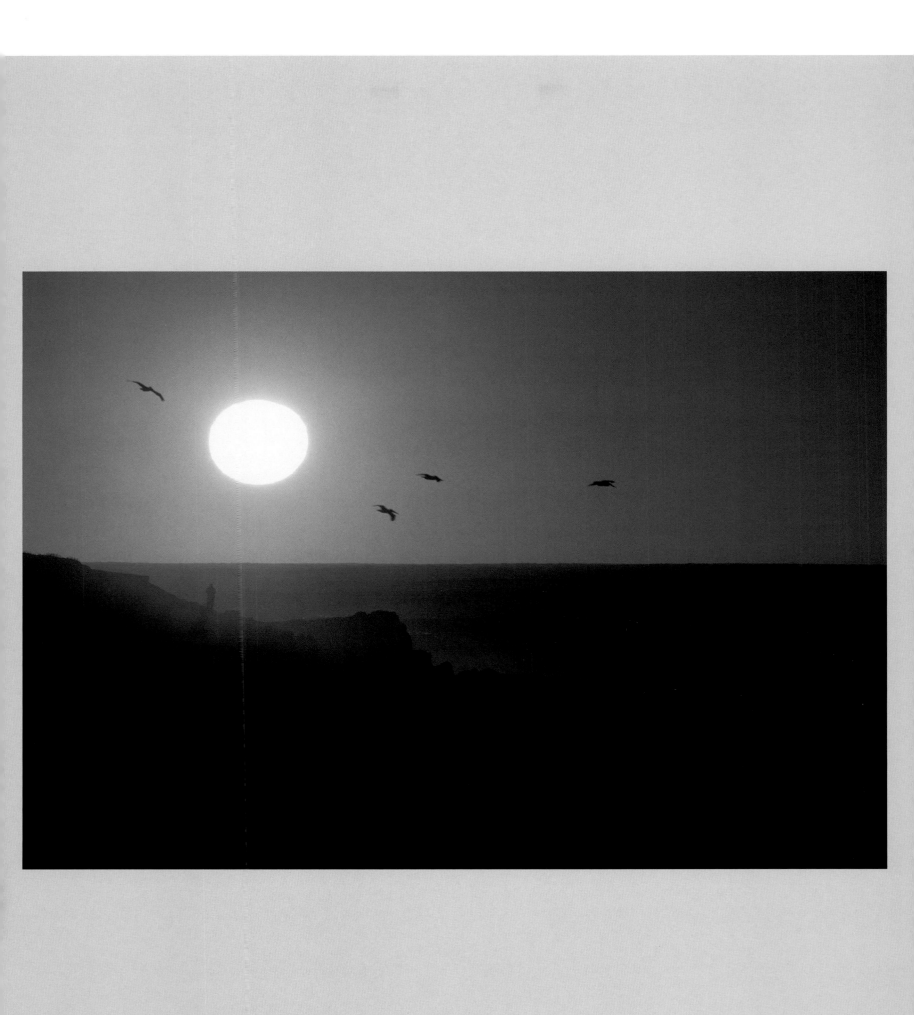

Sunset hues play across the rugged shores of Montaña de Oro (Mountain of Gold)
State Park near San Luis Obispo. The more than eight thousand acres of secluded sand beaches,
coastal plains, canyons, and hills include mountain biking and equestrian trails.

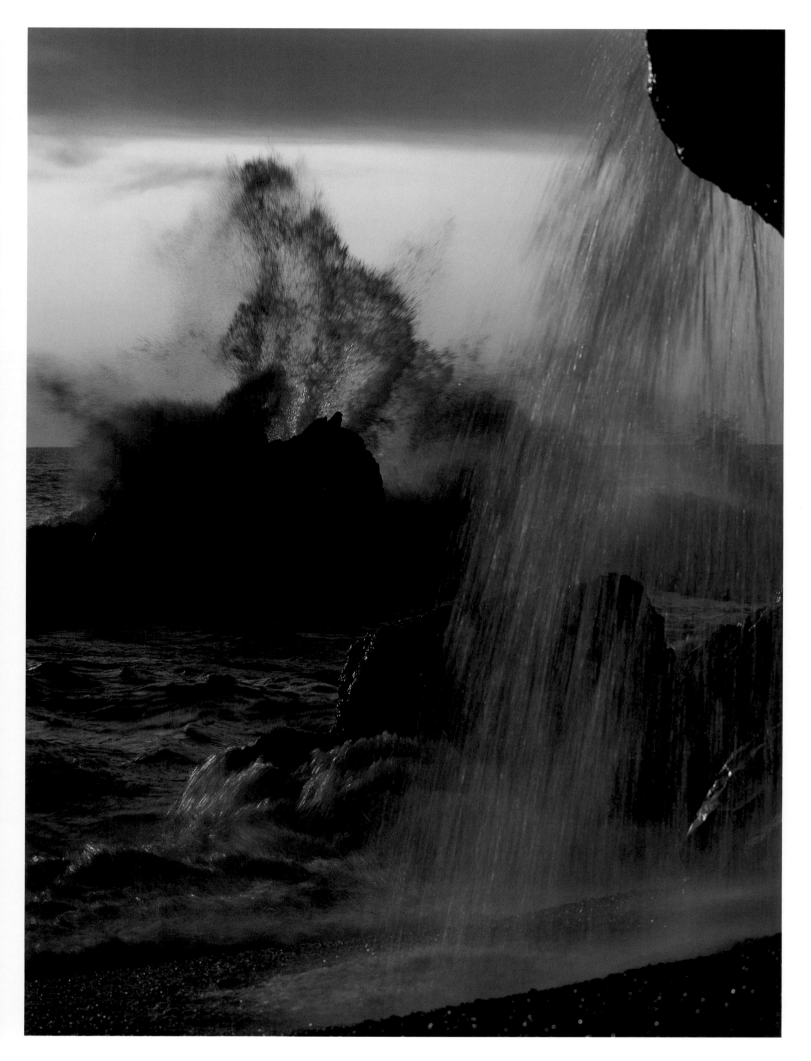

FRESHWATER STREAMS CASCADE FROM THE SLOPES OF THE SANTA LUCIA MOUNTAINS
ONTO THE WAVE-SCULPTED ROCKS OF BIG SUR'S PRECIPITOUS COAST.

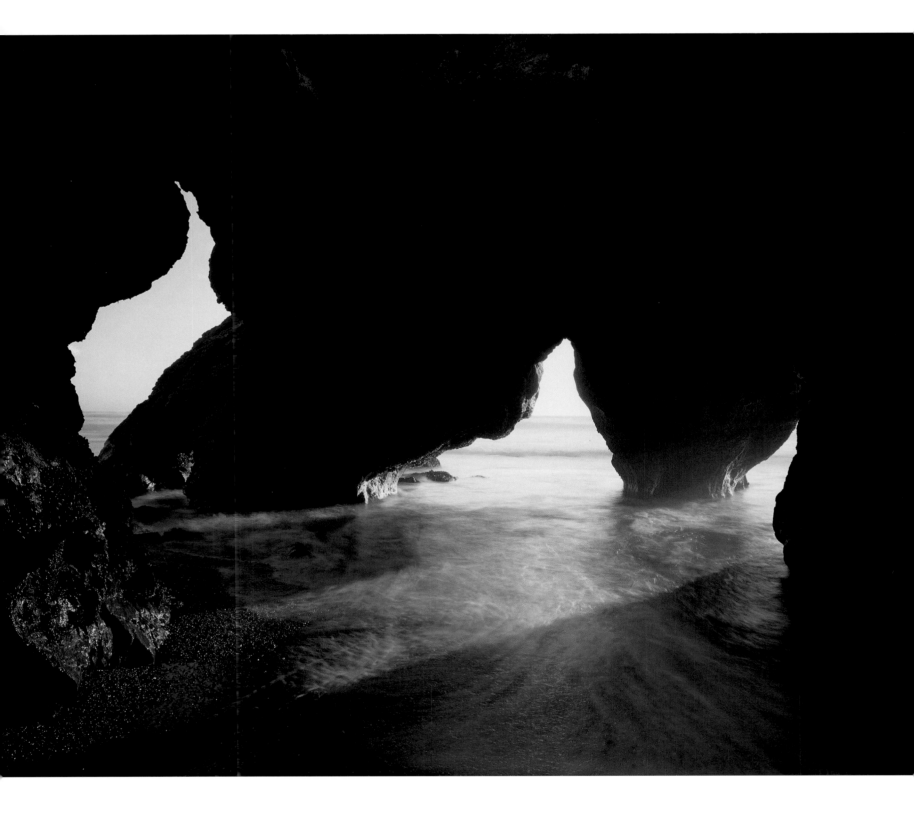

THESE OPENINGS AT NEEDLE ROCK ARE IN SINKYONE WILDERNESS STATE PARK, ALONG
THE LOST COAST AND KING RANGE, NORTHERN CALIFORNIA, AND HINT AT A WILD AND DIVERSE
TERRAIN OF FOREST, PRAIRIE, AND COASTAL BLUFFS WITH UNSPOILED BEACHES.

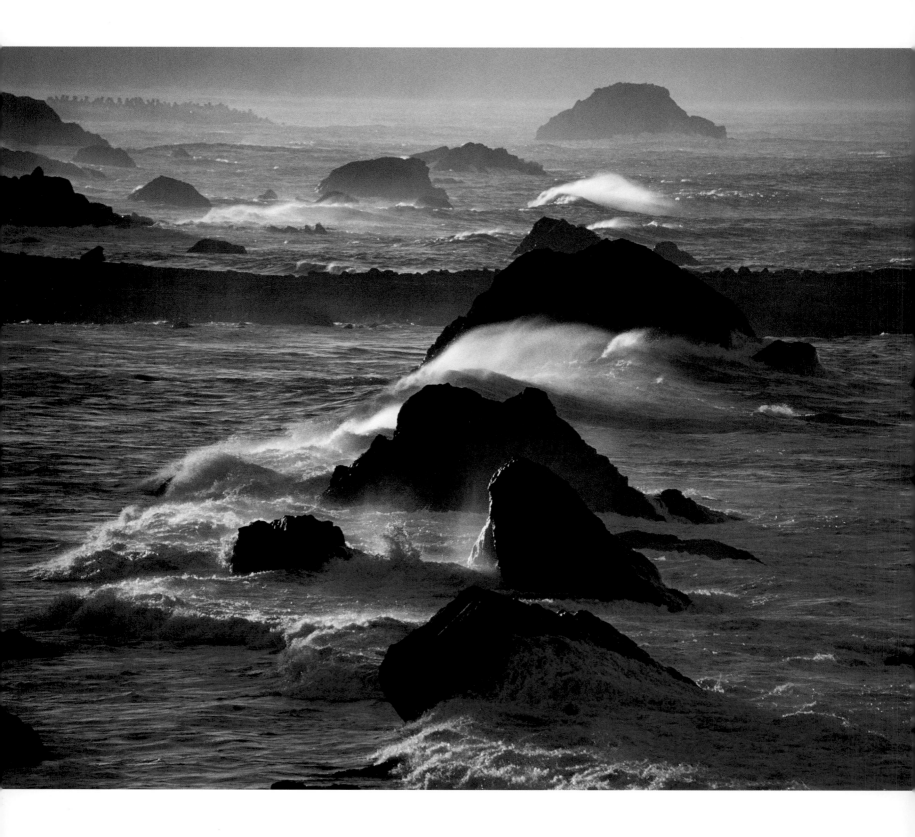

PACIFIC WAVES ARE HELD BACK BY A DOUBLE BARRIER OF ROCK AND OFFSHORE WINDS AT
BATTERY POINT IN CRESCENT CITY, ABOVE REDWOOD NATIONAL PARK.

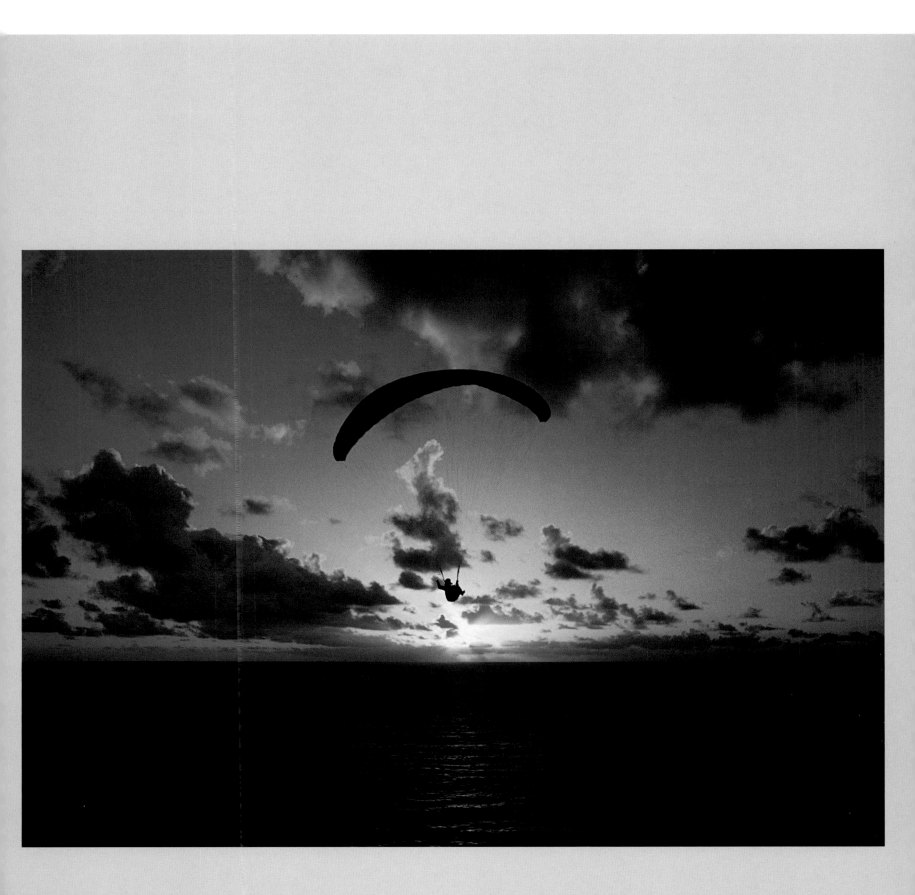

A LONE PARAGLIDER SOARS HIS COLLAPSIBLE "BAG" IN THE LAST UPRUSHING WINDS
OF A SUMMER DAY ALONG THE BLUFFS AT TORREY PINES "AIRPORT."
ONLY HANG GLIDERS AND PARAGLIDERS ARE ALLOWED TO FLY AT TORREY.

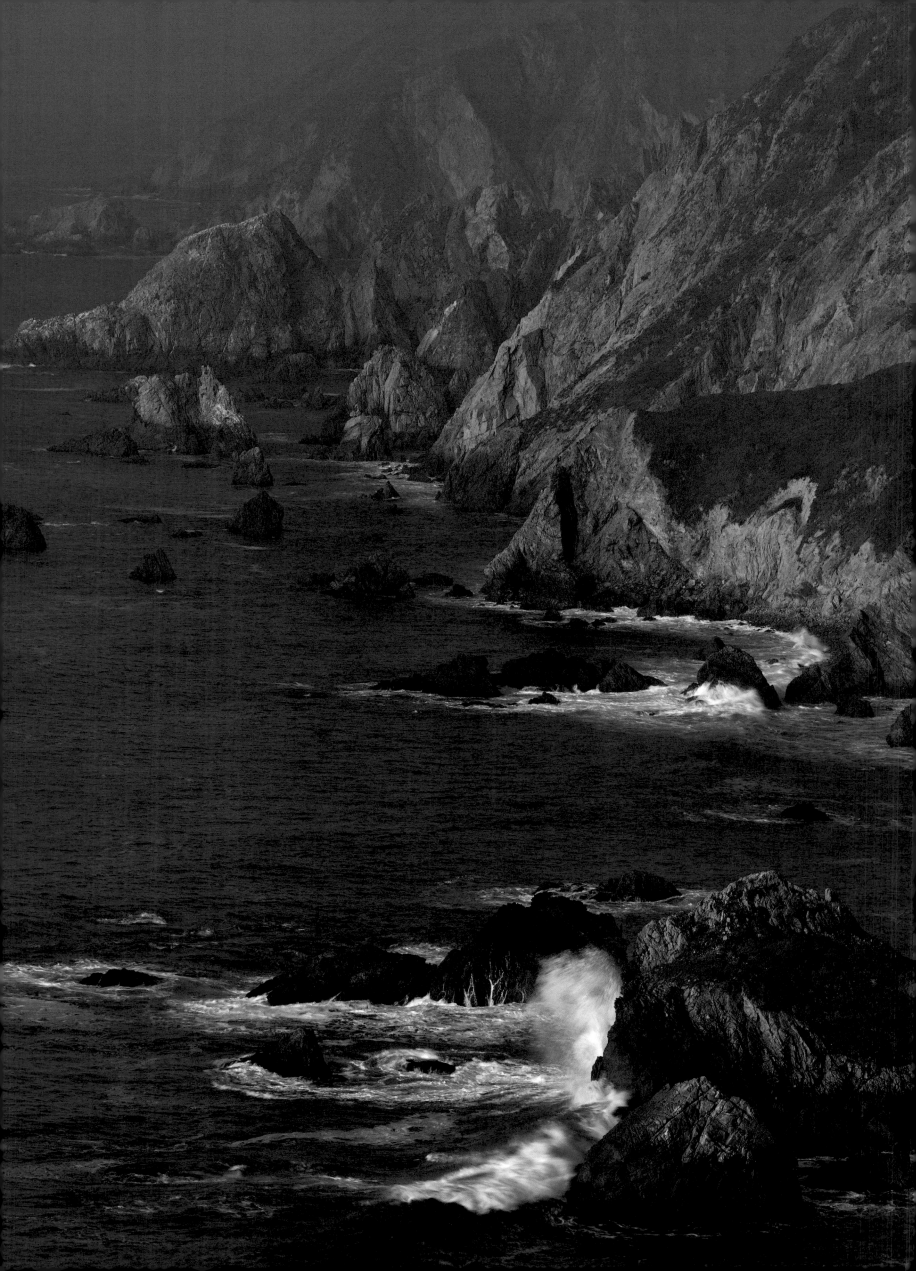

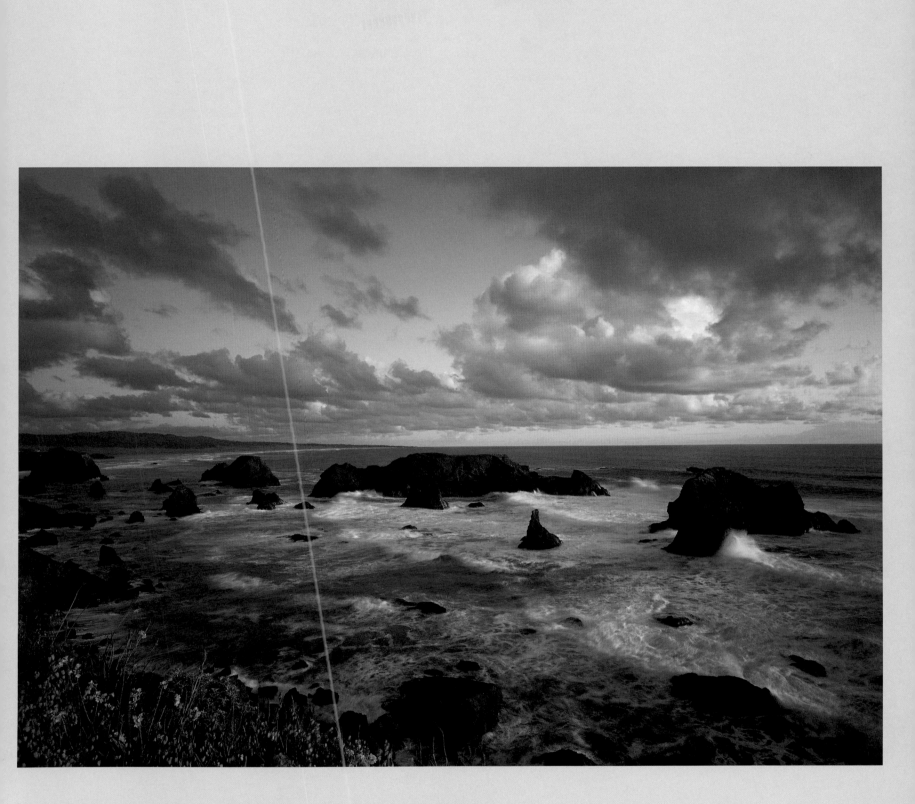

◄ THE ETERNAL DRAMA OF SEA AND LAND PLAYS OUT WITH CLASSICAL VIGOR ALONG POINT REYES NATIONAL SEASHORE.

▲ MACKERRICHER STATE PARK OFFERS AN EVENING VIEW OF DISTANT LAGUNA POINT ALONG THE MENDOCINO COAST.

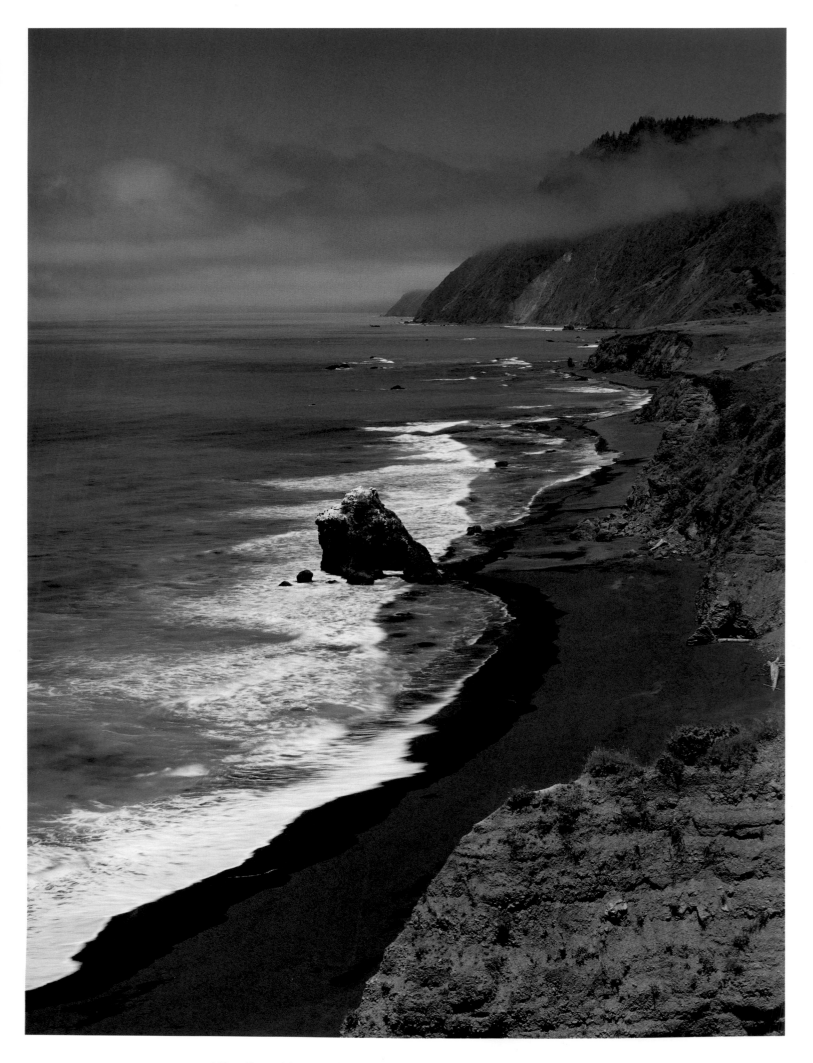

▲ KING RANGE NATIONAL CONSERVATION AREA IS SEEN FROM SINKYONE WILDERNESS STATE PARK.

► THIS MATURE REDWOOD FOREST, IN REDWOOD NATIONAL PARK, IS NURTURED BY THE MORNING FOG.

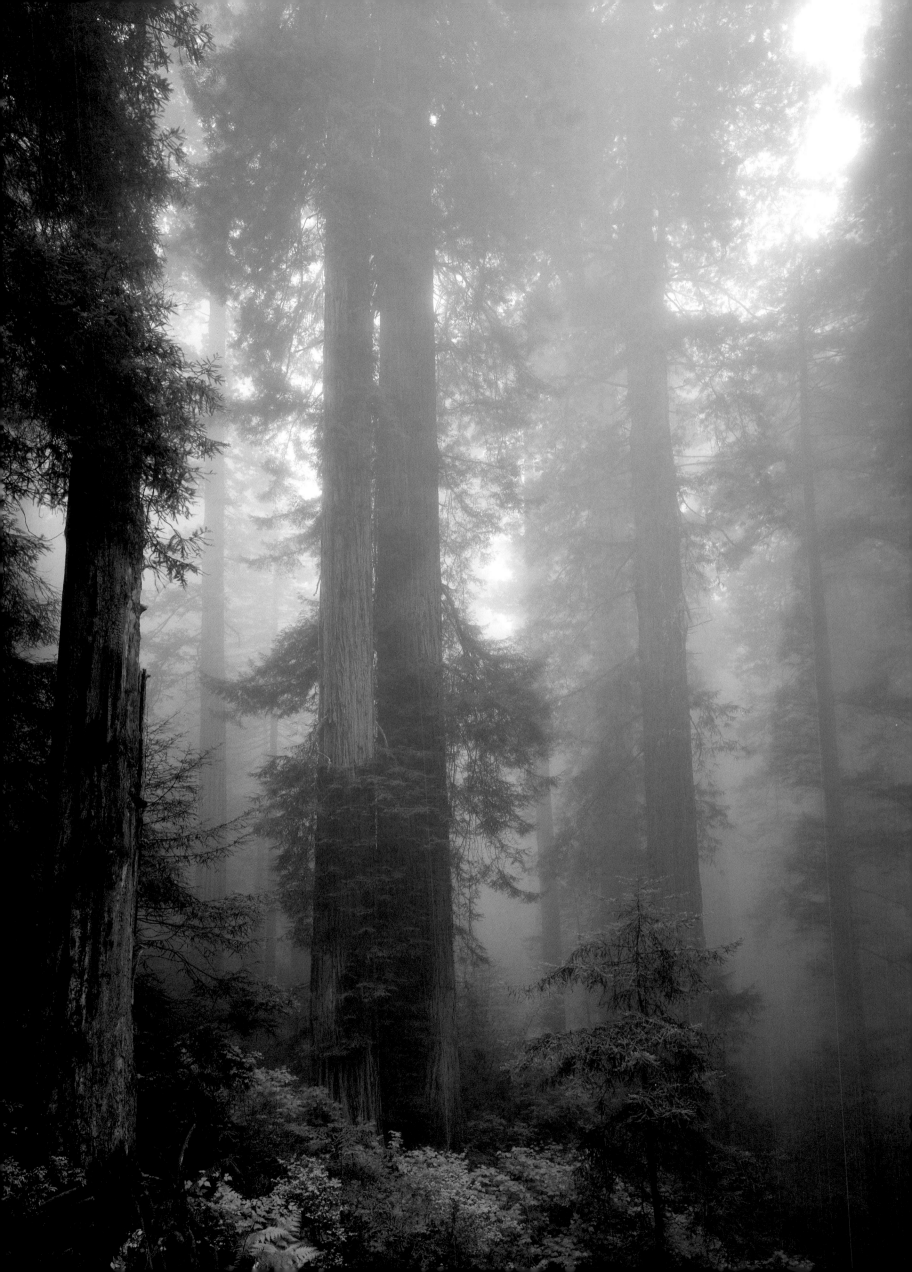

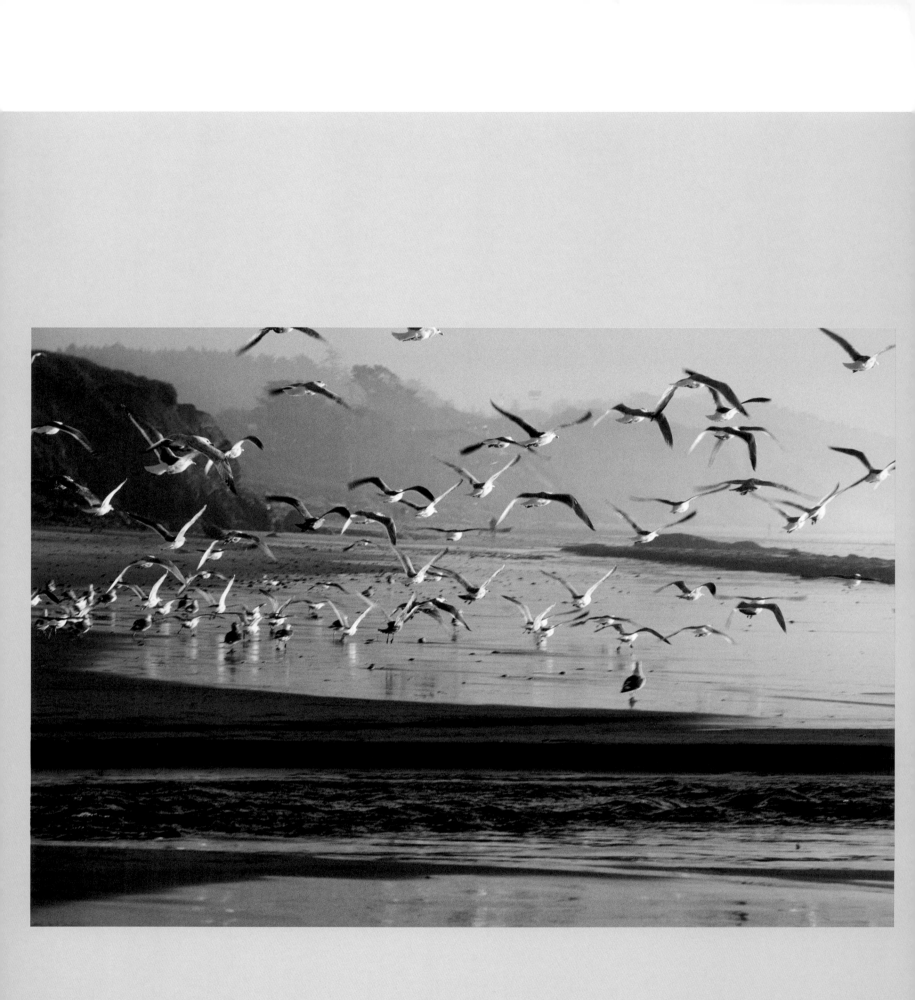

The fluid rhythms of seagull flight and collision avoidance are played out
along Drakes Estero and Drakes Bay, Point Reyes National Seashore.

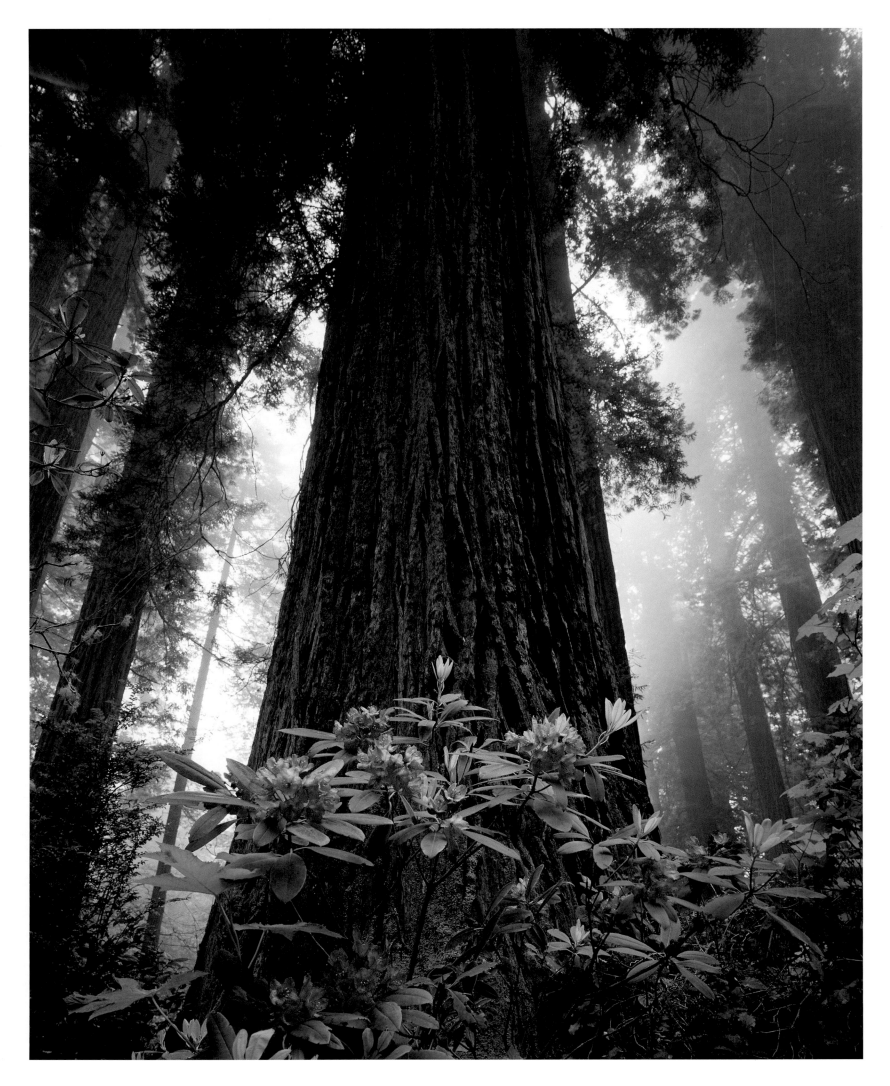

NATIVE RHODODENDRONS *(RHODODENDRON MACROPHYLLUM)* BRIGHTEN THE
BROODING UMBER BARK OF A COASTAL REDWOOD *(SEQUOIA SEMPERVIRENS)*,
DEEP WITHIN FOG-KISSED DEL NORTE COAST REDWOODS STATE PARK.

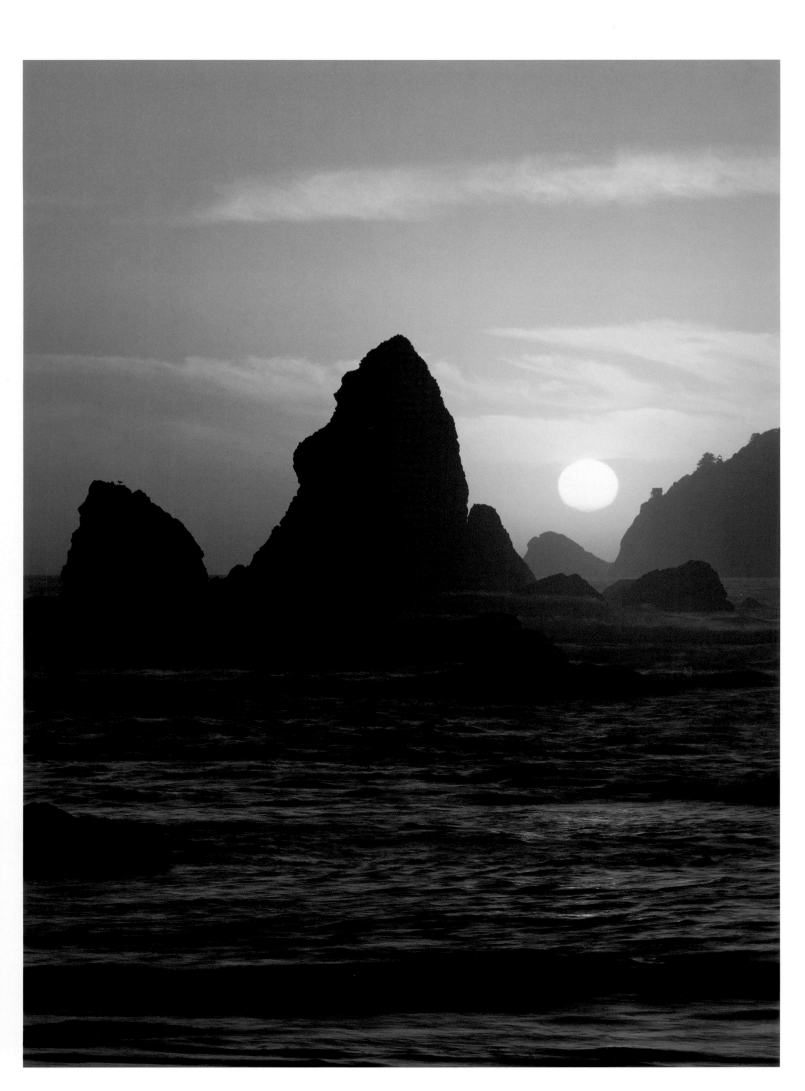

A FLOOD OF SUNSET AMBER LIGHT COMPLETES THE IMPRESSIONISTIC COMPOSITION OF SURF, WIND,
WAVES, AND SEASTACKS ALONG TRINIDAD'S RUGGED MOONSTONE BEACH COASTLINE.

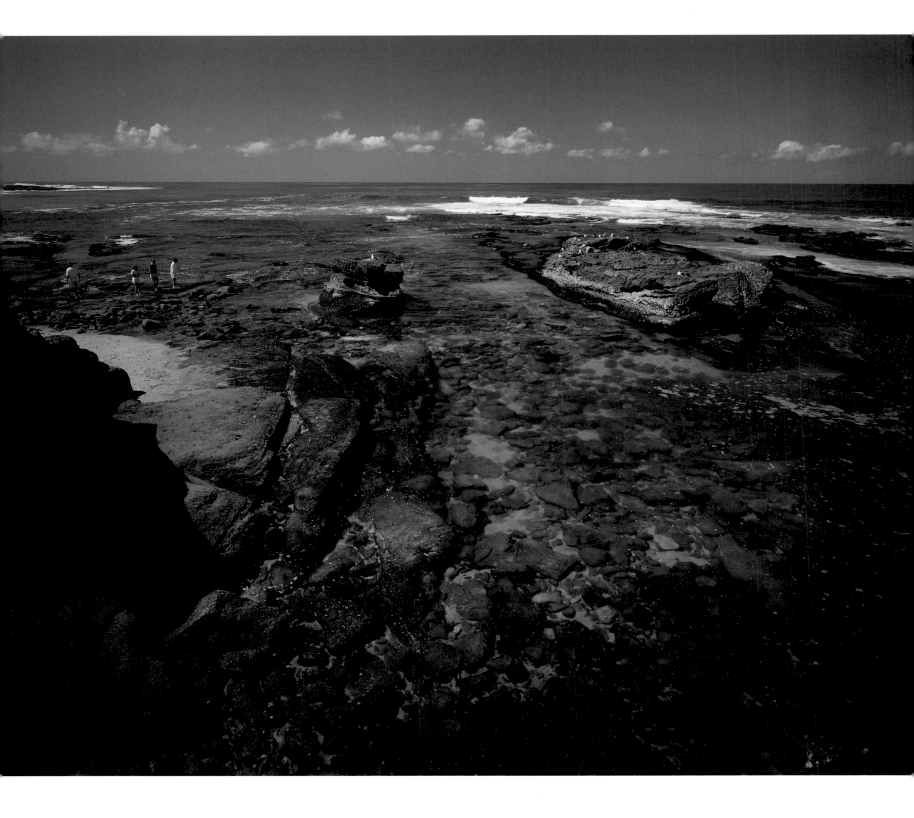

TIDE POOLS ATTRACT VISITORS AT SHELL BEACH ALONG THE LA JOLLA COAST.

TO SEASCAPES UNENDING

It was always a wild, rocky coast, desolate and forbidding to the man of the pavements.... Here the redwood made its last stand. At dawn its majesty is almost painful to behold. That same prehistoric look.

— Henry Miller,
Big Sur and the Oranges of Hieronymus Bosch (1957)

Deep within the otherworldly realm of a coastal redwood grove, a wet and brooding hush effectively rusts to a stop the grinding mind gears of civilization. Many of these dark, ancient giants are so tall you can't see their tops, so big around that twenty people holding hands won't encircle their girth. For thousands of years, they have reached for heaven, preempting the sun from groundfall and so ensuring their success over lesser rivals. Their deeply furrowed cinnamon-red bark has withstood fire, insects, scars, every scourge that time and Earth have thrown at them ... until man. Indifferently harvested for profit and mere curiosity from the mid-1800s to well into this century, groves of giant redwood (genus *Sequoia*) from the Oregon border south to the mountainous Big Sur coast below Monterey Bay now enjoy increasing governmental protection.

Yet even the redwoods are only one part of the multifaceted character of California's thirteen hundred miles of coastline. In the wild regions of the North Coast ranges, rugged rock and plunging, craggy rainforest slopes cloaked in perennial mists hold the line against the crashing Pacific. South of San Francisco Bay, the Central Coast ranges gradually change in character from the high forests, grasses, and precipitous ridges of the thirty-five-hundred-foot Santa Lucia Range at Big Sur to gentler, more accessible grass and scrub highlands, bluffs, broad sandy beaches, and dune sheets running from nearby Cambria to the Mexican border. In warmer, more forgiving southern Pacific waters, modern aquanuts by the millions—surfers, boaters, kayakers, and divers—flock to the water, shaped by the land into protected inlets and tidepools, sea-life-rich, craggy coves, and broad public beaches.

Of all the phrases identified with the California lifestyle, none is more recognized than "Surf's up, dude!" Surfing, forty years after California wave-riding became immortalized by the Beach Boys, Jan and Dean, and other surfer music groups, still rules as a major icon of Golden State recreation. Drive down the coast from the King Range's Shelter Cove to Lompoc's windsurfing mecca, Jalama Beach, from Ventura's Rincon to San Diego's La Jolla beaches, and all along the way, you'll find more seal-like "pods" than ever of surfers in their black wetsuits, patiently straddling their boards, sitting out the teaser waves in wait for the next good swell.

It is the North Coast that retains California's most primitive character. Rain-soaked Douglas fir, madrone, redwood, oak, and tanoak forests, green grasses, and mist-fed lichens drape the steep shoreline ranges with a luxurious emerald mantle. Even the engineering marvel of California Highway 1 is forced to detour inland around one stretch of the big-shouldered King Range, which dives so dramatically into the sea that it earns the romantic name "Lost Coast." Kings Peak, all 4,087 of it, boasts the steepest rise from the sea of any spot on the entire western coast of America.

In summer, Pacific waves often expend the final energies of their long eastward voyages shrouded in thick fogs. In winter, driven by storm conditions such as the El Niño of 1997–98, ocean breakers turn even the gentlest of southern coastal beaches into raging killers.

Geologically, the Coast Ranges are a wrinkled-earth testimony to tectonic plate movement. When the Farallon Plate subducted, or dove beneath, the North American Plate millions of years ago, whole arcs of mountainous islands were scraped off the plate by the continental shelf and conscripted into a new land mass. Mountain chains comprised of these islands are still visible today, landlocked as far east as Utah. Now, pterodactyl-like pelicans soar with instinctual perfection mere inches above incoming swells, indifferent to plates and faults, content as they have been for millions of years to ride the long cushions of air sent up by ever-moving waves.

The wind is really cracking. One of the pilots takes a reading with his Hall tube. "Sixteen gusting to twenty-two!" he yells. Not good. Anything over twenty miles per hour of wind seriously cuts into the upper limits of our gliders' speed range. That signals potential danger, as the winds only blow harder aloft.

Little sand needles sting my face as I keep the nose of the bucking glider down. All I need now is to have the wind flip it into a disaster of aluminum and Dacron rubble cartwheeling downwind across the dune sheet.

The Flying Flea squints out to sea. Jeez, he's already got his helmet on. Mr. Got Rocks, nothing intimidates this guy. When the conditions are marginal, or even really hairy like today, I take my time, surveying the conditions until I know the risk is worth taking. Not Marty. He's usually first off the hill, glad to play "wind dummy" to show us what's in store up there. Yet, with his light weight, he's even more vulnerable to the force of the winds than heavier guys like me. Make that "Fearless" Flying Flea.

It's an incredibly beautiful day along the Guadalupe Dunes near Santa Maria. The wash of deep blue sky is crisper and more inviting than usual for the Central Coast. Maybe the Bubble will kick in today... but probably not. Just as well: it could kill any one of us without warning or discrimination. We've got our hands full enough just dealing with this adrenaline-pumping onshore gale.

Someone once hung a clunky geopolitical term—San-San—onto the five-hundred-mile corridor between San Francisco and San Diego. Within this coastal strip of mountains, temperate green valleys, and arid basins most of California's people dwell, and who can blame them? Blessed by abundant water, rich soils, explosive industrial potential, an abundance of ocean fisheries, and gentler climes than those found in the mountains and deserts to the east, San-San was a paradise ripe for exploitation, and exploited it was. When the transcontinental railroad linking the East and West Coasts was completed in 1869, transportation to Paradise was no longer the ordeal it had been. Nothing would hold back California's growth potential now. The availability of vast, inexpensive tracts of land and abundant employment opened the floodgates. People came from everywhere, and they're still coming.

Throughout Europe's history, similarly rich and varied expanses of land, concentrations of humanity, and diversities of culture bred a mitotic turbidity of warring nation-states. Modern San-Sanians prefer to express their differences in a squaring off of lifestyles, loosely demarcated

by a kind of Mays-Drysdale Line. To whit: any L.A. Dodger fan knows his natural baseball enemy is the San Francisco Giants. If the City by the Bay is an elitist Macintosh town, L.A. is, like, totally pedestrian Windows PC. To get somewhere in the City of Angels, head for the nearest freeway on-ramp and don't let that guy in the Beemer cut in front of you. In The City, just snag a cable car or jump on a high-speed BART (Bay Area Rapid Transit) rail car for an enthralling, elbow-rubbing ride with people of all nationalities.

Northern California's urbanites can be forgiven if they forget San Francisco's nineteenth-century Gold Rush–driven imperialism was every bit as resource- and land-devouring as Southern California's immigrant-fueled, water-grabbing rush to megalopoly in the twentieth. They love their foggy Continental town because it still commands the heart of aesthetic California the way Paris speaks of the spirit of France. Meanwhile, L.A. grows and grows, fast-laning blindly past the disdain of haughty culture en route to the next blockbuster movie, political rally, or sports championship.

California's economic and cultural divergence finds a fusing point in the infrared heat of world-beating success. Old Steel, Old Oil, Old Money, Old Automobile give way to the New Economy: high technology. And nowhere does the techno-future get more ink than in Silicon Valley, California.

Silicon Valley describes a ten-by-thirty-mile area of the San Francisco peninsula between the City by the Bay and San Jose. Once it was a drowsy patchwork of fruit orchards along Highway 101 known as the Valley of Heart's Delight. Today, it is the unquestioned epicenter of the world-changing revolution known as IT—information technology.

Needing to shore up its financial reserves in the 1950s, Stanford University created a technological industrial park on a few acres of its grounds with such attractive leases that Eastman Kodak, General Electric, Admiral Corporation, Shockley Transistor Laboratory, Lockheed, and Hewlett-Packard built factories there. Other companies followed suit, and the term "Silicon Valley" was coined to describe the work being done along the leading edge of electronic innovation.

Within twenty years, two singular events occurred in Silicon Valley that would change the course of human history: Intel's development of product 4004, the first microprocessor, and the debut of Apple 1, the cobbled-together toy of two college-aged whiz kids, Steve Wozniak and Steven Jobs. "Woz" and Jobs called their creation a "personal computer." At the time, no one took much notice.

These days you find more than four thousand technological megacorporations throughout Silicon Valley, including such names as Adobe, AMD, Netscape, Cisco Systems, Seagate Technology, Silicon Graphics, and Sun Microsystems. Combined, they generate more than two hundred billion dollars in IT-related revenue annually.

Bright, ambitious, hard-working people need a broad panoply of services, and the Silicon Valley infrastructure has mushroomed, with

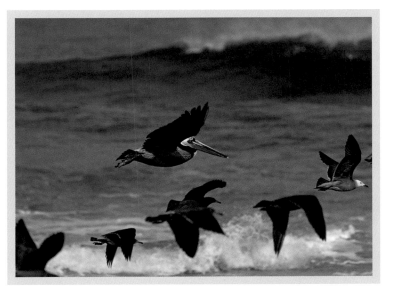

arts and cultural centers to rival those of San Francisco, technological museums, waves and waves of housing developments, restaurants, schools, and all the other trappings associated with boomtowns. And, of course, more and more people to keep it all humming along.

Echoing, framing, and offering verdant respite from the millennial exhaustion of California's headlong rush into its global destiny is one of the most breathtakingly primal coastlines in the world. There, even techno-babbling high achievers go to escape their keyboards and find some much-needed spiritual downtime among the workstations of nature.

Less than an hour's drive south from Silicon Valley, in drifting shrouds of Pacific fog, easing into more natural rhythms comes easy among the Hobbit-like, redwood-moody, skycoast surf-crash realm known as the Big Sur Coast.

The Bubble at Guadalupe Dunes can kill you. The rare condition forms in twenty-five-mile-per-hour-plus winds. First, huge volumes of hot air rise en masse from sun-warmed sand. The ocean wind reacts to the warm air parcel as if it were a ridge or cliff by rising up and over it. A strong band of orographic, or mechanical, lift forms in front of the Bubble. That's what we try to get into for long, soaring flights.

Here's the catch: local pilots from nearby Santa Maria and Pismo Beach warn us that once in a great while, that bubble of glider-sustaining lift unpredictably moves out over the water. Soaring pilots, unwilling to risk a life-threatening ocean landing, are eventually forced to fly downwind—out of the Bubble's lift and right into a hellish turbulence they know lurks behind and below it.

A pilot Marty and I knew died here when he got caught in the Bubble two hundred yards offshore. When he flew back toward land, he lost control in the extreme turbulence and made a death dive to the beach.

Horror stories like this unnerve us. How can we hope to avoid the same fate? Usually, talking to witnesses helps us convince ourselves, not always justifiably, that such tragedies are avoidable. Call it the "won't happen to me" syndrome. Since the pilot took off that day in winds above thirty miles per hour, he had clear warning that an unstable Bubble might develop. We all know flying in winds so dangerously near the top speed of a hang glider is flat-out stupid. He blew it, so no sweat. Won't happen to me.

So here we are, pinned to the sand like butterflies on paper. In my heart, I know that even if the wind hovers around twenty, there's no guarantee the Bubble won't form. The mental image of my daughters' faces helps me decide: I'll sit it out for a while.

But Marty's not waiting. Typical Flea.

In its primordial rawness, Big Sur affects a melding of once and future California. High, steep coastal mountains smash their green-gloved fists right down into the ocean, rarely permitting more than an oversight of sandy beach. Writer Jack Kerouac made pilgrimage through Big Sur's

SEAGULLS AND A BROWN PELICAN SOAR OVER THE BREAKING SURF IN LA JOLLA COVE.

dark cathedrals of redwood and explored—gingerly—the crashing violence of its many high-cliff, dead-end sea coves. In the savagery of the Pacific's endless siege of implacable continental rock, he encountered an irony of God-fearing humility worth writing about in his book *Big Sur:* "The blue sea behind the crashing high waves is full of huge black rocks rising like old ogresome castles dripping wet slime, a billion years of woe right there, the moogrus big clunk of it right there with its slaverous lips of foam at the base—So that you emerge from pleasant little wood paths with a stem of grass in your teeth and drop it to see doom."

The only road along the coast is California Highway 1. At Big Sur it is nothing more than a tenuous lifeline of asphalt and arcing white cement bridges that hug the precarious thirty-five-hundred-foot shoulders of the Santa Lucia mountains. It's a hair-raising adventure to wind your giddy way five hundred feet above the storm of water against garapata rock through a course of so many tight turns and sheer drop-offs that you invite, not carsickness, but airsickness.

Increasingly as you move north through minimal settlements such as Gorda, you round a curve to discover an oasis of low, flat-topped cliffs such as Pacific Valley or the Big Sur Lodge, set in a lush, wooded mini-canyon. A favorite gathering place is Nepenthe, the famous restaurant and watering hole that clings to the side of a five-hundred-foot sheer ocean cliff. There is arguably no more enchanting vista in the world than this: leaning against Nepenthe's candle-lit balcony to drink in moonlit silver reflecting the water-weavings of tide and gravity so far below.

If California's polymorphic coastline was the beacon that first drew the galleon moths of gold-hungry imperialists, Big Sur is its Church of Inner Light. Rugged individualists, brain-fried tech wizards, artists, counterculturists, dropouts, and vision questers alike, looking to focus awareness on their personal place in the cosmos, flutter in to partake of mind- and soul-expanding workshops at Esalen Institute or meditative Zen chants and hot-spring soaks at the Tassajara Buddhist Meditation Center in nearby Carmel Valley.

Marty calls for a wire launch. Two guys run over to hold his side wires as he hooks in and carefully raises the nose until the sail flaps in frenzied neutrality.

"Have a good one, pal!" I yell, not expecting a reply. Marty's concentration is intense. It needs to be: if the wind gets under the sail, he'll be thrown downwind like a roof in a hurricane, hospital visit guaranteed. Yet he manages to send me a quick "You too!" gathers himself, checks the wind ribbon, raises the nose just enough to fill the sail, then yells "Go!"

His wire launchers let go and throw themselves to the sand as he surges forward, trying to run. The gale has other ideas as it jerks man and glider skyward. He pulls his body forward to penetrate into the wind and Whammo! up he zooms like a puppet on a string, 100 feet, 200, 300, in mere seconds. He stabilizes and tracks slowly forward. I hear his big war whoop filter down through the windy howl. He's up and solid.

There's nothing like a safe wind-dummy launch to get rid of the butterflies. Within minutes, all five of us take off and start working the lift north and south above the long, convoluted dune sheet, as free-wheeling and in control as any soaring bird that ever took flight.

After a few minutes, nobody's getting any higher than my bantamweight buddy Marty, and he's topped out at about 400 feet. No Bubble today. I can relax and enjoy this magnificent feeling: a paradox of security and thrill, a safe danger in the mouth of strong winds over golden sands and blue-green water. Life is a miracle.

For an hour and more we sail along, so many multicolored arrowheads working the lift up and down the five miles of coast. Marty and I fly in and out of formation with each other, sometimes calling back and forth. Seagulls slide in off our wingtips, sharing air with the weird newcomers. California Dreamin', skysurfer style.

Artists dreaming of transcendent inspiration found California's rich variety of landscapes and vegetation at once immense and luminous, yet tenderly intimate and profoundly personal. After all, what is art if not the irrepressible human response to miraculous life, death, and the universe around us? As San Francisco became the economic and cultural center of mid-nineteenth-century California, art that celebrated the glorious fall of light upon the state's diverse natural landscape began to reach a world hungry for visions of the great golden frontier so ripe with beauty and opportunity. Advocates of wilderness preservation found ambassadors in mesmerizing paintings that served up nature, at times with near-reckless, unabashed grandiosity, as a balancing force against the blind march of industry and civilization.

But just as the fabled light of the French countryside incited upstart European painters to rebellious Impressionism in the late nineteenth century, California's shimmering, new-frontier coastal and inland vistas drove artists to expand upon and diverge from the teachings of the established painting schools of their European forebears. Snubbed by the art establishment of San Francisco, the young lions headed south in search of more supportive environments. Soon, in idyllic coastal retreats from Carmel-by-the-Sea to Santa Barbara to Laguna Beach, they founded their own creative enclaves and "colonies." There and in other locales, experimentation and new art movements began and flourished. By the time of the 1915 Panama-Pacific International Exposition in San Francisco, where more than ten thousand paintings from Europe and the United States were exhibited beneath the fabulous dome of the Palace of Fine Arts, California Impressionists, displaying their works right alongside famous international artists, took many of the top prizes. California art and its artists had arrived.

Today, paintings by artists such as William Keith, Donna Schuster, Selden Connor Gile, Guy Rose, Granville Redmond, Joan Brown, and Richard Diebenkorn command respect—and high prices—throughout the world.

California's coasts, mountains, and gentle valleys have inspired every form of artistic expression. Mark Twain wrote some of his most enduring works while living here. Depression-era writers such as John Steinbeck, who crafted tales of the harsh but colorful life of Monterey Bay and the Salinas Valley, along with Upton Sinclair, Nathaniel West, and Mary Austin, gave us new insights into the downside of finding the end of the rainbow. Henry Miller's lusty literary insurrections found a home from 1944 to 1962 in hedonistic Big Sur revels, while Robinson Jeffers' poetry drew heavily from his Big Sur experiences to encounter and question mankind's darker urges. Joan Didion's fiction and nonfiction cast a sharp, apocalyptic eye on American politics and culture. The interpretive photographic genius of Ansel Adams, Carmel's Edward, Brett, and Cole Weston, and the Santa Barbara dynasty of Josef, David, and Marc Muench brought world awareness to California's coastal magnificence.

Meanwhile, nineteenth- and early twentieth-century women artists and photographers made significant contributions in spite of the male-dominated, empire-building focus of the times. One Julia Shannon advertised her photography business less than a year after the first male photographer set up shop in Gold Rush California. Laura Armer led a richly diverse career spanning 1899 to the 1930s that included fine-art photography, landscape painting, feature and documentary film making, and photography of Native Americans. From 1857 to 1876 Eliza W. Withington ran a successful landscape photography business and wrote about the backbreaking physical demands of using cumbersome glass-plate negatives to make stereographs in the field.

Over time, the California art experience has matured, diversified, sought new frontiers and new ways of expression—just what you'd expect from the golden land on the edge of tomorrow.

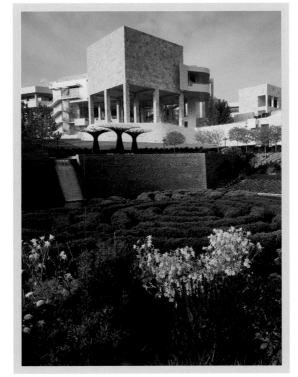

After an hour of smooth, soaring flight, the wind suddenly drops off in velocity and grows rough. One by one, the lower gliders lose lift and glide down to make tiptoe Superman landings on the sand. Before long, only Marty and I are still flying, and we're working hard to stay up within ever-shrinking pockets of lift.

I ease my glider close enough so the Flea can hear me cry out, "Getting tired?"

"Naw, this is great!" He sounds like a big kid. "Getting bumpy, though."

"Yeah. Thermals off the sand?"

"Maybe. Not sure."

We cruise on up the beach in formation, serenaded by the steady crash of the surf, just 200 feet below now. Then it happens: just as we both cruise across a big dune, the air suddenly grows more turbulent. I tense up, remembering the guy who died here.

"Better move off a bit," I call up to Marty. It's dumb to fly close in rough air.

He drops into view below the canopy of flutter-buzzing left wingtip. I'm thinking "time to land" when my variometer starts singing,

an intermittent chirp at first, then a steadily higher-pitched cry that indicates we're flying into strong lift. But how can that be?

Through the wind I barely hear Marty's vario squealing too. Suddenly the bumps are gone . . . and now the vario tone grows higher and higher in pitch. I glance over to read a five-hundred-feet-per-minute climb rate on its dial! We're going up like bats outta hell!

The altimeter races through 800, then 1,000, then soon 1,500 feet! Marty holds a tight formation with me, never changing his relative position, as if we were glued side by side to a sheet of glass.

I start hollering, "The Bubble! It's gotta be the Bubble!" He's yelling too, but I can't make out his words. Below, the guys who landed are scrambling to take off again, but no joy: they can't get up into the lift and end up landing mere yards from their takeoff dune. The wind has completely quit on the beach. And we're soaring directly above it! Wow!

The lack of ground wind is welcome news: that means the Bubble will stay put. No worries about being dragged out to sea. We're safe.

"Hey!" I holler as we rise on the invisible elevator through 2,000 feet. "We hit it! You Flea! You Fabulous Flying Flea!" His laughter reaches me through the constant rushing of the wind.

Out at sea, the deep green ocean gives up whitecaps to the gale. Up the coast, the blustery cliffs are drenched in van Gogh's primary ochres, Gauguin's Tahitian olive drabs, and Redmond's sublime greens and poppy golds. The sky gods have blessed us again.

And we have it all to ourselves, two bird brothers riding the line between heaven and Mother Earth.

California's seacoast shows us in its tidepool sea-life mystery and crimson ice-plant delicacy, in its moonlit grunion spawn and twice-yearly offshore whale migration, in its rocky cliff rookeries teeming with sea mammal and bird life, that life's brush strokes rain endlessly upon eternity's canvasses. In leaving behind, even for a weekend, our constructed world, we can antidote that "more is less" feeling: along our native shores, less soon feels like so much, much more.

Rolling up and down the great westward-pointing coastal prow of America, we gather spiritual fuel for our life journeys. Next time you're besieged by the endless stoplights and paper chases of your life, take up meditative solitude along the Lost Coast. Drive up Mount Tamalpais for an exhilarating night-light view of vibrant San Francisco. Let Big Sur's ethereal mists coax forth a poem, song, or charcoal sketch.

Or imagine yourself on a walk along Santa Barbara's Hendry's Beach, hand in hand with a beloved mate or child. Gaze out upon that golden sea. Listen to your breath as you draw it in and release it back to the sky. Hear how your own body rhythms match the rhythms of the crashing waves? See those jagged island mountains just across the water, lying with magenta liquidity along the horizon? In both their surreal watercolor translucency and your heart's response to them, you have found certain proof of the eternal. Let this marriage of land and sea be an ever-reappearing pentimento to remind you that love really is all that matters.

◄ TWO HIGH-RISE BUILDINGS MIRROR SUMMER SKIES ABOVE THE ORANGE COUNTY CORPORATE PLAZA.

▲ THE CENTRAL GARDEN AT THE GETTY CENTER IN LOS ANGELES IS LOCATED IN A NATURAL RAVINE.

THE GARDEN WAS DESIGNED BY CALIFORNIA ARTIST ROBERT IRWIN.

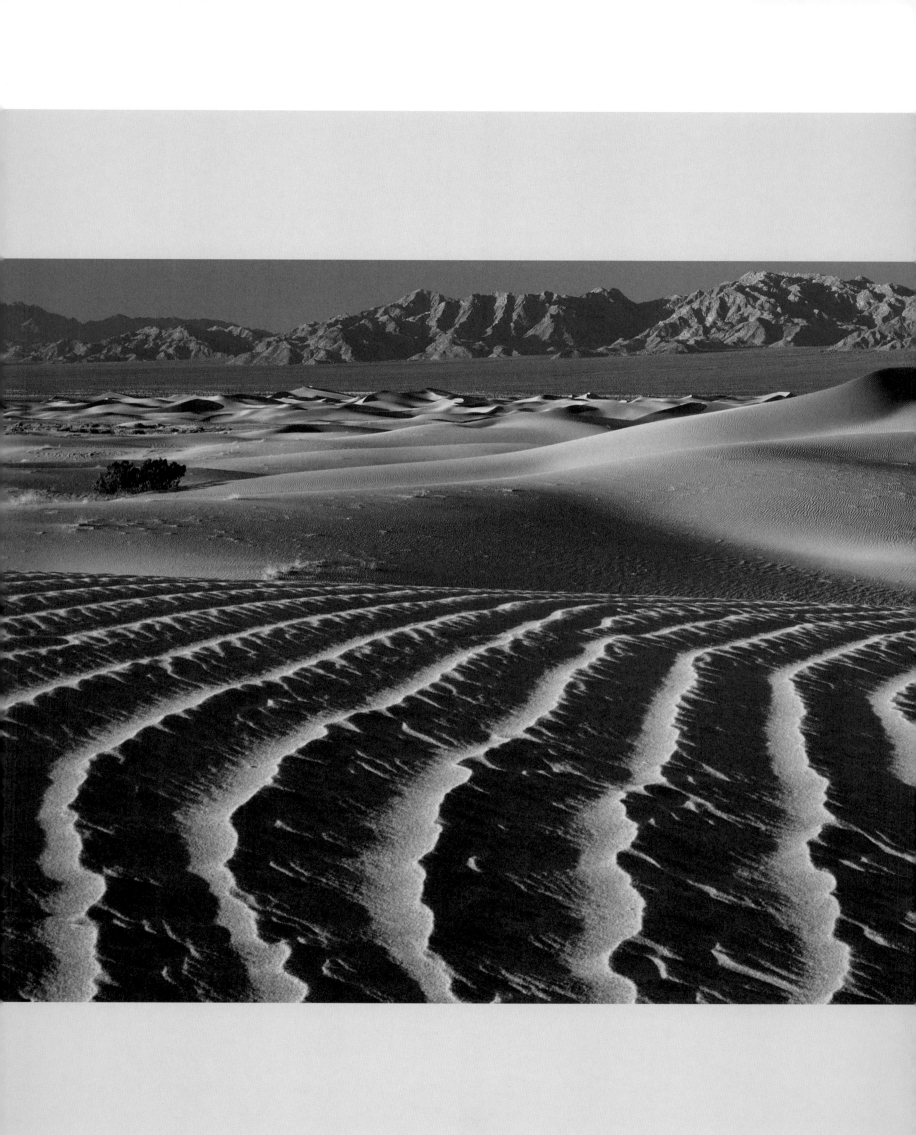

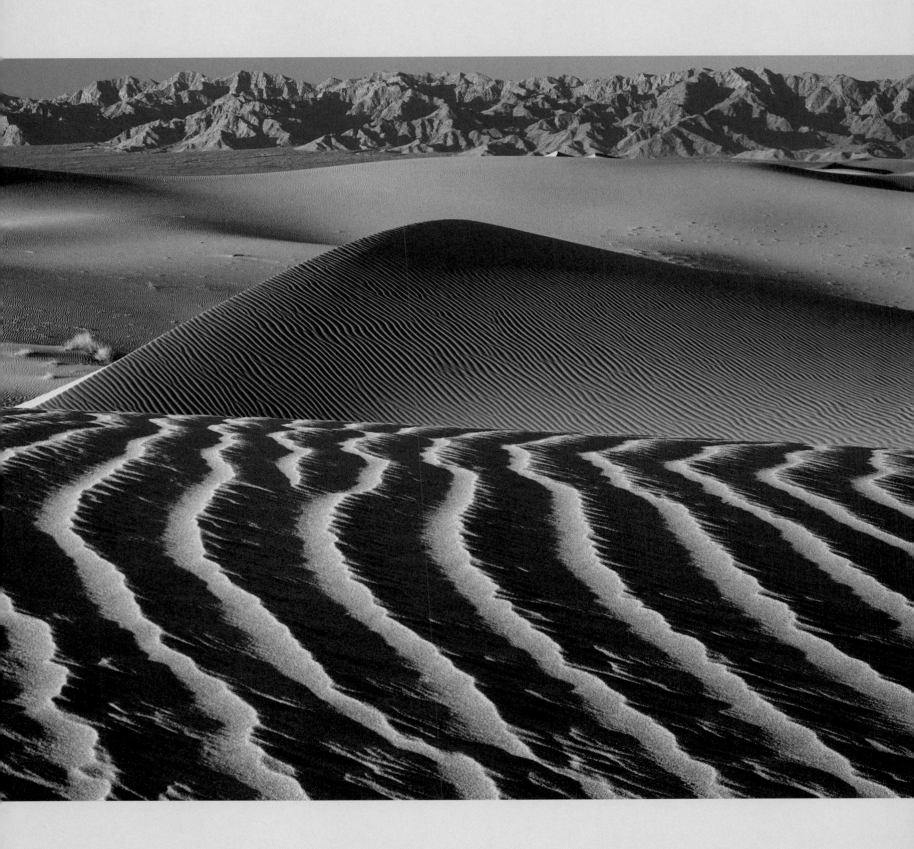

SHIFTING WINDS SCULPT THE SAND DUNES IN THE CADIZ DUNES WILDERNESS OF THE MOJAVE DESERT.

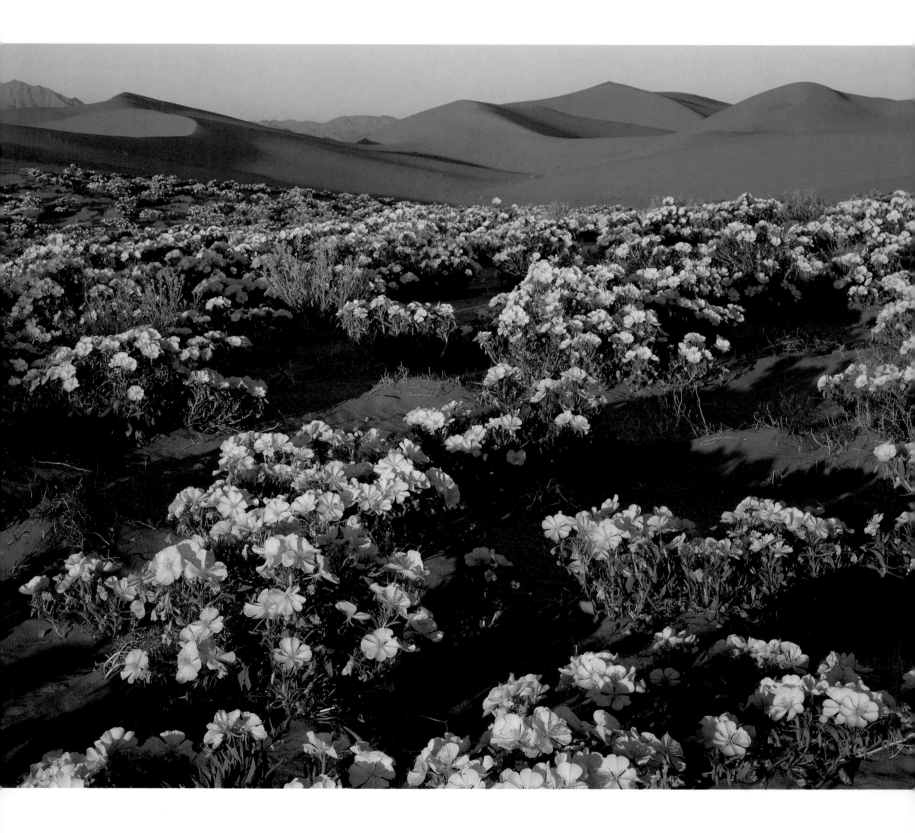

A FRAGRANT BLUSH OF DUNE PRIMROSE (OENOTHERA DELTOIDES) CARPETS
THE DESERT DUNES OF CADIZ VALLEY.

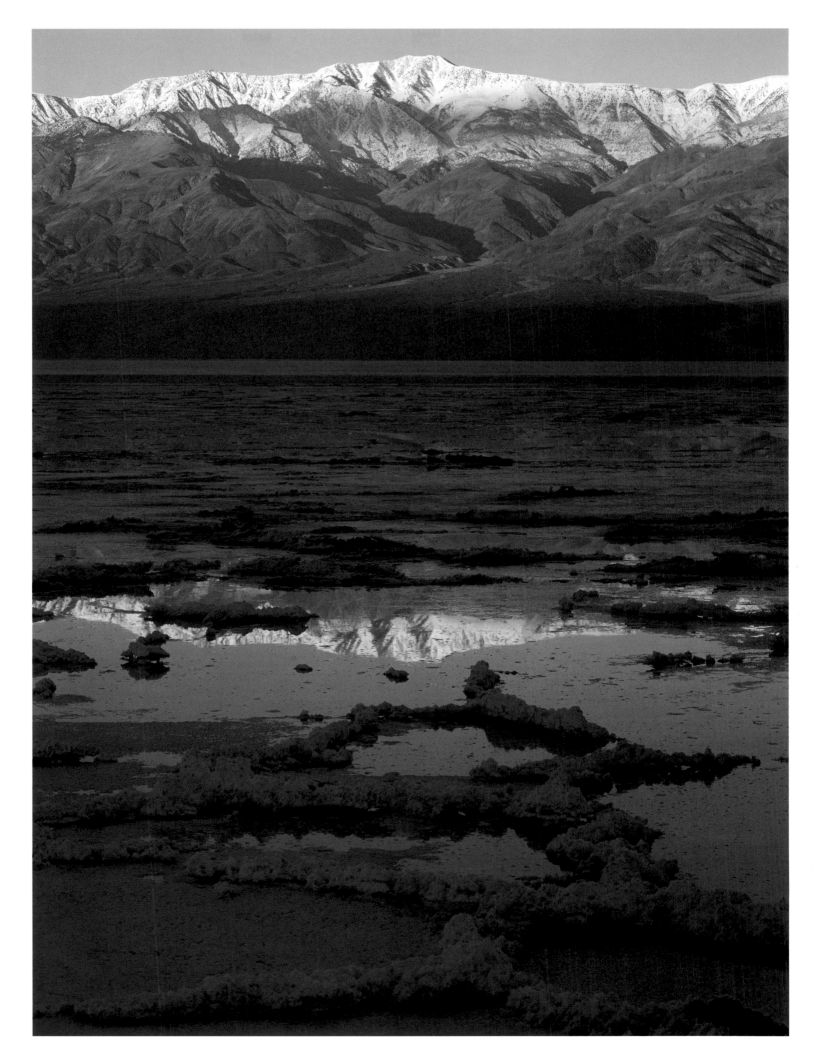

TELESCOPE PEAK (11,049 FEET) REVERBERATES IN THE BRINY WATERS OF APTLY NAMED
BADWATER IN DEATH VALLEY NATIONAL PARK. AT 282 FEET BELOW SEA LEVEL,
IT IS THE LOWEST ELEVATION IN NORTH AMERICA.

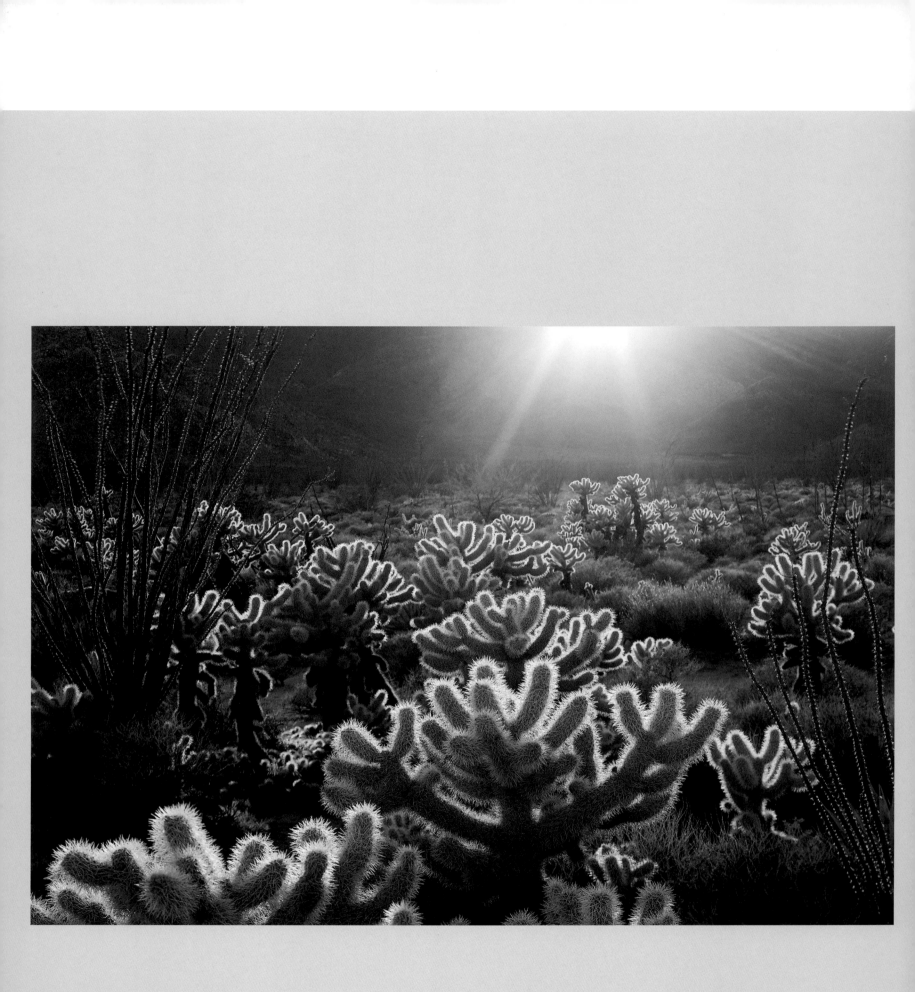

▲ A COLONY OF TEDDY BEAR CHOLLA CACTUS *(CYLINDROPUNTIA BIGELOVII)* GLOWS IN THE LAST RAYS OF
SUNLIGHT IN VALLECITO VALLEY, ANZA BORREGO DESERT STATE PARK.
► WINDS BLOW OVER THE CREST OF THE EUREKA DUNES IN DEATH VALLEY NATIONAL PARK.

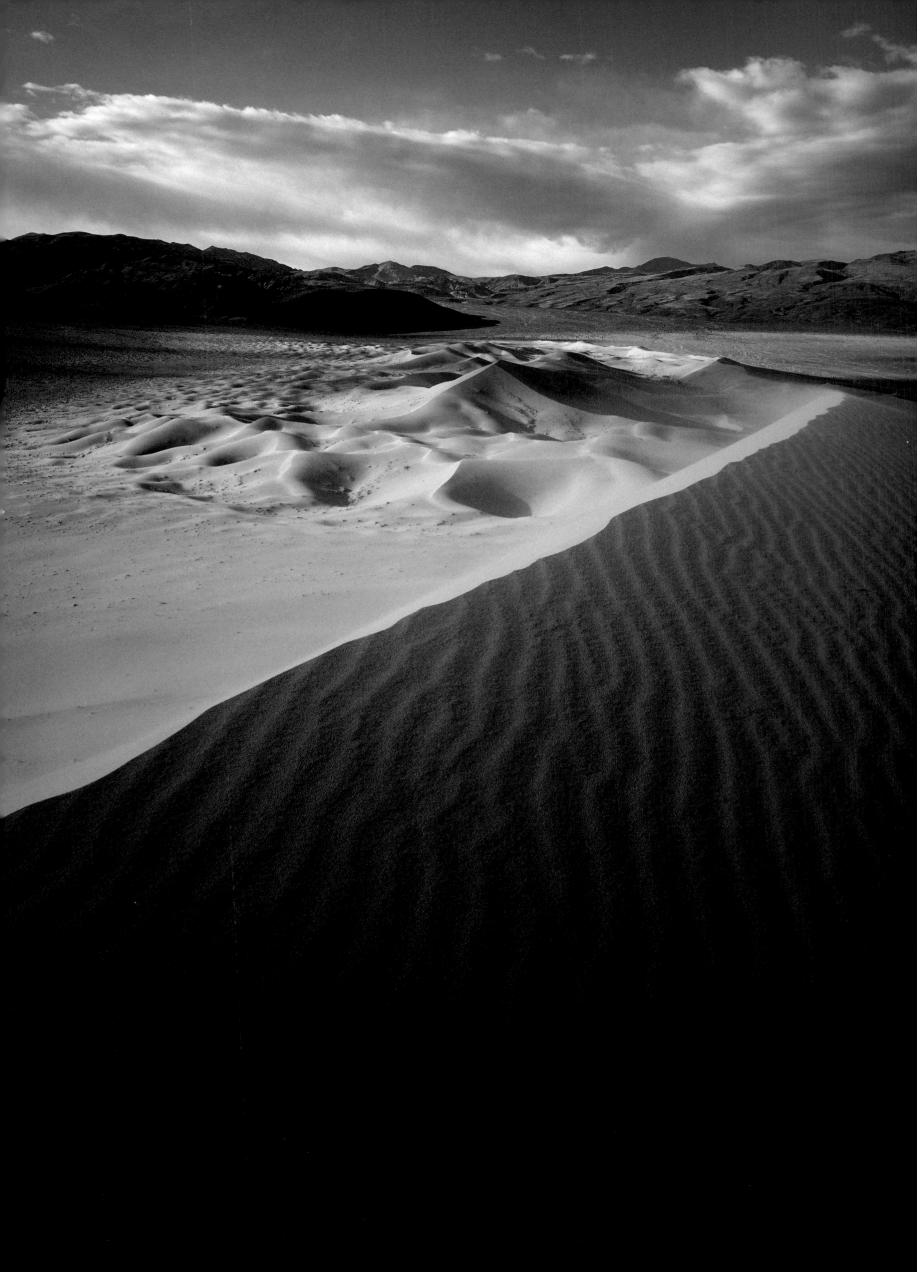

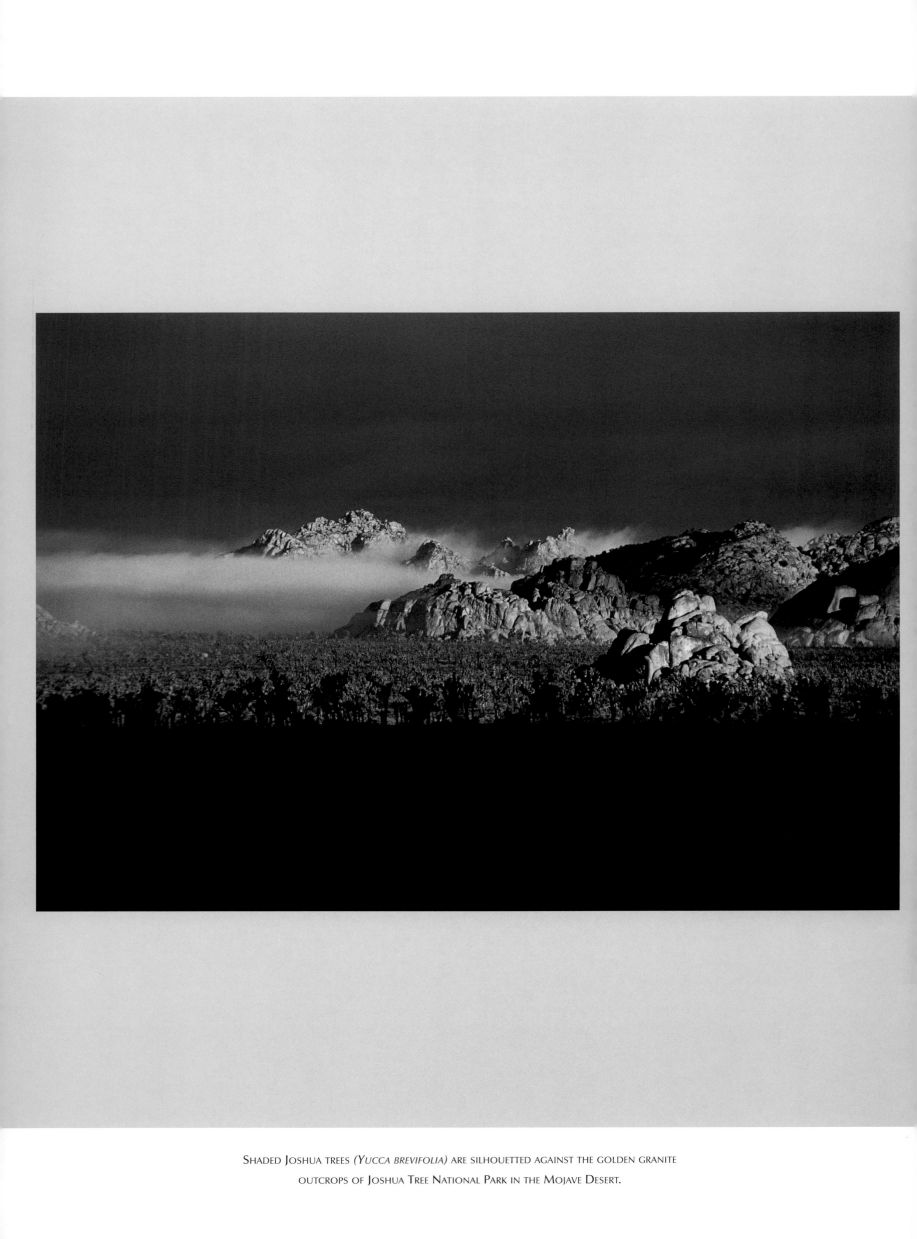

Shaded Joshua trees *(Yucca brevifolia)* are silhouetted against the golden granite
outcrops of Joshua Tree National Park in the Mojave Desert.

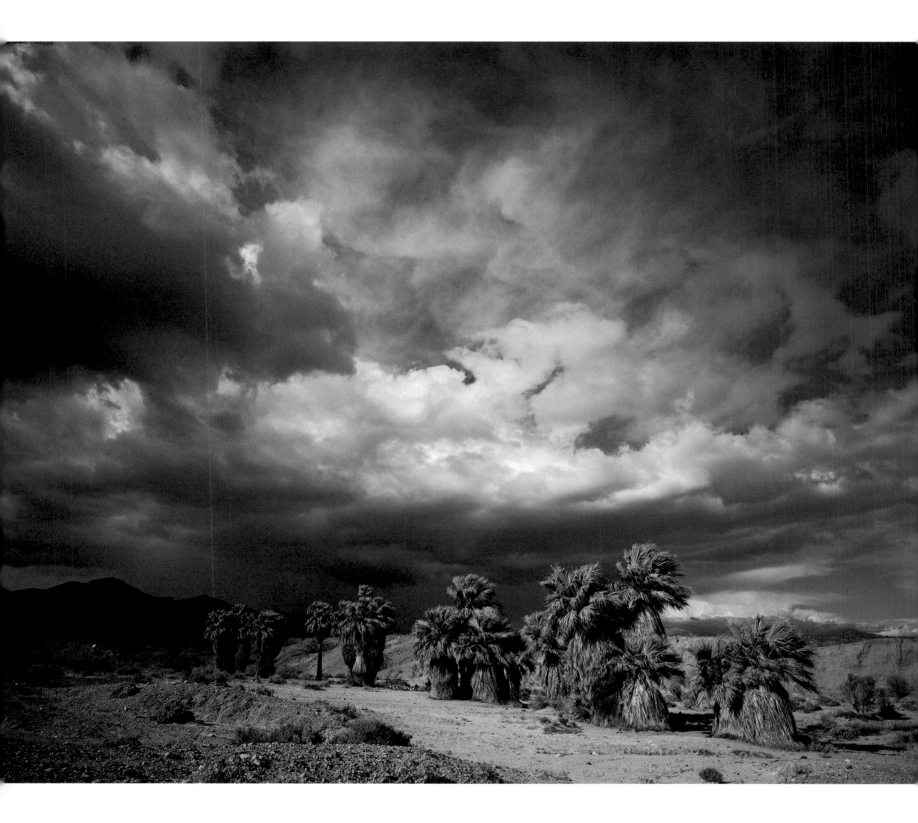

A grove of California fan palms (Washingtonia filifera) seems to dance
in anticipation of an approaching storm. They make up the Seventeen Palms Oasis,
nourished by an underground spring in Anza Borrego Desert State Park.

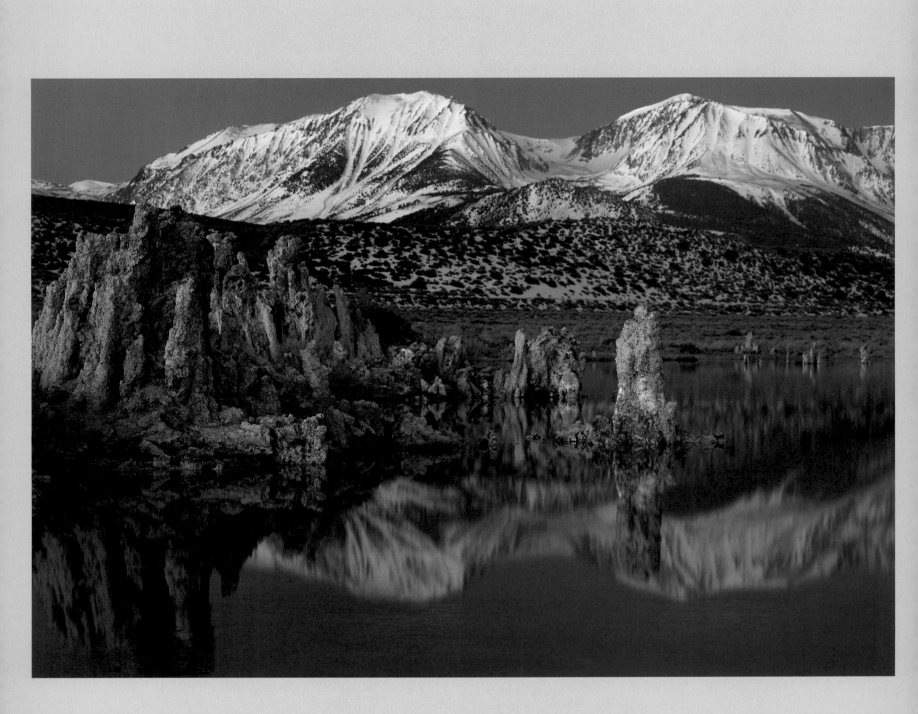

▲ Ancient tufa formations, chemically formed by infusions of mineral-rich fresh water
into the highly saline Mono Lake, stand a ghostly vigil.
► Anthropomorphic petroglyphs etched into the desert varnish of volcanic walls
are found in canyons of the Coso Range near China Lake in the southern Owens Valley.

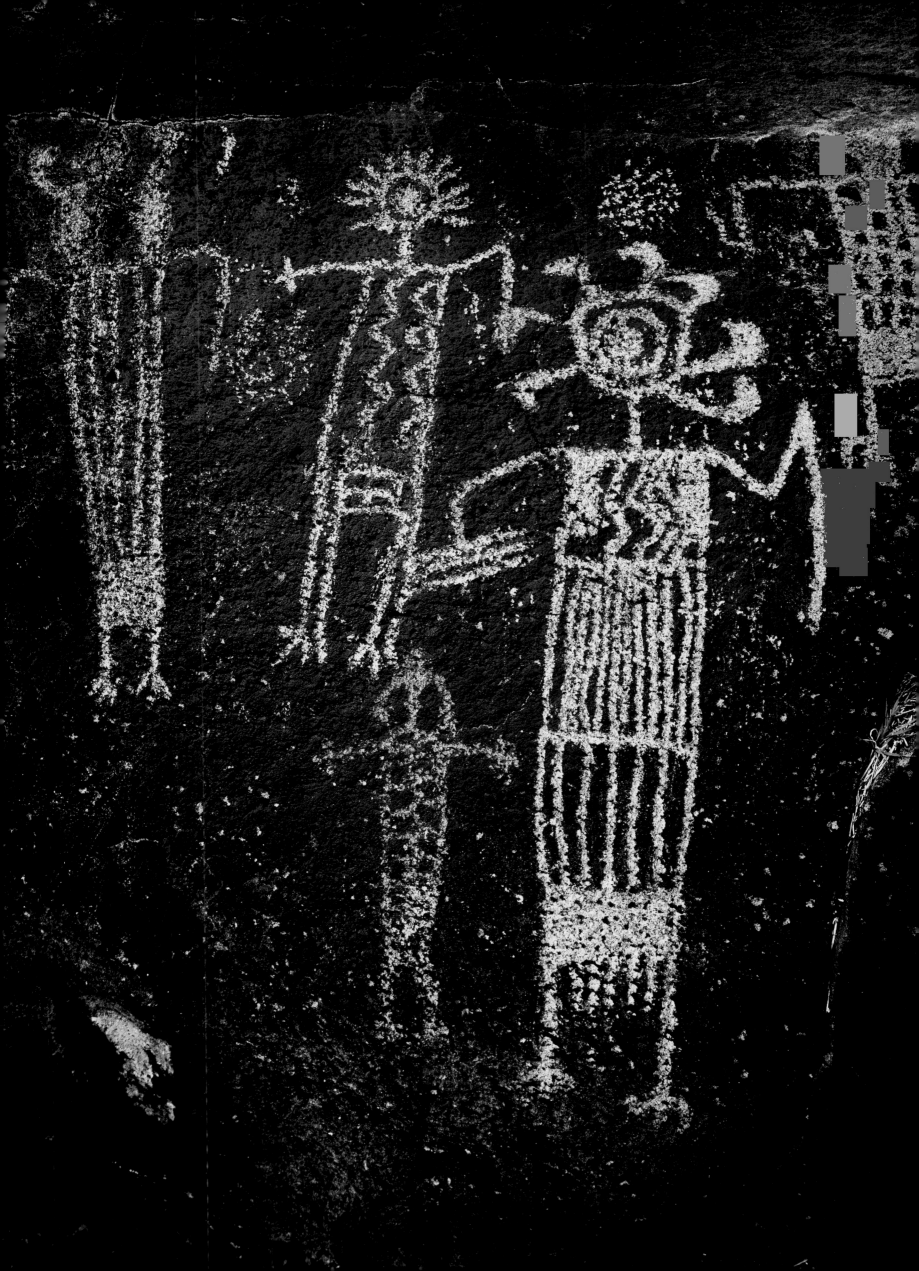

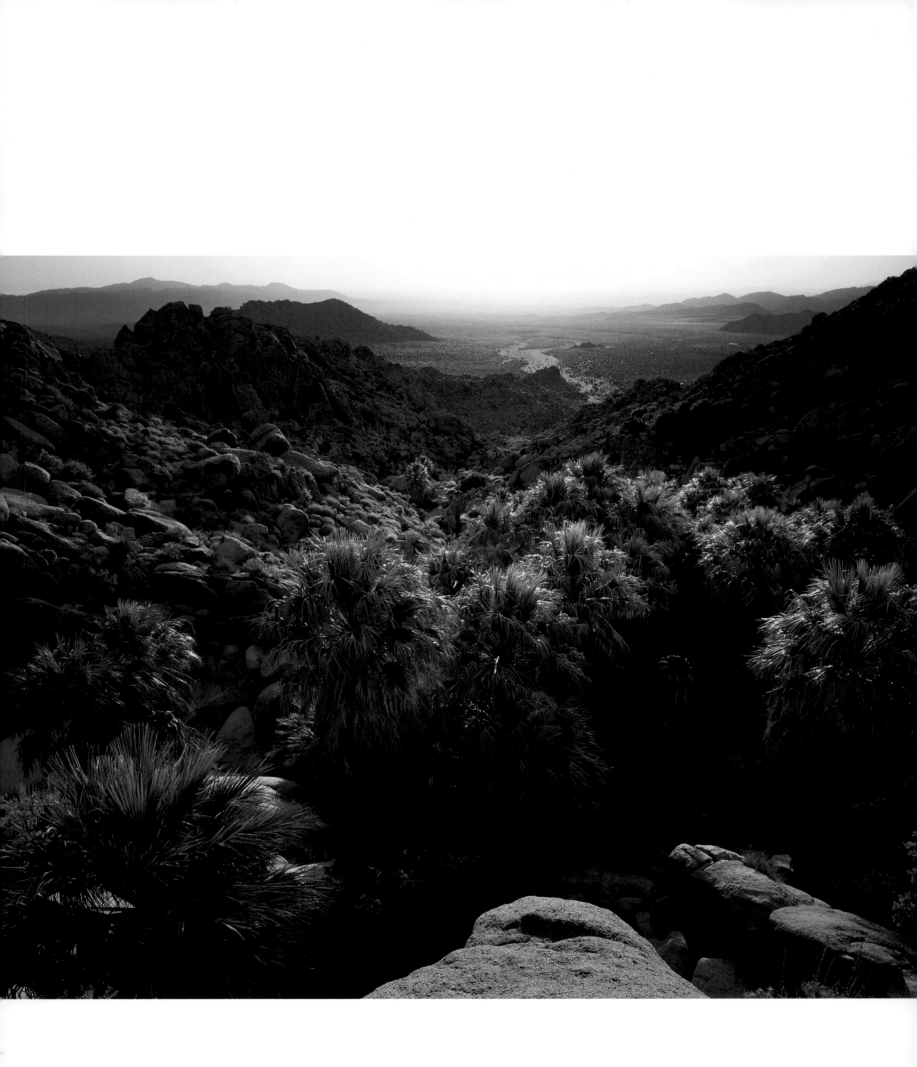

THE MORTERO PALMS OASIS AND ITS LARGE GROVE OF CALIFORNIA FAN PALMS

MAKE FOR A JOYOUS SYMPHONY OF MORNING BIRD AND INSECT SONGS AT THE BASE OF THE

JACUMBA MOUNTAINS WILDERNESS, COLORADO DESERT.

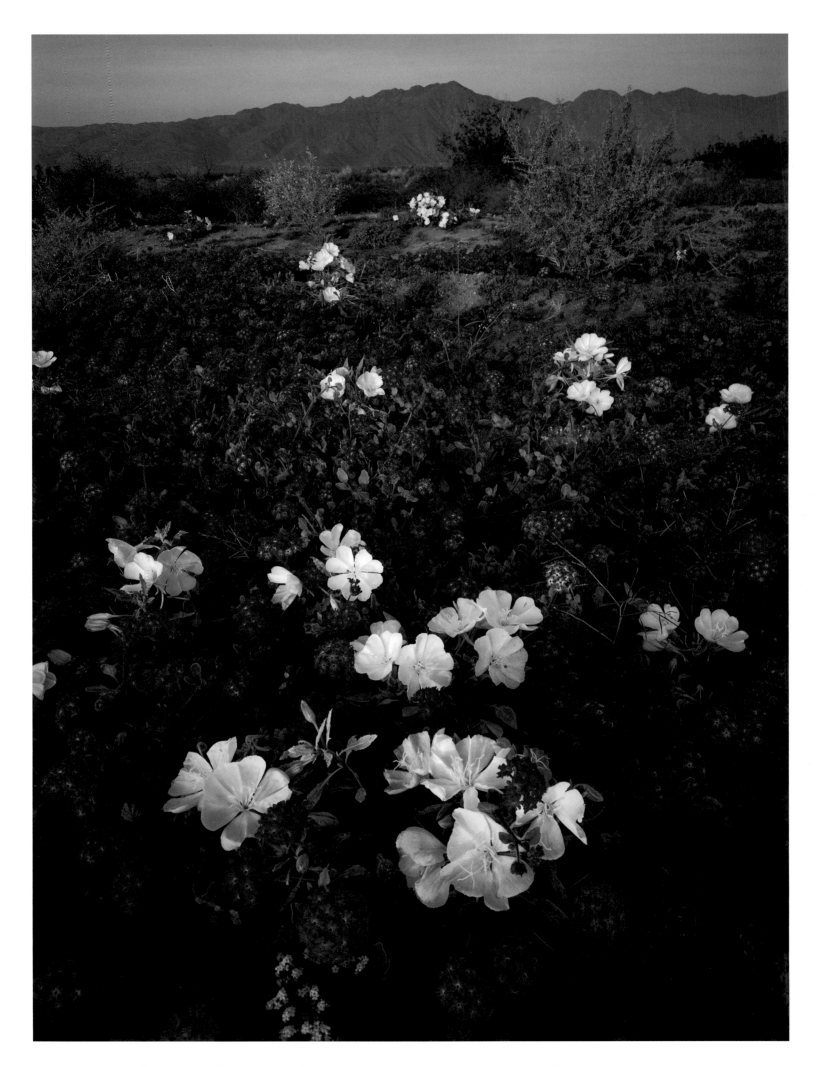

Sand verbena *(Abronia villosa)* and dune evening primrose flood the desert of Borrego
Valley with pink and violet exuberance in dawn's first light, San Ysidro Mountains,
Anza Borrego Desert State Park.

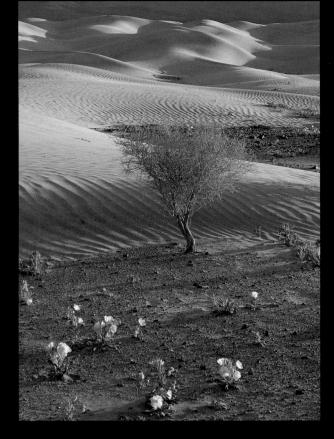

▲ Morning light shines on primrose and Eureka
Valley dunes in Death Valley National Park.
► A plank supports an outhouse in the mining
ghost town of Bodie State Historic Park.

An idyllic night scene highlights star tracks from the earth's rotation.

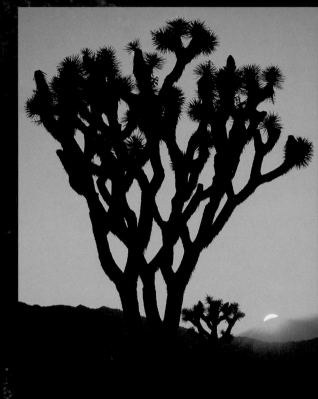

◀ ▲ Perhaps these petroglyphs, superimposed over older designs in Coso Range volcanic rock, celebrate a successful hunt of bighorn sheep.

▲ Joshua trees soak up the final rays of sunshine in Joshua Tree National Park.

Reflected light from a dense growth of ferns turns the entrance to a lava tube cave green in Lava Beds National Monument.

Background: Painted ceremonial motifs decorate walls in Fern Cave, Lava Beds National Monument.

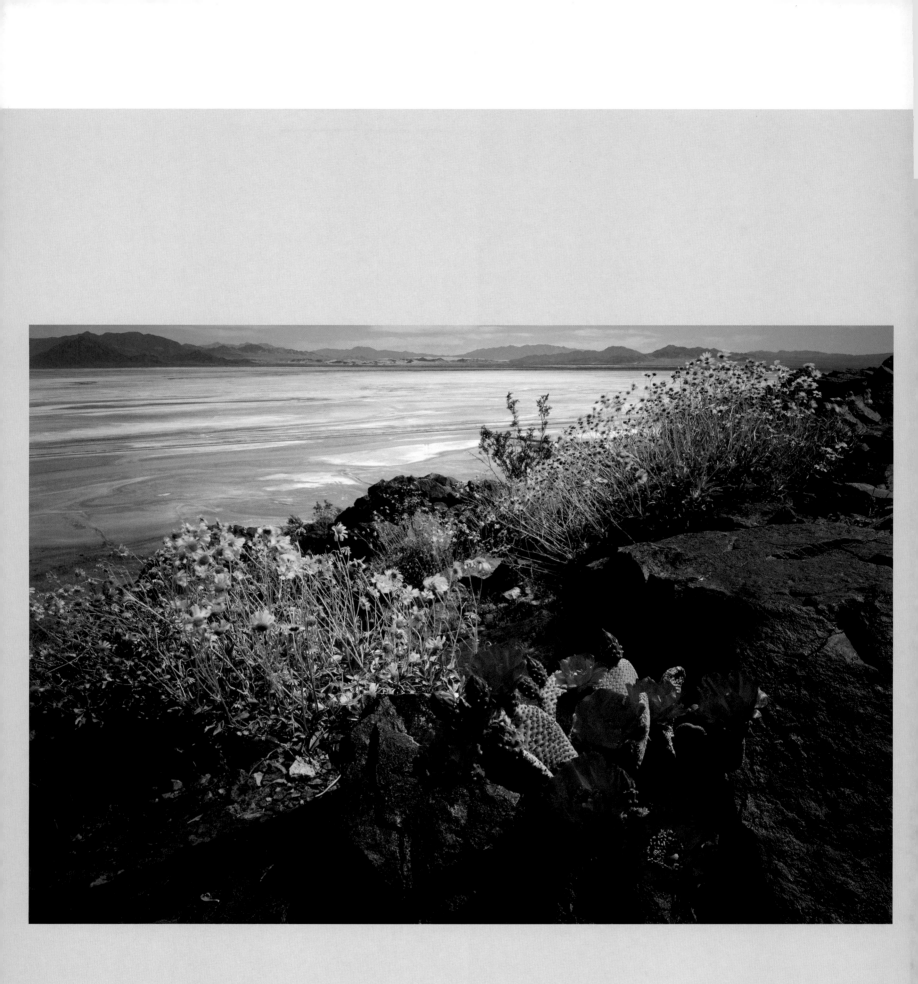

▲ APRIL CLUSTERS OF BRITTLEBRUSH (*ENCELIA FARINOSA*) AND BEAVERTAIL CACTUS (*OPUNTIA BASILARIS*) SEND UP A
SPRING RAINBOW FROM THE ARID EXPANSE OF DEVIL'S PLAYGROUND, MOJAVE NATIONAL PRESERVE.
► PHACELIA (*PHACELIA FIMBRIATA*) AND YELLOW PRIMROSE (*OENOTHERA MACROCARPA*) BRIGHTEN THE ALLUVIAL
SOILS OF FURNACE CREEK WASH. THE PANAMINT RANGE, AT TOP, OVERLOOKS THIS DEATH VALLEY SCENE.

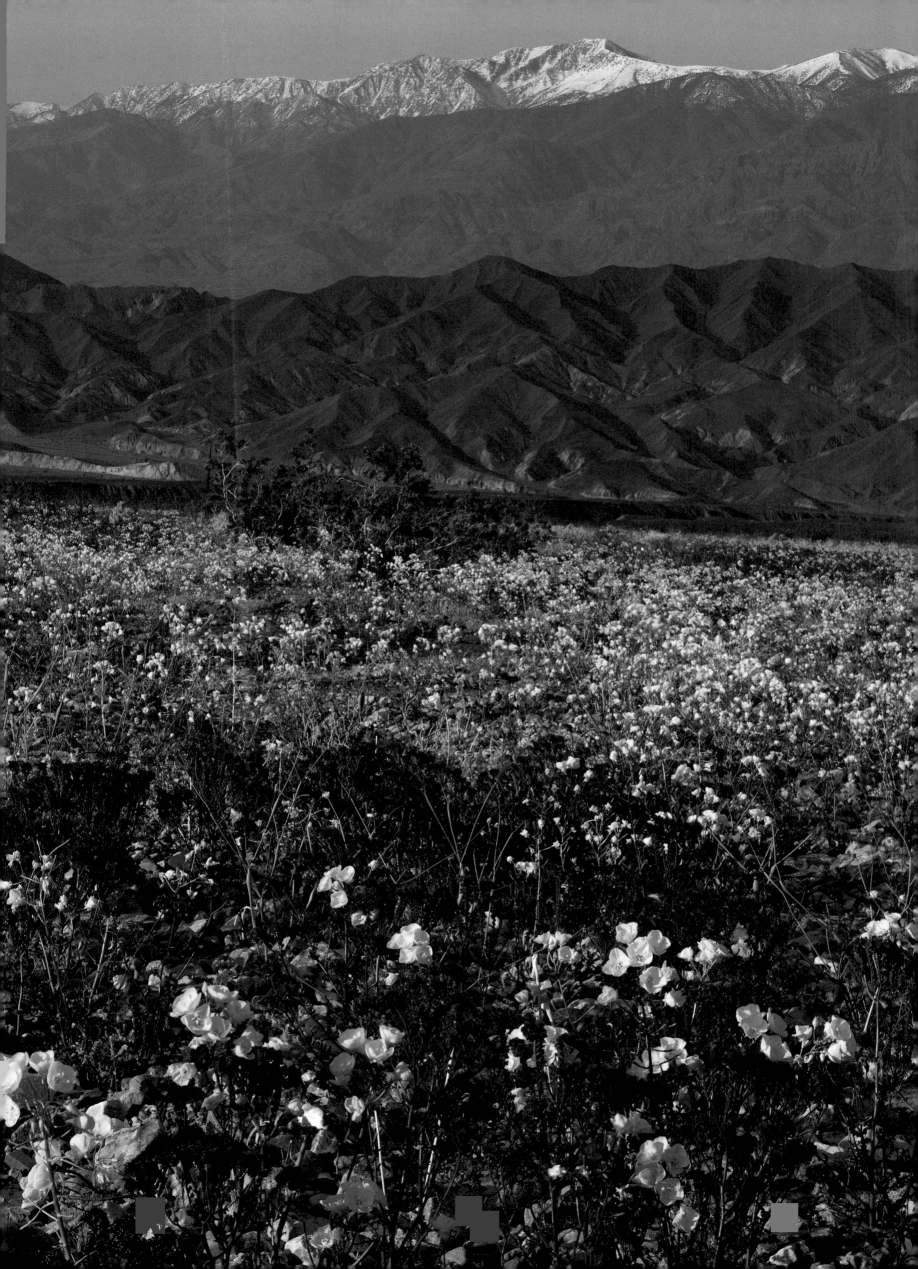

IN DESERT COMMUNION

There are hills, rounded, blunt, burned, squeezed up out of chaos, chrome and vermilion painted, aspiring to the snowline.... For all the toll the desert takes of a man it gives compensations, deep breaths, deep sleep, and the communion of the stars....
— Mary Austin, *The Land of Little Rain* (1903)

Like Moses, we can renew our connection with the divine in the desert. But take along the water jug.

On a relief map, California's sun-blasted arid lands appear as an invading scourge, driving deeply from the east into the southern half of the state and occupying its northeast corner as well. Fully 28 percent of the state's land, some twenty-one million acres, is desert. The vast and arid domain occupies all the lands east of the Cascade, Sierra Nevada, Transverse, and Peninsula Ranges, from Oregon to Mexico. That's no accident: mountains, especially extensive, high mountains like California's, squeeze rain from the clouds as air masses rise over them, so that little moisture reaches the downwind regions.

Adding to the meteorological picture is the Mediterranean wet winter/dry summer weather pattern. Although winter storms now and then make it down from the Gulf of Alaska to drop rain on the desert, summer-long Pacific high-pressure systems draw cool, moist air from the ocean onto shore, which creates fog all along the coast—but only drier weather inland.

California's celebrated diversity is nowhere more evident than along its mountain/desert interface. The lowest spot in the nation at 280 feet below sea level is Badwater, Death Valley. Just eighty-five miles away, 14,495-foot Mount Whitney, loftiest point in the Lower 48, reaches for the stars.

The desert is better visualized as three geographic zones of altitude and temperature: the Great Basin (high and cold), the Mojave (mid-elevation and warm), and the Colorado (low and hot). Again, diversity: sunk within the Great Basin's high, relatively cold terrain is Death Valley, the most water-starved inferno in America.

The Great Basin is made up of high mountains, wide valleys, or basins, in a recurring geologic pattern that sweeps all the way east to the Rockies. By contrast, the wedge-shaped Mojave Desert lies mostly within California and is warmer and flatter than the Basin. From its western point against the southern Sierra and the Transverse Ranges that reach in from the coast, the Mojave widens to fill a two-hundred-mile expanse along the Arizona border. Its elevations are mostly between two- and four thousand feet. The lowest and generally hottest of the three is the Colorado Desert. Bounded on the west by the Peninsula Ranges and, partly, by the great San Andreas Fault, it reaches into Mexico and Arizona and includes the Imperial Valley, Joshua Tree National Monument, and the Salton Sea.

"Man, we gotta be desperate," I complain.

"I think you're right," Marty says with a rueful smile, his short brown hair dancing in the dry breeze.

Here we are at the western edge of the broad Mojave, two veteran sky junkies who don't need to prove anything to anybody when it comes to flying. We've climbed to eighteen thousand feet over the mountains, cruised miles and miles above blustery coastal dune sheets, and thermaled up from low hills to tickle the dark gray bellies of flatland cumulus clouds. Which makes this little adventure seem all the more pathetic. Why didn't we go to the ball game instead of driving all the way out here from L.A.?

Like Friday-night wallflowers, we stand atop the twenty-foothigh slope of the California Aqueduct, waiting for this balky breeze to invite us to the dance. The aqueduct runs for miles, so it could be a long, fun, soaring flight—if we had just a little more wind velocity.

I hold the wind meter aloft. Acrid whiffs of sage and creosote bush sting my senses into sharp attention. At least it feels, I don't know... cleansing, just to be here. Primitive, instinctual. I like the big wide stillness of the desert. It whispers of life's paradoxes, of creatures so fragile yet so dangerous in their focus on mere survival.

"I thinks it's blowing a little harder," Marty offers.

"Don't think so, Flea," I say, reading the meter. "Still around twelve." We need at least fifteen miles per hour to soar this little bump.

"Really? Hmmm. Feels stronger. I'm sure it's soarable," he says, trying to talk himself into taking off as he looks out upon the broad, dusk-yellow Mojave. I can almost hear the machinery of his mind grinding away at the hang-glider pilot's eternal dilemma: to go or not to go? In this light wind, we'll be lucky to get a ten-second, wind-extended glide to the sand below. That's hardly worth the twenty minutes it took to set up the gliders, not to mention the ninety-minute car trip. We haven't had such pitiful luck since we taught ourselves to fly from low, rounded hills, years ago.

Still, here we are, and air time is air time. Talk about rationalizing. Foot-launched fliers are a stubborn breed, especially when they're standing on a launch site gazing out on the beautiful world below—even when it's just twenty feet below.

The ancient bristlecone pine is one stubborn organism. Anchored by roots that grab into limey dolomite soil like iron stakes, the bristlecone is the earth's oldest living tree. Ironically, the same severe climate that decrees a harsh life upon the bristlecone also contributes to its longevity. Since few other plant species can survive in such severe conditions, competition is limited. In sparsely populated groves that lie between ten thousand and eleven thousand feet in the White Mountains, just east of the Sierra, the bristlecone stands mostly alone against scathing winter winds and parching summer aridity.

Before the time of Christ, before Alexander the Great conquered Egypt in 332 B.C., seventeen bristlecone pines still standing today were already two thousand years old! Like saltwater taffy inexorably twisted and frozen into contorted shapes by the elements, these haunting sentinels sometimes live as long as fifty-five hundred years. One, named Methuselah but unidentified lest it be vandalized, is likely the most ancient tree in the world at forty-seven hundred years.

Whole eras of wind-driven sand and grit blast away at the bristlecone's bark: on the older trees, only a narrow strip of a few inches remains. These spartan veneers carry the faint life-spark of nourishment from roots to tiny branch-tip needles.

At the western foot of the White Mountains lies the long, narrow Owens Valley. Tempers blew sky high in the Owens during the early part

of the twentieth century. Echoing the battle over San Francisco's diversion of western Sierra water that ultimately drowned the Hetch Hetchy Valley into a reservoir, Owens Valley farmers railed with bristlecone-like tenacity against Los Angeles over eastern Sierra water rights. The conflict took on the tenor of Gold Rush bloodlust when water pipes as big around as elephants were repeatedly bombed and murderous threats rang in the parching air. Many court battles were waged, for naught: L.A. got its water.

The ecological toll from usurpation of Owens Valley water was most dramatically evident at Mono Lake, a large, salty body Mark Twain dubbed the "Dead Sea of California" in his 1862 visit to the area. Mono's water level dropped dozens of feet. Not long after, the ecosystem throughout Mono Basin began to unravel. The most graphic evidence of the change was the gradual otherworldly emergence of once-submerged, crusty-lumped tufa towers. The tufas grow as a result of chemical interaction between Mono's saline water and fresh mineral water welling up from lake-bed springs.

In 1994, after years of litigation, a win-win court ruling set a permanent limit on the amount of water that could be diverted southward. Since then, Mono Lake has risen nearly ten feet en route to its mandated return to 6,392 feet above sea level.

A pathetic little gust piques my interest. I look toward Edwards, hoping to see dust cloud signs of stronger winds. No joy, as fighter pilots say when they fail to spot a sought-after target.

Sprawling across the desert just thirty miles to the northeast, Edwards Air Force Base, formerly Muroc Dry Lake, is where Chuck Yeager broke the sound barrier, and where the Space Shuttle still lands now and then. The desert is home to every form of aviation enthusiasm. The many airports and glider ports, civilian and military test flight centers, even hot-air-balloon launch areas, all provide easy access to the alkaline skies.

Another thirty miles southeast of Edwards, El Mirage Dry Lake's four miles of lake bottom emerges every spring from winter rains to dry into a hard, flat surface perfect for recreational activity of every type. Marty and I have flown ultralights, been towed up in hang gliders, driven land sailers (a sailboat with wheels), and raced 110 miles per hour in our jalopies just to see if we could make them go that fast.

I've watched a meteor shower with my daughters in the dead of an Independence Day night at El Mirage. Another night, with oldest daughter, Bridget, on my lap so she could reach the van steering wheel, we careened around hummocks of creosote bush. Happening upon a huge herd of very large jackrabbits, to the immense delight of B. and her suddenly awake sister, Jamie, we dimmed the headlights, following at a respectful distance as they hopped hither and yon into the inky blackness. Night of the Lupus.

Once we drove out to simply marvel at a gush of stars ladled from the crescent moon.

The girl's excited squeals return faintly to me now, like the teasing breezes rolling up the slope of this monotonous aqueduct.

When most people think of "California desert," the Mojave is what comes to mind. The second of California's three arid regions, this huge wedge of chocolate mountains and vanilla sands, dry lake beds and sagebrush, challenges the senses. It is a classic desert of wonderfully varying character, mood, and stark beauty.

All deserts can be rich and inviting lands for modern visitors unconstrained by basic survival issues. You can get lost and find yourself in the vast, monochromatic silences. Far from the busy clutter of where you came from, the simplest things take over your awareness: breathing, water, shelter, food. Life and death reveal themselves as partners, not enemies. Everywhere in the desert, you find evidence of life's defiance of entropy.

And no living thing fights harder to live than King Clone.

That was what botanists called a yards-wide oval of lowly creosote scrub brush found in the Johnson Valley. Their tests indicated King Clone was at least 11,700 years old. Its fanciful name comes from its survival tactics. The bush imbeds branch tips in the sandy soil, where they take root, generating clones that grow independently of the "mother" plant.

Joshua Tree National Monument, a huge wilderness of granitic peaks, domes, ridges, and boulders, may be the most popular spot in the Mojave. Los Angelenos call it the "high desert," a fitting term for terrain features that range from two thousand to almost six thousand feet above sea level. Everywhere, the shaggy-trunked, spiny-leaved Joshua Tree raises its arms to heaven, mourning the cosmetic price it pays for survival: it is, after all, a member of the transcendentally delicate lily family.

Nearby Hollywood turned Mojave regions into a kind of home for singing movie cowboys of the 1930s. These citified range riders unwittingly introduced the notion that civilization and wilderness could coexist, even in the same harsh deserts that had so threatened the existence of the overland immigrants less than a century before. Over the dusty trails, Roy Rogers and Dale Evans, Gene Autry, Tom Mix, Monty Montana, Herb Jeffries, and the rest of the gang rode down the black hats not only on horseback, but in jeeps and trucks. They used telephones and other modern trappings of the New West, but never strayed too far from a guitar-strumming, tenor-crooning ballad meant to woo a bashful sweetheart.

The wind just isn't singing to us today. We've waited more than an hour and it's still blowing at about ten miles per hour.

"Well," says Marty, letting out a sigh, "I needed to get out of town anyway."

"Town" means the megaclutter of L.A., and he's right. Only an hour-and-a-half drive away, this endless Mojave restores a much-needed sense of calm.

PICTOGRAPHS ARE FOUND IN THE LAGUNA MOUNTAINS OF ANZA BORREGO DESERT STATE PARK.

Marty scratches his head and picks up his harness.

"Well," is all he says.

"Aw, you're kidding me, right?" I ask, chuckling.

"Might as well take a short hop."

"Now I know we're hurtin'."

The Colorado Desert region covers the southernmost, lowest, and hottest regions in California. Roughly two hundred miles wide by one hundred miles long, its blasted wastelands enfold the astonishing green oases of the Coachella and Imperial Valleys and the irrigation-created Salton Sea. One of the largest state parks in America, six-hundred-thousand-acre Anza-Borrego Desert State Park, draws thousands of visitors annually to its fascinating landscape. Badlands, palm canyons, desert washes, and craggy rock promontories spread across elevations from near sea level up to six thousand feet. Campgrounds and well-marked trails make it the ideal place for a first pilgrimage to the desert.

Marty muscles the glider up, steps backward a couple of steps on the flat top of the aqueduct's road, and runs for all he's worth straight at the windward edge.

"Go gettum', boy!" I holler as his sail fills with what little wind there is. He runs off the berm and immediately carves a smooth right turn, and—amazing—he's maintaining altitude!

Down the perfect slope of the aqueduct he cruises, right on the ragged edge of losing the lift. His downwind wingtip actually overlaps the top of the ridge by three or four feet so he can keep the glider within the narrow band of lifting air. Then, with the deft skill born of hundreds of hours of foot-launched soaring, he manages a quick, smooth, 180-degree turn without losing any altitude. And back toward me he comes. I have to step back to let him pass.

"All right, Flea! Go to it!" I holler, tremendously impressed.

"Come on up!" he yells.

"You mean down!" After all, I can see the entire top of his sail as he cruises by.

I hear his gleeful laughter. No way I can do what he's doing. He's thirty pounds lighter than I am, and today, that's the difference between soaring pilot and frustrated observer.

From out of nowhere a big, beautiful, red-tailed hawk swoops down to slide into formation with Marty's glider. As if the dance were choreographed, the hawk leads him back on up the line. I can't believe it. Hawks will join thermaling gaggles of gliders in the mountains, but I've never seen one share ridge lift, especially this low to the ground. I quickly sit down, afraid I might spook the bird away.

On his next pass, Marty calls out, "Do you see that guy?"

"Are you kidding? He's right in front of me!" I can see the hawk's top wing feathers ruffle lightly. That means he's working too, keeping his flying speed right on the ragged edge of the stall to milk every inch of lift from the breeze. Just like Marty, in fact. God, he's a graceful pilot. For just a moment, I'm the slightest bit jealous, as if the hawk offers Marty membership in an exclusive club from which I am barred.

The 1915 citizens of El Centro must have been desperately tired of having to drive all the way around the forty-mile expanse of sand that interfered with their automobile adventures to Arizona. Why else would they have gone to so much trouble to build a wooden-plank road right across the dunes? The single-lane highway stretched six miles into the Colorado Desert and saved a great deal of travel time for the clattery, short-range vehicles of the day. Replaced by a paved road in 1926, the plank road fell into disrepair and was swallowed up by the sand or broken up for firewood. Nothing like it was ever built anywhere else in the United States, which is probably why tourists seek out the last, BLM-protected fifteen hundred feet of it to this day.

Hardiness and ingenuity, perseverance and imagination: all prime requisites for desert-dwellers, two-legged and otherwise.

For long minutes I sit on my haunches, watching the silent communion of man and raptor. Even if the wind were stronger, I wouldn't risk spoiling Marty's pas de deux with the hawk. And I'm rediscovering how soul-satisfying it can be just watching highly skilled fliers finesse the best the sky has to offer. And these two guys are as good as it gets.

After several passes, the hawk lets out a shrill cry, flaps once, then again, and climbs into the sky. He's sniffed out a thermal. I watch him turn and turn, rising higher downwind until I can't see him anymore.

I know Marty would follow if he could.

Finally, arms no doubt tired from all the tight maneuvering, Marty turns east, into the rising band of sunset maroon sky, to settle seconds later into a tippy-toe landing next to my van below.

Sun-and-wind-burned but happy, we roll onto Highway 14 and head for home, chattering about the severe yet delicate beauty of the Mojave and, most of all, the hawk. Even now, in the deepening gloom, we scan the scrub brush hillocks and forested mountain peaks, sizing up every nuance of the moving landscape and its potential to focus the wind into soaring flight. Once you know how to read the sky as a moving ocean of wind, all landscape features become an infinitely tantalizing theater of possibilities.

"That hawk. That was really something," Marty says, still slightly awed by the blessing as we ease down the Sepulveda Pass into Santa Monica.

"Doesn't get any better than that," I say.

He simply nods, as we relax into contented silence.

Because there is comparatively little of value to mine in the California deserts, because so little rain falls here, millions of acres of undeveloped expanses have come under state and federal protection. Rejoice! In our desert wilderness areas, we celebrate the egalitarian notion that practicing stewardship over natural landscapes serves the sanctity of all forms of life, and thus the most primal center of our own humanity.

California's great desert regions remind us that we are an inseparable part of the shifting sands of time. We ride the great unbroken wheel of the universe, and we see so little. In its unapologetic boundlessness, the desert invites simple respect for the earth, our sacred home. Called to attention by the deafening silence, and so more highly attuned to nuances of our fragile existence, we slowly remember to revere the infinite horizons for what they tell us of immortality: that we are the dust of stars, equal to the grain of sand at our feet and the mountain it was eroded from.

RETURN AND REBIRTH

I remember that the Gabilan Mountains to the east of the valley were light gay mountains full of sun and loveliness and a kind of invitation, so that you wanted to climb into their warm foothills almost as you want to climb into the lap of a beloved mother.

— John Steinbeck, *East of Eden* (1952)

Whenever I drive through the Salinas Valley, I search the guardian hills of the Gabilans for the rainbow signature of Marty's wing. The habit has become a ritual homage to his memory since we lost him in a flying accident, years ago.

Even these days, as unstoppable as the Pacific tide, the heartwheel sometimes turns and I realize, no, I still haven't let him go.

Today is one of those days. En route to visit my daughters in Santa Cruz, I impulsively leave Highway 101 and wind up a dirt road to a gentle knob of a hill in the safe lap of the Gabilans. Marty and I made some glider test hops here once. Far from the drama of Yosemite, Guadalupe Dunes, or the desert, here is where I feel his spirit most, though I can't say why.

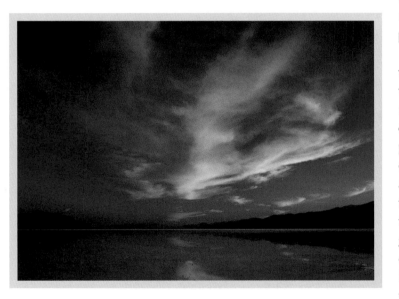

I sit, breathing in the wonderful heavy air from the green checkerboard farmland below. Soon, my road-rush mind chatter ebbs away and my senses circle up like a thermaling bird seeking the thin, hard blue of altitude.

Flying throughout California with Marty, I learned to take from the outdoors what I took from church as a boy: a sense of awe and wonder at the great unsolvable puzzle of life. Now, missing my buddy just a bit, I'm wanting again some small measure of deliverance from the melancholy of loss.

A rustling in the grass brings my attention to a late afternoon gust tumbling up the slope. In the distant west, the amber torch of the setting sun slowly settles into ivory billows of Monterey Bay fog. Such enduring beauty.

I breathe deep the gathering dusk. In time, a sigh of acceptance eases from deep within me. Slowly, the heartwheel turns again. My soul swells with gratitude. What joys of earth and sky we shared! We experienced California's wild places in a way few humans ever will.

Suddenly, a shrill cry: out of the west, a red-tailed hawk floats up in lazy circles from the valley floor. Oh, such a handsome lad. His head swivels left and right, as if he's watching me. Another piercing whistle. Then a wide, easy bank, tip feathers fluttering, and right over my head he goes, on up the mountain and beyond. So sure and free, so full of grace.

I laugh. Hard to mistake that style. I call out the old, familiar greeting: "Have a good one, pal!"

"Appalachian Spring" thunders through my being. If you listen, your soul will tell you when it's home.

A few million years from now, all this empire along the golden coast will be gone to dust. Our distant descendants, bearing some small resemblance to us, will, we can hope, have found a way to the stars. Along the way, birds will hatch, breed, and soar. Winds will blow; rain will fall. Green things will seek the sun, as always. And the great land masses will grind on and on.

The entire coast of California, so say the geologists, will have migrated northwest up the San Andreas Fault to the vicinity of present-day Alaska. In that distant eon, all these lands we marvel at today will have evolved into a string of new islands.

California's wilds invite us to consider such things and choose to realize that we are a part of the flow of existence, as we have always been and ever will be.

Imagine you rejoin the skies one last time, hooked into a sailcloth glider. Race high now above the vast Pacific coastline. Far below, lines of gray whales make their slow migration through the Santa Barbara Channel. Farther north, mighty redwoods push and push toward the sun.

Float along, far above the wrinkled ridges, then low over valleys whose oaks hold safe the rolling land. Feel the hot, dry bump of desert thermals push you up past the mountain bristlecone pines clinging to life. Wheel now, free as a thought, dropping down to skim the thrashing Lost Coast sea. Taste the salt air as you bank with the gulls in strong lift above a misty coastal cliff. Now zoom, fast as lightning, through the deep granite vaults of Yosemite Valley, and up and over the roof of Half Dome to skim Hetch Hetchy Reservoir's deep blue waters. Once this was a Yosemite too. Our children count on us to remember that, and to extend our stewardship over the land, and so upon their futures.

We can touch again our deepest life experience within California's wilds, if we simply go. In the mountains, we feel again our youth, power, passion, and intimations of immortality. Soothed by grassy plains and rolling hills, we flow into warmhearted affection for our earth mother, as if we were oak leaves warmed by the sun. All along the sundown sea's western slopes and beaches, coves and crags, the drumbeat rhythm of the waves stirs our blood pulse, informing a certainty of kith and kinship with all living things above and below the undulating sea. In the stark night desert, silence whispers of eternal struggles: the scampering kangaroo rat against the barn owl's nocturnal swoop, Yucca blossoms against hot dry air, stone against sun, wind, and rain, white light against hard black shadow.

Finally, we land from our flights through California, refreshed and, as from a cathedral, renewed.

BADWATER REFLECTS THE BRILLIANT CIRRUS CLOUDS IN DEATH VALLEY NATIONAL PARK.

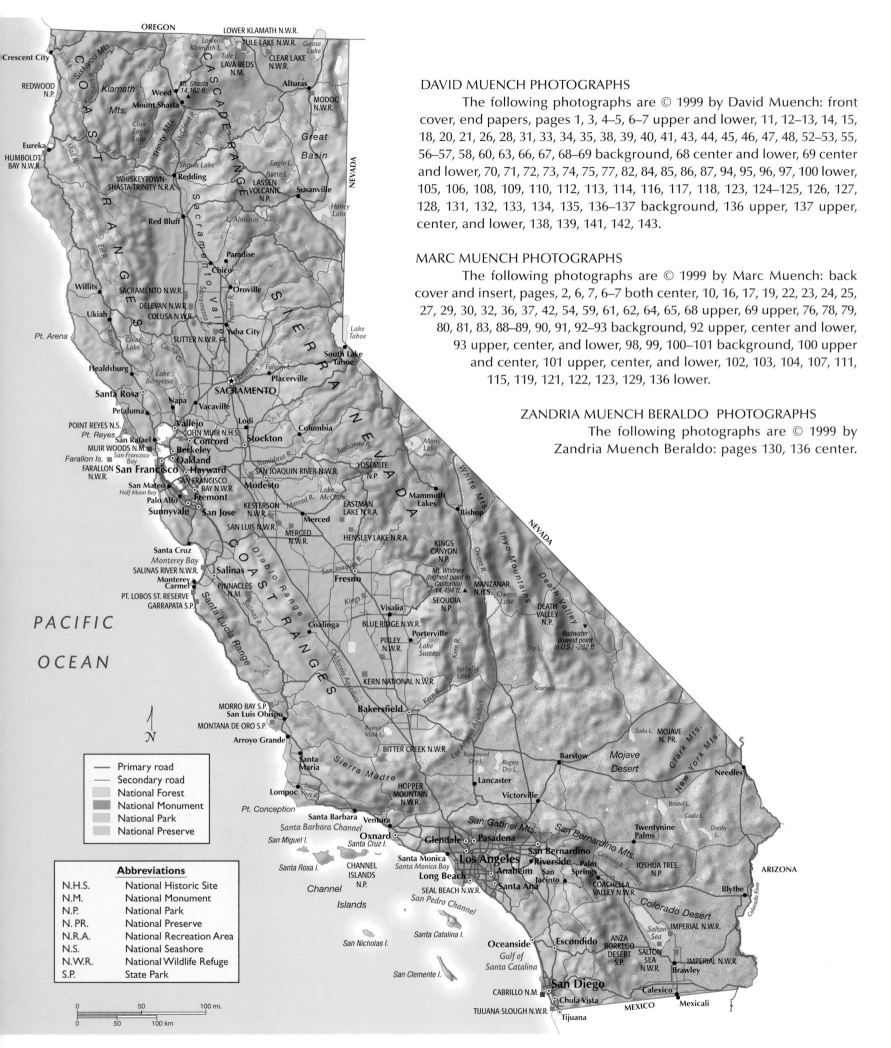

DAVID MUENCH PHOTOGRAPHS

The following photographs are © 1999 by David Muench: front cover, end papers, pages 1, 3, 4–5, 6–7 upper and lower, 11, 12–13, 14, 15, 18, 20, 21, 26, 28, 31, 33, 34, 35, 38, 39, 40, 41, 43, 44, 45, 46, 47, 48, 52–53, 55, 56–57, 58, 60, 63, 66, 67, 68–69 background, 68 center and lower, 69 center and lower, 70, 71, 72, 73, 74, 75, 77, 82, 84, 85, 86, 87, 94, 95, 96, 97, 100 lower, 105, 106, 108, 109, 110, 112, 113, 114, 116, 117, 118, 123, 124–125, 126, 127, 128, 131, 132, 133, 134, 135, 136–137 background, 136 upper, 137 upper, center, and lower, 138, 139, 141, 142, 143.

MARC MUENCH PHOTOGRAPHS

The following photographs are © 1999 by Marc Muench: back cover and insert, pages 2, 6, 7, 6–7 both center, 10, 16, 17, 19, 22, 23, 24, 25, 27, 29, 30, 32, 36, 37, 42, 54, 59, 61, 62, 64, 65, 68 upper, 69 upper, 76, 78, 79, 80, 81, 83, 88–89, 90, 91, 92–93 background, 92 upper, center and lower, 93 upper, center, and lower, 98, 99, 100–101 background, 100 upper and center, 101 upper, center, and lower, 102, 103, 104, 107, 111, 115, 119, 121, 122, 123, 129, 136 lower.

ZANDRIA MUENCH BERALDO PHOTOGRAPHS

The following photographs are © 1999 by Zandria Muench Beraldo: pages 130, 136 center.

QUOTE SOURCES

Austin, Mary. 1974. *The Land of Little Rain.* New York: Gordon Press.

Frémont, John C. 1845. *Report of the Second Expedition.* Washington, D.C.: U.S. Government Printing Office.

Miller, Henry. 1978. *Big Sur and the Oranges of Hieronymus Bosch.* New York: W. W. Norton & Company.

Muir, John. 1911. *My First Summer in the Sierra.* Boston: Houghton Mifflin.

Piazzoni, Gottardo. 1993. *Paintings of California,* ed. Arnold Skolnick. Berkeley, Los Angeles, London: University of California Press.

Proust, Marcel. 1934. *Remembrance of Things Past.* New York: Random House.

Steinbeck, John. 1952. *East of Eden.* New York: Penguin Books.